After Effects

and **Cinema 4D**

Lite

After Effects and Cinema 4D

Lite

3D Motion Graphics and Visual Effects using CINEWARE

Chris Jackson

Focal Press
Taylor & Francis Group

NEW YORK AND LONDON

First published 2015

by Focal Press
70 Blanchard Road, Suite 402, Burlington, MA 01803

and by Focal Press
2 Park Square, Milton Park, Abingdon, Oxon OX14 4RN

Focal Press is an imprint of the Taylor & Francis Group, an informa business

Notices

Knowledge and best practice in this field are constantly changing. As new research and experience broaden our understanding, changes in research methods, professional practices, or medical treatment may become necessary.

Practitioners and researchers must always rely on their own experience and knowledge in evaluating and using any information, methods, compounds, or experiments described herein. In using such information or methods they should be mindful of their own safety and the safety of others, including parties for whom they have a professional responsibility.

Product or corporate names may be trademarks or registered trademarks, and are used only for identification and explanation without intent to infringe.

Library of Congress Cataloging in Publication Data

Jackson, Chris (Chris B.)
After effects and Cinema 4D lite : 3D motion graphics and visual effects using CINEWARE / Chris Jackson.
pages cm
Includes index.

1. Computer animation. 2. Three-dimensional display systems. 3. Adobe After effects. 4. Cinema 4D XL. I. Title.
TR897.7.J329 2015
777'.7--dc23
2014019803

ISBN: 978-1-138-77793-4 (pbk)
ISBN: 978-1-135-77232-5 (ebk)

Typeset in Syntax
By Chris Jackson

Printed and bound in the United States of America by Sheridan Books, Inc. (a Sheridan Group Company).

Table of Contents

Chapter 3: 3D Camera Tracking and Compositing with CINEWARE

Chapter 4: Casting Shadows Using Layers with CINEWARE

Chapter 5: Lighting Effects

Chapter 6: Materials and Shaders in Motion

Chapter 7: Working with Cameras in CINEMA 4D and CINEWARE

Chapter 8: Multi-Pass Rendering with CINEWARE

Chapter 9: Beyond CINEMA 4D Lite

Introduction

After Effects designers: Enter a new dimension with CINEMA 4D Lite's robust toolset. You are about to take a journey that combines these two powerhouse applications. Enter the world of CINEWARE and CINEMA 4D. Welcome aboard.

What is this Book About?

One of the most exciting new features in After Effects CC is the integration of CINEMA 4D using the CINEWARE plug-in and a free version of CINEMA 4D Lite. Both provide a wide assortment of new 3D tools and options that are difficult or nearly impossible to achieve in After Effects alone. This book demonstrates how the new workflow bridges the two applications together to raise the design bar for motion graphics and broadcast design.

Each chapter helps After Effects designers understand how CINEWARE and CINEMA 4D Lite integrates within their motion graphics project. Now that Adobe has partnered with Maxon, the two programs are tightly interwoven together with the latest software release. After Effects provides an easy-to-use application for creating visual effects and motion graphics. CINEMA 4D Lite provides a powerful 3D modeling and animation package. The CINEWARE plug-in makes working between the two applications extremely flexible.

For motion graphics designers, CINEMA 4D takes their motion graphics project to the next level in 3D animation. 3D models can now be composited seamlessly as a layer within a composition using the CINEWARE plug-in. After Effects also can apply its assortment of visual effects to multi-layered 3D files. Not only can you import and composite CINEMA 4D files into tracked video footage, but you can also export your composition from After Effects as a CINEMA 4D file. The creative possibilities are endless.

All an After Effects user needs to do is know more about CINEMA 4D Lite, its features, and what they can do with them to enhance their motion graphics projects. That is what this book addresses. The book's objective is to bridge the two applications together and clearly demonstrate how CINEMA 4D Lite and After Effects can be integrated to produce enriched content for motion graphics using CINEWARE.

Who is this Book For?

The primary audience for this book is motion graphics designers and graphic designers. These readers can be professionals in the workforce, students, or anyone interested in creatively enhancing their After Effects projects with 3D content. This book assumes that readers have prior After Effects experience. They should have a working knowledge of the After Effects workspace.

The book provides an introduction to CINEWARE and CINEMA 4D Lite, its workspace and tools. The book does not necessarily show the reader what all the tools do; rather, it shows how to use them to enrich motion graphics projects. What differentiates this book from similar books is that readers will build real world examples and, as a result, learn how to use the software through each project's implementation rather than reading chapters that only

explain what each button or effect does. Practical application of 3D modeling and motion graphics is the best way to learn and understand how to integrate these two powerful applications. After Effects is the leading application for motion graphics design and with the new enhanced 3D capabilities present, showcasing After Effects content using CINEMA 4D Lite is the best way to go.

Regardless of how a reader approaches this book, using CINEMA 4D Lite to enhance After Effects content is growing in popularity. This book teaches readers how to think creatively and get excited about 3D modeling, motion graphics, and visual effects in their After Effects projects. It clearly illustrates how these two applications complement each other and help raise the design bar for motion graphics and broadcast design.

Book Structure and Layout Conventions

After Effects and CINEMA 4D Lite is designed to walk the reader through project-based exercises that effectively use After Effects and CINEMA 4D Lite. The exercises are built for the new features in version After Effects CC. CINEMA 4D Lite and CINEWARE are included free with this version.

To use this book, you need After Effects CC installed on either your Macintosh or Windows computer. If you do not have a licensed copy, you can download time-limited trial versions on Adobe's website *www.adobe.com*. If you own a professional version of CINEMA 4D, you can use that with CINEWARE instead of the Lite version that comes with After Effects. Refer to Chapter 9, page 259, to see how to change both the render and executable path to the professional version of CINEMA 4D instead of the Lite version.

The book's structure discusses how the two applications can work together in unison. Chapters 1 and 2 introduce you to CINEMA 4D Lite, its workspace and workflow. As you build a typical 3D project, comparisons are made between CINEMA 4D Lite and After Effects. Chapters 3 and 4 illustrate how CINEWARE allows you to seamlessly import and export content between each application.

Chapters 5 through 8 delve deeper into 3D modeling techniques and provide more in-depth exercises on materials, lighting, and animation in CINEMA 4D Lite. You will learn about using visible and volumetric lighting. Chapter 6 explores using procedural shaders to enhance the surfaces of your 3D models. In Chapter 7 the CINEWARE settings are discussed to demonstrate how to edit with a CINEMA 4D camera or a 3D camera layer created in After Effects.

CINEMA 4D Lite provides Multi-Pass rendering which renders certain parameters, channels, and effects onto different layers to refine later in After Effects. When combined together, the layers create the final rendered 2D image. Separately, each Multi-Pass image layer can be modified in After Effects to achieve a different render without having to go back to CINEMA 4D Lite.

The last chapter discusses how to upgrade CINEMA 4D Lite to unlock even more features, such as Mograph, to enhance your motion graphics projects. Chapter exercises consist of practical applications as well as experimental projects. Each exercise provides step-by-step instructions and tips for the reader to use in conceptualizing and visualizing creative 3D solutions to their own motion graphics projects.

To help you get the most out of this book, let's look at the layout conventions used in the chapters.

► **Words in bold** within the main text refer to keywords, names of files, folders, 3D objects, parameters, channels, layers, or compositions.
► Menu selections are presented like this: **MoGraph > Effector > Cloner**.
► Icons are used throughout the book. Here is a brief explanation of what they are and what they mean.

 Download Source Files: The source files for this book are available to readers at *www.focalpress.com/9781138777934*

 Note: Supplemental information to the text that sheds light on a procedure or offers miscellaneous options available to you.

 Important: Information that you need to read.

All of the chapter footage and files are provided to readers at the following URL: *www.focalpress.com/9781138777934*. Each chapter has its own compressed (zip) file. Inside each chapter folder you will find the material needed to complete each exercise. Completed versions for every exercise are provided.

All of the material inside this book and accompanying digital files are copyright protected. They are included only for your learning and experimentation. Please respect the copyright. I encourage you to use your own artwork and experiment with each exercise. This is not an exact science. The specific values given in this book are suggestions. The position of lights and cameras are used to provide a solution. If you want to experiment, by all means, do so. That is the best way to learn.

About the Author

Chris Jackson is a computer graphics designer and a Full Professor at Rochester Institute of Technology (RIT). He teaches in, and is the Graduate Director for, the Visual Communication Design MFA program. With over 13 years of academic experience and 18 years of professional work in graphic design, instructional writing, multimedia design, and motion graphics, Chris

brings diverse expertise to his courses in applied computer graphics and design. He teaches courses in interaction design and development for applied computer graphics, 2D and 3D animation, and motion graphics.

Chris continues to create a body of work that contributes to his field in computer graphics design. Chris is author of *Flash Cinematic Techniques: Enhancing Animated Shorts and Interactive Storytelling* (Focal Press, 2010), *Flash + After Effects, Second Edition* (Focal Press, 2010), and co-author of *Flash 3D: Animation, Interactivity and Games* (Focal Press, 2006). His books have been translated into foreign languages. His scholarly work has been featured in Animation Magazine and cited in Adobe's user manuals as a resource for learning about After Effects.

As an Adobe Higher Education Leader and Adobe Video Ambassador, Chris' research and scholarly work has also been peer-reviewed, published, and presented at Adobe MAX, SIGGRAPH, TypeCon, the UCDA Design Education Summit, and the Society for Technical Communication (STC) National and International Conferences.

He has been a featured speaker at Adobe MAX since 2008 and has been awarded the honor as MAX Master, which means Chris was a community favorite and was ranked as one of the top 20 speakers for his presentation.

Chris continues to be an animator, designer, and consultant for worldwide corporations and nonprofit organizations. His professional work has received over 25 distinguished national and international awards for online communication. His interactive work is on permanent exhibit at the National Museum of Play at The Strong in Rochester, New York.

Acknowledgements

This book is dedicated to my wife, Justine. Thank you for all your unconditional love and the constant support. This book is for my parents, Roger and Glenda. Thank you for your inspiration and encouragement for me to become an artist. You made it possible for me to fulfill my dreams.

This book has taken many months to write with a lot of time and effort put into making the examples. I owe a debt of gratitude to all at Focal Press, but especially Peter Linsley, Emma Elder, and Dennis McGonagle. Thank you for all your support and advice in enabling me to bring this book to print.

Special thanks goes to my past, and present, Visual Communication Design students at the Rochester Institute of Technology. Thank you for never-ending creativity and inspiration. I wish you all the best in your future design endeavors.

For Instructors

After Effects and CINEMA 4D Lite provides hands-on exercises that clearly demonstrate core features in CINEMA 4D Lite and After Effects. As an instructor, I know you appreciate the hard work and effort that goes into creating lessons and examples for your courses. I hope you find the information and exercises useful and can adapt it for your own classes.

All that I ask is for your help and cooperation in protecting the copyright of this book. If an instructor or student distributes copies of the source files to anyone who has not purchased the book, that violates the copyright protection. Reproducing pages from this book or duplicating any part of the source files is also a copyright infringement. If you own the book, you can adapt the exercises using your own footage and artwork without infringing copyright.

Thank you for your cooperation!

Credits

The following video clips were modified for this book:

- ► **Caribbean Jetty**, www.videvo.net/video/caribbean-jetty/1710
- ► **Old Vintage Film Scratches**, video by Shawn www.videezy.com/elements-and-effects/486-old-vintage-film-scratches
- ► **Walking on Train Tracks Stock Video**, video by DolandW www.videezy.com/travel/1067-walking-on-train-tracks-stock-video
- ► **Garage**, video by David Royka
- ► **Chessboard**, video by Chris Jackson

CHAPTER 1

Getting Started in CINEMA 4D

Our journey begins with exploring the powerful workflow between After Effects and CINEMA 4D. This chapter introduces CINEMA 4D Lite and how to start integrating 3D models into your After Effects projects using the CINEWARE plug-in.

What is CINEMA 4D Lite and CINEWARE?

MAXON CINEMA 4D is one of the leading 3D software packages used today to create stunning 3D motion graphics, product visualizations, video game assets, and much more. It provides an intuitive, user-friendly interface and set of tools for 3D modeling, texturing, lighting, animation, and rendering. After Effects CC now includes a Lite version of CINEMA 4D that can advance your skill sets in motion graphics and visual effects in a new dimension.

How can CINEMA 4D do this? After Effects provides limited 3D capabilities. In fact, After Effects has supported 2.5D in several versions. This acts as a hybrid between the 2D and 3D worlds. In After Effects you place a 2D object in 3D space by turning on its layer's 3D switch. Even though the layer can now be positioned and rotated in 3D space, it still remains a flat 2D object (Figure 1.1).

Figure 1.1: *After Effects supports 2.5D where the objects (layers) remain flat.*

In CINEMA 4D, you create a 3D scene using wireframe objects that can be viewed from any angle by a virtual camera. The basic 3D workflow consists of creating and arranging 3D objects; applying color and texture; lighting the scene; viewing the scene with cameras; setting keyframes for animation; and rendering an image or animation. The final rendered image can include all of the visual information found in the world including: perspective and depth, light and shadow, form and texture, and motion (Figure 1.2).

Even though CINEMA 4D Lite is a scaled-down version of CINEMA 4D, it still provides a surprisingly extensive set of tools, features, and functions to create 3D content for After Effects. CINEMA 4D Lite also provides animation capabilities and control using keyframes and F-curves. The application is a completely separate software package installed automatically with After Effects CC. The bundled software resides in the After Effects Plugins folder.

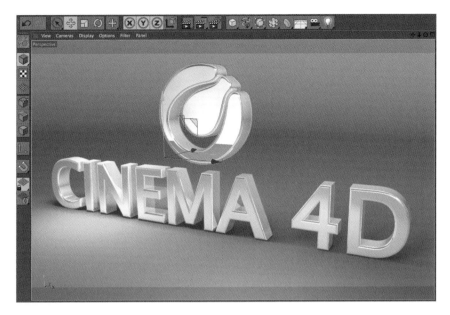

Figure 1.2: *CINEMA 4D creates 3D scenes that can be viewed from any angle.*

What is CINEWARE? CINEWARE is a plug-in and integral part of the entire After Effects and CINEMA 4D Lite workflow. The plug-in serves as a bridge, connecting the two software packages together. CINEWARE displays in the Effect Controls panel in After Effects and acts as a real-time interface between a composition in After Effects and the CINEMA 4D render engine (Figure 1.3). If you have the professional version of CINEMA 4D, you can use that directly as CINEWARE will open native CINEMA 4D files in After Effects CC.

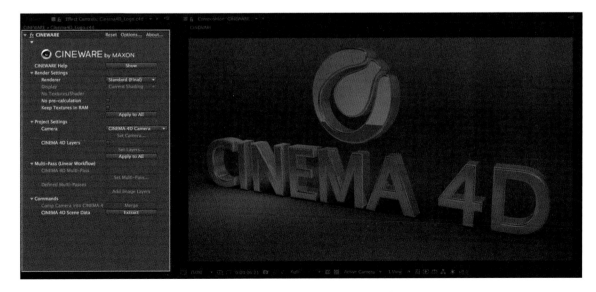

Figure 1.3: *CINEWARE bridges After Effects and CINEMA 4D together in real-time.*

Creating a CINEMA 4D File

As a 2D artist/designer who wants to add a 3D skill set to your motion graphics repertoire you need a solid understanding of how to create 3D models and operate in 3D space. CINEMA 4D has a relatively quick learning curve and provides the tools necessary for you to create your own 3D content. So let's dive in and get an overview of how CINEMA 4D Lite and CINEWARE work.

In this chapter, you will build and animate 3D text using CINEMA 4D Lite. The animation will be composited in After Effects using the CINEWARE plug-in. The goal is to introduce the new workflow between After Effects and CINEMA 4D. Subsequent chapters will provide more in-depth exercises on 3D modeling, lighting, and animation that is universal across many 3D software packages.

 Download (www.focalpress.com/9781138777934) the **Chapter_01.zip** *file to your hard drive. It contains all the files needed to complete the exercises.*

To see what you will build, locate and play the **DiveInCINEWARE.mov** file in the **Completed** folder inside **Chapter_01** (Figure 1.4). The following exercise provides an introduction to using the CINEWARE plug-in in After Effects. It is a step-by-step tutorial that introduces you to CINEMA 4D Lite, its workspace and integrated workflow with After Effects CC.

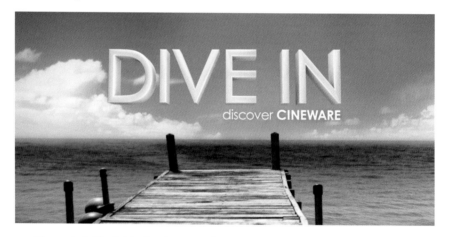

Figure 1.4: *The finished project is a title sequence rendered using CINEWARE.*

Exercise 1: Setting Up a CINEMA 4D File

CINEMA 4D Lite can only be opened through After Effects CC as a new file or a new layer within an existing composition. Just like all footage in After Effects, the CINEMA 4D (.c4d) file created is linked and stored in the Project panel. The 3D footage is added to a composition as a layer with the CINEWARE effect.

1. Launch **Adobe After Effects**. It opens an empty project by default. Save the project as **CINEWARE_Intro.aep** inside the downloaded **Chapter_01** folder.

2. Double-click in the Project panel to open the Import File dialog box. Locate the **Ocean.mov** QuickTime movie in the **Footage** folder inside **Chapter_01**. Click **Open** to import the footage into the Project panel (Figure 1.5).

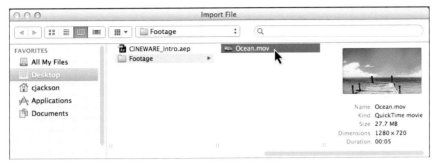

Figure 1.5: *Import the QuickTime movie into After Effects.*

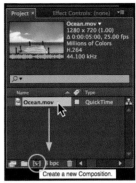

Figure 1.6: *Create a new Composition in the Project panel using the imported QuickTime movie.*

3. Click and drag the imported file to the **Create a new Composition** icon at the bottom of the Project panel (Figure 1.6). A new composition is created.

4. To add 3D graphics into this composition, you'll need to create a CINEMA 4D layer. Make sure the Timeline panel is active and highlighted. Select **Layer > New > MAXON CINEMA 4D File** (Figure 1.7).

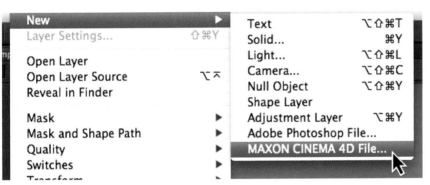

Figure 1.7: *CINEMA 4D Lite can only be opened through After Effects CC by creating a new file or a new layer within an existing composition.*

5. The first thing that you will see is a dialog box asking you to save your new MAXON CINEMA 4D file. Save the project as **3DText.c4d** in the **Footage** folder inside the **Chapter_01** folder. Click **Save**.

6. After saving the file, CINEMA 4D Lite automatically launches and opens the new file. To make sure that you are using the same layout configuration as the book, locate the **Layout** pop-up menu in the upper right corner. Select **Standard** from the menu options (Figure 1.8).

Figure 1.8: *The interface layout should be set to Standard to be consistent with exercises in this book.*

 If you are opening CINEMA 4D Lite for the first time, you may see a registration dialog box to activate three, free MoGraph functions. Follow the steps to register and activate these features as you will be using them later in this chapter.

The CINEMA 4D Interface

CINEMA 4D Lite's user interface consists of menus, icon panels that contain shortcuts to frequently used commands, a main viewport that displays the 3D scene, and managers that "manage" all aspects of your 3D content. See the screen shot example below (Figure 1.9). The four main managers include:

- **Objects Manager**: This lists all of the elements in the scene. It is formatted as a tree-based structure displaying objects and their hierarchy in a scene.

- **Attributes Manager:** This provides contextual information and properties for selected objects and tools. When you create a new file, the Attributes Manager displays information about the document file including its frame rate and number of frames in the timeline.

- **Coordinates Manager:** This is used for precision modeling or manipulation as it provides numerical data on a selected object's position, size, and rotation that can be used as information or modified to change the object.

- **Materials Manager:** This contains all of the shaders and materials used in the 3D scene. Materials define the surface texture of a 3D object and include several parameters such as color, reflectivity, refraction, and transparency.

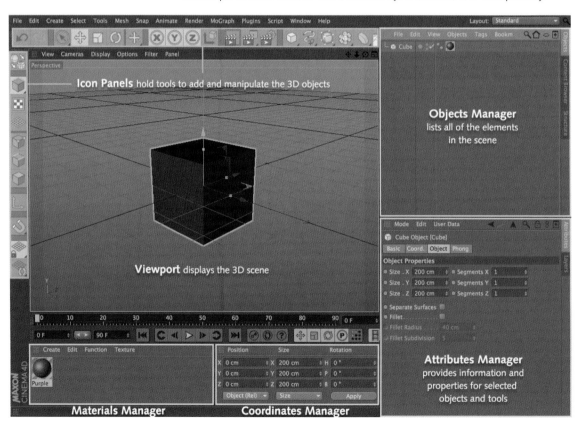

Figure 1.9: *The four main managers and viewport in CINEMA 4D Lite.*

Editing the Project Settings

CINEMA 4D Lite's default resolution is 800 by 600 pixels. The width and height of the composition in After Effects is 1280 by 720 pixels at 25 frames-per-second. Since this CINEMA 4D file will be composited with the video, the first thing you need to do is change the render settings to match the frames-per-second and dimensions of the composition in After Effects.

7. Locate the three clapboard icons in the top center of the user interface. Click on the icon to the right that has the sprocket (Figure 1.10). This will open the Render Settings dialog box.

Figure 1.10: *Open the Render Settings in CINEMA 4D Lite.*

8. Since this CINEMA 4D file will be rendered using After Effects, you can set the output to a higher resolution. Click on the arrow icon under **Output**. From the preset pop-up menu, select **Film/Video> HDV/HDTV 720 25**. (Figure 1.11) When you are done, close the Render Settings dialog box.

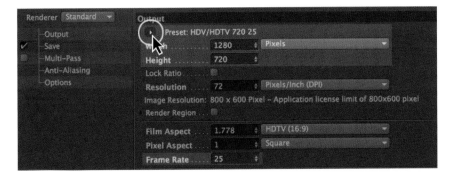

Figure 1.11: *Reset the output to a higher resolution to match the After Effects file.*

9. Locate the Timeline panel under the viewport window editor. The default duration for an animation in CINEMA 4D Lite is 90 frames (Figure 1.12).

Figure 1.12: *The Timeline panel is located underneath the viewport window editor.*

10. Change the duration of the project from 90 frames to 150 frames. Type **150** into the text entry dialog box. To see all frames in the Timeline panel, click on the right arrow icon next to **90 F** and drag to the right (Figure 1.13).

Figure 1.13: *Change the duration of the Timeline panel to 150 frames.*

Understanding the CINEWARE Workflow

Now that you have created a CINEMA 4D file, how do you view it in After Effects? The CINEWARE workflow allows you to jump back and forth between both applications to adjust and fine tune your 3D objects without the need to render a file in CINEMA 4D.

11. First, save your CINEMA 4D Lite file. This is a simple yet very important step in the CINEWARE workflow as this file is linked to After Effects.

> *Whenever a change is made in the CINEMA 4D Lite file, you must save the file first in order to see the updates in After Effects. As your CINEMA 4D file gets more complex, allow some time to save the file before jumping back to After Effects. This will avoid After Effects losing the link to the CINEMA 4D file while it is saving the file's content.*

12. Go to After Effects. Notice that a CINEMA 4D layer has been added to the Timeline. The Composition panel displays a grid floor (Figure 1.14).

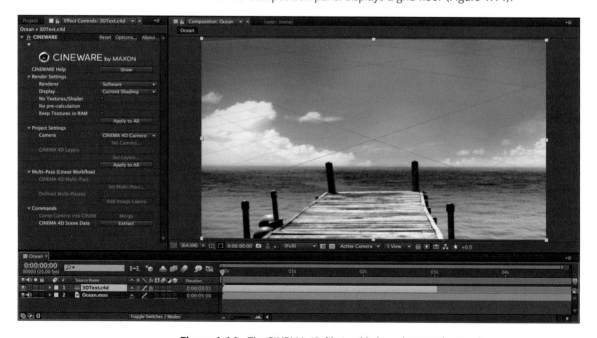

Figure 1.14: *The CINEMA 4D file is added as a layer in the Timeline.*

The CINEWARE effect is automatically applied to the layer and allows After Effects to read the CINEMA 4D file and display the 3D scene in the Composition panel. As you can see, CINEWARE is an extremely powerful plug-in that provides a real time link to a CINEMA 4D file. There are a lot more features and functions to CINEWARE that will be covered later. But first, you need to adjust the duration of the CINEMA 4D layer in the Timeline.

13. After you changed the frame duration in the CINEMA 4D file, a ghosted bar now extends to the end of the composition in the Timeline. Retrim its Out Point by clicking and dragging it to the end of the composition (Figure 1.15).

Figure 1.15: *Retrim the Out Point to extend to the end of the composition.*

14. Save your After Effects project. This completes setting up the files between After Effects and CINEMA 4D. Now comes the fun part, creating 3D models. The next exercise focuses on a modeling technique to add 3D type to the project.

Modeling in CINEMA 4D Lite

The first step in a 3D modeling workflow is the creation of a **model**. Basically, a model is a collection of 3D objects arranged together in a scene. CINEMA 4D provides a set of objects to start the 3D modeling process. In this exercise you will build 3D text using a **spline** object and a **NURB** generator.

Splines are vertices (dots) connected by lines in 3D space. A spline has no three-dimensional depth, but with the combination of NURBS you can create complex 3D objects. NURBS are generators. Common types of NURBS are extrude, lathe, loft, and sweep. For this exercise, you will use an extruded NURB. An **extruded NURB** takes a two-dimensional spline – a letter form – and extends the shape along a path creating a solid object (Figure 1.16).

Figure 1.16: *An extruded NURB takes a 2D spline and extends it along a path.*

Exercise 2: Creating an Extruded NURB

1. In CINEMA 4D, locate the spline icon above the viewport window (Figure 1.17). Click and hold the icon to reveal the pop-up palette of spline shapes. While this palette is open, left-click on the **Text** icon to add a text spline.

Figure 1.17: *Locate the spline icon in the icon panel above the viewport.*

CINEMA 4D color codes the icons for different types of objects that you can add to a scene. Icons for objects are blue. The Text spline icon is a visual shortcut for the actual menu command of selecting Create > Spline > Text from the top menu bar.

2. Make sure the Text spline is selected. The Attributes Manager displays the contextual information and properties for the selected object. Go to the Attributes Manager and make the following changes (Figure 1.18):

 ▶ Change the text to **DIVE IN**.

 ▶ Change the font to **Century Gothic**, or whatever typeface you prefer.

 ▶ Set the font style to **Regular**.

 ▶ Decrease the value of the **Height** property to **150 cm**.

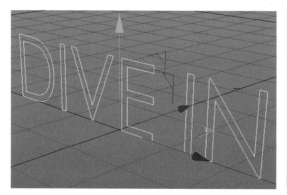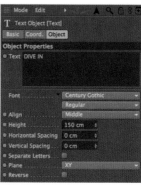

Figure 1.18: *Use the Attributes Manager to modify the Text spline object.*

3. Select the **Extrude NURBS** from the NURBS object palette above the viewport (Figure 1.19). In the Objects Manager, an Extrude NURBS object appears above the Text spline. Note that CINEMA 4D color codes its 3D generators green.

Figure 1.20: *Make the Text spline a child of the Extrude NURBS to create the 3D object.*

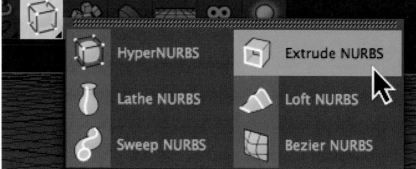

Figure 1.19: *Add an Extrude NURB to the 3D scene.*

4. Go to the Objects Manager. Click and drag the Text spline into the Extrude NURBS object. In the viewport, the 2D text becomes a 3D extruded object. The NURB automatically extends the Text spline along its Z-axis (Figure 1.20).

i *CINEMA 4D uses a parent-child method when creating and arranging 3D objects in a scene. In this exercise the Extrude NURBS is the parent and the Text spline is its child. Understanding this becomes a powerful tool for creating complex models that are easy to use in building a scene and animation.*

5. Make sure the Extrude NURBS is selected in the Object Manager. Go to the Attributes Manager and increase the **Z-Movement** value to **50 cm**.

6. Click on the **Caps** tab. Change the **Start/End Caps** to **Fillet Cap** to add a beveled edge, and decrease the Radius value to **2 cm** (Figure 1.21).

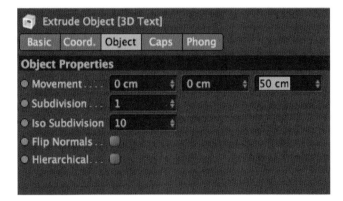 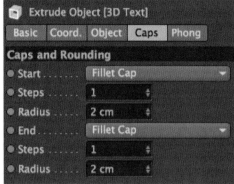

Figure 1.21: *Use the Attributes Manager to modify the Extruded NURBS.*

7. Go to the Objects Manager and double-click on the **Extrude NURBS** name. Rename it **3D Text** and press **Return**.

8. Save your CINEMA 4D file. Jump back to After Effects and you will see the 3D extruded text update in the Composition panel (Figure 1.22). When working between CINEMA 4D and After Effects, all you need to do is save the 3D file and it automatically updates in real time through CINEWARE in After Effects.

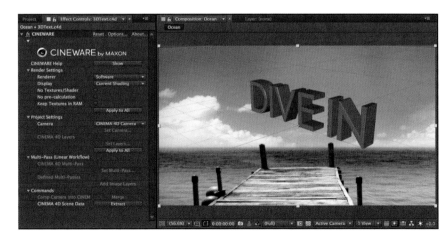

Figure 1.22: *CINEWARE updates the saved CINEMA 4D file in the Composition panel.*

9. In order to match the perspective in the video, let's export a frame from After Effects to use in CINEMA 4D as a reference. First, turn off the visibility of the **3DText** layer by clicking on its **eye** switch in the Timeline (Figure 1.23).

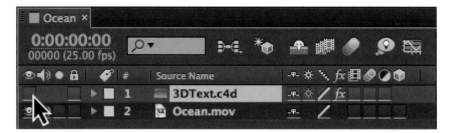

Figure 1.23: *Turn off the visibility of the CINEMA 4D layer in the Timeline.*

10. Move the Current Time Indicator (CTI) to the last frame in the Timeline.

11. Select **Composition > Save Frame As > Photoshop Layers** (Figure 1.24). In the Save dialog box, save the file in the **Footage** folder. Click **Save**.

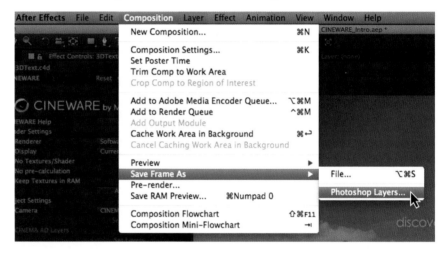

Figure 1.24: *Save the last frame of the composition as a Photoshop file.*

12. Turn on the visibility of the CINEMA 4D layer by clicking on its **eye** switch again in the Timeline (Figure 1.25).

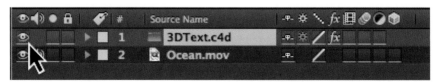

Figure 1.25: *Turn of the visibility of the CINEMA 4D layer in the Timeline.*

13. Save your After Effects project. Now that you have a 3D model in CINEMA 4D, the next exercise will focus on adding a material to it.

Applying Materials in CINEMA 4D Lite

After the models are completed, the next step in a 3D workflow is creating and applying materials. New objects are textured gray by default in CINEMA 4D. To change this you need to create a material in the Materials Manager. This exercise shows how materials are created and applied.

Exercise 3: Creating and Applying Materials

1. In CINEMA 4D, go to the Materials Manager. Select **Create > New Material**. A preview of the new material appears in the manager's panel (Figure 1.26).

Figure 1.26: *Create a new material in the Materials Manager.*

2. Double-click on the **Mat** icon to open the Material Editor dialog box.

3. Textures give a model color, highlights, and other important surface properties. Each material in CINEMA 4D has several channels that you can turn on and modify. In the **Color** channel, make the following changes (Figure 1.27):

 ▸ Change the **RGB Color** values to R = **255**, G = **190**, B = **90**.

 ▸ Double-click on the **Mat** name. Rename the texture to **Text** and press **Return**.

 ▸ When you are done, close the Material Editor dialog box.

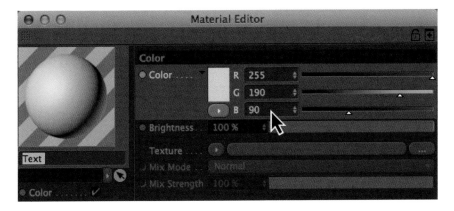

Figure 1.27: *Change the RGB color settings for the new material.*

4. Go to the Materials Manager. Select **Create > New Material** to add a second new material to the manager's panel.

5. Double-click on the **Mat** icon to open the Material Editor dialog box. In the **Color** channel, make the following changes:

- Change the **RGB Color** values to R = **255**, G = **225**, B = **120**.

- Double-click on the **Mat** name. Rename the texture to **Bevel** and press **Return**.

6. Click on the **Specular** name and make the following changes to increase the highlights for this channel:

- Decrease the **Width** value to **30%**.

- Increase the **Height** value to **85%**.

- Increase the **Inner Width** value to **30%**.

- When you are done, close the Material Editor dialog box.

7. Go to the Materials Manager. Select **Create > New Material** to add a third material to the manager's panel.

8. In the **Color** channel, make the following changes (Figure 1.28):

- Click on the **Texture** arrow and select **Load Image** from the pop-up menu.

- Locate the **Ocean.psd** file in the **footage** folder in **Chapter_01**. Click **Open**.

- Double-click on the **Mat** name. Rename the texture to **Background** and press **Return**.

- When you are done, close the Material Editor dialog box.

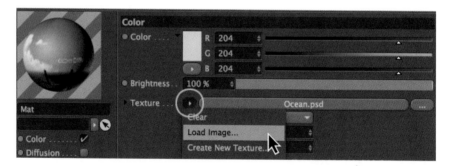

Figure 1.28: *Load an image as a material using the texture parameter.*

9. Click and drag the **Text** material from the Materials Manager and drop it onto the **3D Text** (Extrude NURBS) **name** in the Objects Manager (Figure 1.29). The object changes color in the viewport. A Texture Tag appears to the right of the 3D Text object in the Objects Manager.

Figure 1.29: *Drag and drop a material onto an object's name in the Objects Manager.*

CINEMA 4D allows you to apply a material to an object in a couple of ways. You can drag that material onto the object in the viewport and release. If your scene is complex, you can also drag a material onto the name of an object in the Objects Manager.

10. Click and drag the **Bevel** material from the Materials Manager and drop it onto the **3D Text** (Extrude NURBS) **name** in the Objects Manager (Figure 1.30). Now you have two materials applied to the same object.

Figure 1.30: *Drag and drop another material onto the 3D Text in the Objects Manager.*

As you can see, to apply a material to an object all you have to do is drag and drop. You can apply multiple textures and also restrict a material to a certain portion of an object. For the extruded text, the second material you applied needs to be restricted to the rounding, or beveled edge.

11. To restrict the Bevel material on the 3D Text object, select its Texture Tag in the Objects Manager. The Attributes Manager displays the contextual information and properties for the selected tag.

12. Go to the Attributes Manager and set the **Selection** to R1, short for rounding one. Type in **R1** in the text entry box and press **Return** (Figure 1.31). This restricts the material to the front rounding of the extruded text.

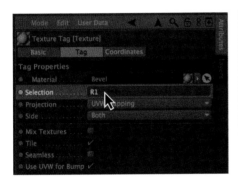

Figure 1.31: *Restrict the material to the front rounding of the extruded text.*

The selection R1 only restricts a material to the front rounding. If you want to restrict the material to the back rounding, hold down the Control key and click and drag the Texture Tag to the right. That will make a copy of it once you release the mouse. For this selection R1 becomes R2 (back). You can also use the selection C1 and C2 for the extruded caps.

13. Save your CINEMA 4D file. Jump back to After Effects to see the updates.

Moving Around in CINEMA 4D Lite

Moving around in 3D space may seem intimidating at first, especially if you are coming from a more traditional 2D background. CINEMA 4D Lite provides intuitive tools and some great keyboard shortcuts that will quickly get you navigating around your scene. Let's get moving in 3D space.

Exercise 4: Navigating in the Viewport

The window editor in CINEMA 4D is referred to as the viewport. It is similar to the Composition panel in After Effects. The extruded text you created appears in the center of the viewport. All objects created by selecting a menu or icon command appear at the origin point, or center, of the 3D scene. Note that the X-Y-Z position for the text is zero in the Coordinates Manager (Figure 1.32).

A default camera provides the view displayed in the viewport. This camera is not listed in the Objects Manager nor can you see it or select it. When modeling, you need the ability to see your objects from multiple views to see how they look and/or align to other objects. The viewport contains its own set of menus located at the top of the panel. It also contains four navigation tools.

Figure 1.32: *The text was added at the origin point of the 3D scene. The X-Y-Z coordinates are set to zero.*

1. Locate the four icons in the top right corner of the viewport. These icons are the navigation tools and enable you to change the current camera's view. This includes camera panning, dollying, orbiting, and toggling from one camera view to a 4-view mode. Let's explore each navigation icon.

2. Click and hold down the mouse button on the first navigation icon ✥, then drag the mouse around. This tool pans the camera around in the view.

3. Click and hold down the mouse button on the second navigation icon ⬍, then drag the mouse again. This tool dollies the current camera in and out. This is not zooming as the default camera is moving in 3D space.

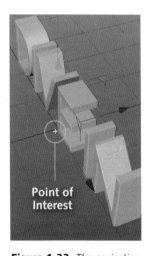

4. Click and hold down the mouse button on the third navigation icon ⟳. Again, drag the mouse. This tool pivots around a point of interest. This is represented by the small white cross in the viewport. It is a point in 3D space that the camera is focused on (Figure 1.33).

5. Click on the last of the four navigation icons ⬑. This will switch the current single camera view to a 4-view mode. This icon is different from the others as it enables you to toggle from a single view to 4-view mode and back.

Point of Interest

The multiple views allow you to fine tune your object's placement in the scene. In any of the four viewports, click on their toggle-view navigation icon to maximize that particular view. Toggle back to the 4-view mode by clicking on the toggle-view navigation icon again.

Figure 1.33: *The navigation tools pan, dolly, and orbit around a point of interest in the viewport. This is visually represented as a white cross.*

6. Click on the toogle-view icon ⬑ in the top-left perspective view to toggle back to a single camera view (Figure 1.34).

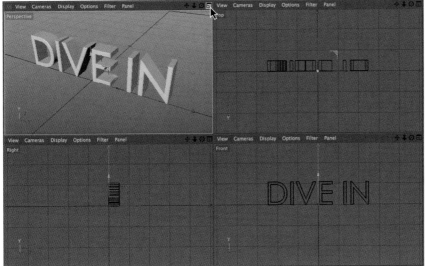

Figure 1.34: *You can toggle from a single camera view to a 4-view mode.*

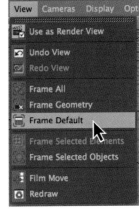

Figure 1.35: *You can always return to the default camera view in the viewport.*

7. In the viewport select **View > Frame Default** to return the camera's view to its original default vantage point (Figure 1.35).

> *The keyboard shortcut for the first navigation icon is the '1' key (hold down this key and drag the mouse to pan the camera). The keyboard shortcut for the second navigation icon is the '2' key (hold down this key and drag the mouse to dolly the camera in and out). The keyboard shortcut for the third navigation icon is the '3' key (hold down this key and drag the mouse to orbit the camera around the point of interest).*

Now that you are familiar with the viewport and how to change the camera's view, let's try and match the viewport's camera perspective to the video's perspective in After Effects. You will use the Background material you created as a reference. First we need an object to apply the material.

8. In CINEMA 4D, locate the Floor icon above the viewport window (Figure 1.36). Click and hold the icon to reveal the pop-up palette. While this palette is open, left-click on the **Background** icon to add the object to the Objects Manager.

Keyboard Shortcuts

1 to **Pan** the Camera

2 to **Dolly** the Camera

3 to **Orbit** the Camera

Cmd + Shift + Z to undo a camera move

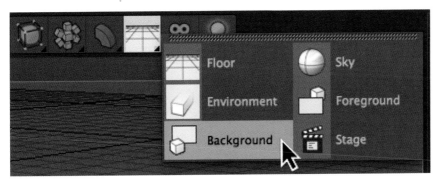

Figure 1.36: *Add a Background object to the Objects Manager.*

9. Click and drag the **Background** material from the Materials Manager and drop it onto the **Background name** in the Objects Manager (Figure 1.37). The viewport displays the rendered frame from After Effects. You will use this as a reference to move the default camera's perspective view to match the video's perspective.

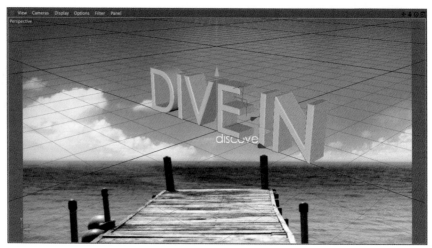

Figure 1.37: *Add the Background material to the background object.*

> Note that the Background object in CINEMA 4D Lite will not render in CINEWARE. This allows you to use it for reference in aligning 3D objects to a composition.

10. In the viewport, click and hold down the mouse button on the **orbit** icon. Drag the mouse to match the perspective of the background image.

11. In the viewport, click and hold down the mouse button on the **pan** icon. Drag the mouse to match the perspective of the background image.

 Align the horizon line of the grid to the horizon in the image. Use the orbit tool to rotate the camera to match the perspective of the dock as close as you can. The text should remain at the origin point of 0-0-0 and look like it is sitting on the dock. Align the "N" in "IN" to the "E" in "CINEWARE" (Figure 1.38).

Figure 1.38: *Move the default camera in the viewport to match the perspective.*

12. Click on the **Render View** icon above the viewport to render the scene in the viewport window. This is a quick preview of what the final render will look like in CINEWARE (Figure 1.39).

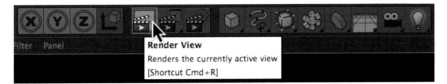

Figure 1.39: *Click on the Render View icon to preview the scene in the viewport.*

13. Save your CINEMA 4D file. Select **File > Save**.

14. Jump back to After Effects. The CINEWARE effect automatically updates the Composition panel to reflect the saved changes made in CINEMA 4D Lite. Note that the CINEMA 4D file is displayed in After Effects with the wireframes visible. This is the default renderer setting called **Software** (Figure 1.40).

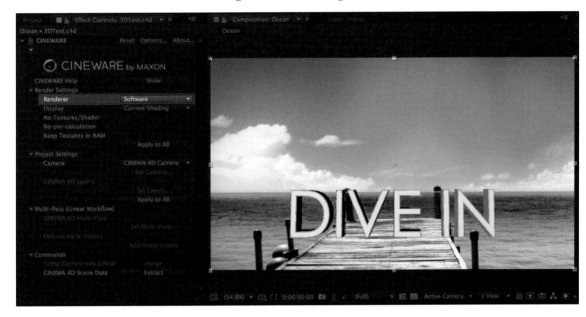

Figure 1.40: *The default renderer in CINEWARE is called Software.*

Figure 1.41: *Change the renderer to Standard (Final) to view how the CINEMA 4D file will render.*

15. Change the CINEWARE renderer from **Software** to **Standard (Final)**. This will render the 3D text in the Composition panel similar to the Render View function in CINEMA 4D (Figure 1.41).

16. Save your After Effects project. Now that your 3D scene matches the perspective in the video, the next step is to mimic the lighting. CINEMA 4D automatically uses a default light for rendering. The next exercise demonstrates how to add your own lights to the 3D scene and modify their properties in the Attributes Manager.

Adding Lights in CINEMA 4D Lite

Lighting is just as important to a 3D scene as its objects. Dramatic lighting and shadows can turn a dull scene into a masterpiece. CINEMA 4D provides several different types of lights including omni and spot lights. The default light is an omni light which acts like a light bulb. It is positioned slightly to the left of the default camera. This light is completely white and doesn't cast any shadow. Let's add some new lights to the scene to make it more interesting.

Exercise 5: Let There Be Light!

1. Jump back to CINEMA 4D. Click on the **Light** icon to add a light source to your 3D scene (Figure 1.42). Notice that the default lighting is turned off as soon as you add the Light object.

Figure 1.42: *Add a Light object to the 3D scene. The default lighting will turn off.*

2. With the Light object selected in the Objects Manager, go to the Attributes Manager and click on the **Coord.** tab. Set the **Y-Position** to **800 cm** (Figure 1.43). This moves the light above the text.

Figure 1.43: *Position the light above the text by increasing the Y-Position value.*

3. Click on the **General** tab and increase the **Intensity** value to **150%**. Change the **RGB Color** values to R = **210**, G = **240**, B = **255**. This light will act like the sun (Figure 1.45).

4. By default, lights in CINEMA 4D do not cast shadows. To turn on the shadows, select **Shadows Maps (Soft)** from the **Shadow** drop-down menu (Figure 1.44).

Figure 1.44: *Turn on shadows for the light object.*

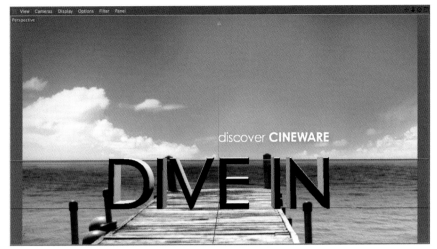

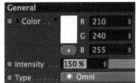

Figure 1.45: *Change the light's color and intensity in the Attributes Manager.*

5. Add another Light object to your 3D scene. With the Light object selected in the Objects Manager, go to the Attributes Manager:

 ► Click on the **Coord.** tab. Set the **Z-Position** to **200 cm**. This will position the light behind the 3D text.

 ► Click on the **General** tab and decrease the **Intensity** value to **80%**.

 ► Change the **RGB Color** values to R = **100**, G = **175**, B = **255**.

6. Add another Light object to your 3D scene. With the Light object selected in the Objects Manager, go to the Attributes Manager:

 ► Click on the **Coord.** tab.

 ► Set the **Y-Position** to **100 cm** and the **Z-Position** to **-800 cm**. This will position the light in front of the 3D text.

7. Add the final Light object to your 3D scene (Figure 1.46). With the Light object selected in the Objects Manager, go to the Attributes Manager:

 ► Click on the **Coord.** tab. Set the **X-Position** to **300 cm Y-Position** to **100 cm** and the **Z-Position** to **350 cm**.

 ► Click on the **General** tab and change the **RGB Color** values to R = **170**, G = **230**, B = **250**.

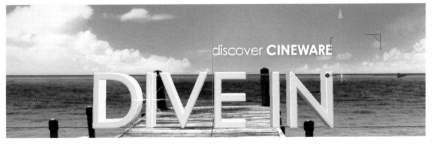

Figure 1.46: *Use the Light objects to mimic the lighting in the video.*

Modifying Objects in 3D Space

Now that you have placed your Light objects in 3D space, let's review the screen coordinate system in CINEMA 4D Lite. All 3D modeling applications divide their screen coordinate systems into three axes (Figure 1.47).

- ► The **X-axis** (red) runs horizontally across the viewport with its origin, or 0-point in the center of the 3D scene.
- ► The **Y-axis** (green) runs vertically, with its 0-point in the center of the scene.
- ► The **Z-axis** (blue) runs into and out of the viewport (toward and away from the viewer), with its 0-point also at the center of the 3D scene.

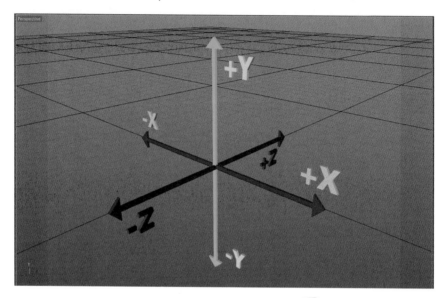

Figure 1.47: *The 3D coordinate system in CINEMA 4D Lite.*

8. Select the **3D Text** (Extrude NURBS) in the Objects Manager.

9. Select the **Move** tool in the icon panel above the viewport and then click on the extruded text. The text's axes will be visible in the viewport window. Each of the axes' arrows can be selected and dragged in its corresponding direction.

10. Click and hold down the mouse button on the green arrow, then drag the mouse. Notice that the text only moves along the Y-axis (Figure 1.48).

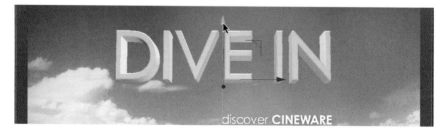

Figure 1.48: *By clicking on an arrow you can move an object along a specific axis.*

11. In addition to using the Move tool, you can also set the position of the text using the Coordinates tab in the Attributes Manager. Make sure the extruded object is still selected in the Objects Manager. Go to the Attributes Manager and click on the **Coord.** tab. Set the **Y-Position** at **180 cm** (Figure 1.49). Leave the extruded object's **X-Position** and **Z-Position** at **0 cm**.

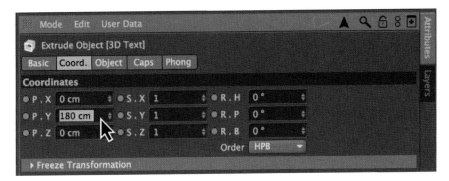

Figure 1.49: *Use the Coordinates tab in the Attributes Manager to position the 3D text.*

12. Save your CINEMA 4D Lite file. Select **File > Save**.

13. Jump back to After Effects. The CINEWARE effect automatically updates the Composition panel to reflect the saved changes (Figure 1.50).

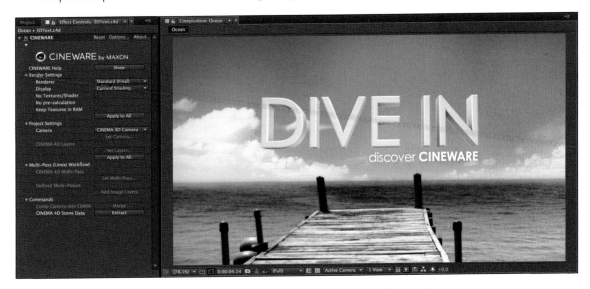

Figure 1.50: *CINEWARE updates the saved CINEMA 4D file in the Composition panel.*

You are almost done. The next part of the 3D workflow is to create movement. Animation in CINEMA 4D is very similar to animation in After Effects. You record keyframes for the different states of an object at different times and let CINEMA 4D produce an animation by interpolating between each keyframe. In the next exercise you will record keyframes for the extruded object's position to produce a simple animation.

Animating in CINEMA 4D Lite

In this exercise you will animate each extruded letter's position using the MoGraph tools in CINEMA 4D Lite. MoGraph is an add-on module for creating motion graphics. CINEMA 4D Lite includes the **Fracture** object and two effectors, **Plain** and **Random**. These tools will allow you to animate each letter form over a period of time.

Before you begin this exercise, make sure you have registered your version of CINEMA 4D Lite to access the MoGraph tools. If you did not do this when you first launched CINEMA 4D Lite, select **Help > Personalize** to open the information dialog box. Enter the activation code provided to get access to the MoGraph tools for this exercise (Figure 1.51).

Figure 1.51: *Activate the three MoGraph tools in CINEMA 4D Lite.*

Exercise 6: Animating with MoGraph

The goal of this exercise is to become familiar with animation techniques to move 3D models in CINEMA 4D Lite. Let's get started.

1. In CINEMA 4D, make sure the extruded text has been positioned vertically on its Y-axis at 180 cm.

2. Go to the Objects Manager and select the **3D Text** extruded object.

3. Hold down the Option key and select the **MoGraph > Fracture**. Holding down the Option key automatically makes the extruded text a child of the Fracture object in CINEMA 4D (Figure 1.52).

4. Select the **Fracture** object in the Objects Manager. Go to the Attributes Manager and change the Mode to **Explode Segments and Connect**. This will separate each extruded letter as its own object (Figure 1.53).

Figure 1.53: *Change the Fracture's mode to separate each letter form.*

5. In order for the Fracture object to work, it needs to have an effector applied to it. Make sure the **Fracture** object is still selected in the Objects Manager. Select **MoGraph > Effector > Plain**. The text will move up vertically in the viewport. The Plain Effector is automatically applied to the Fracture object because it was selected in the Objects Manager.

6. Click on the **Plain** Effector in the Objects Manager. Go to the Attributes Manager and click on the **Falloff** tab.

 ▸ Change the **Shape** from **Infinite** to **Linear**. A wireframe box appears in the viewport. This will allow you to control the fracturing of the text.

 ▸ Click on the checkbox for **Invert** (Figure 1.54).

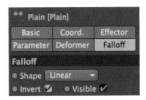

Figure 1.54: *Change the Plain Effector's falloff shape in the Attributes Manager.*

7. Click on the **Coord.** tab for the Plain Effector and enter **-90** degrees for the **Heading (R.H)**. The wireframe box rotates in the viewport. This orients the linear falloff along the X-axis instead of the default Z-axis.

8. Click and drag the yellow arrow inside the wireframe box left and right to see how the linear falloff affects the movement of the letters (Figure 1.55).

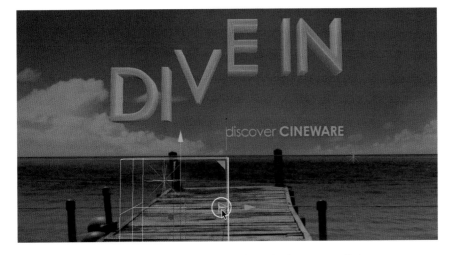

Figure 1.55: *Move the linear falloff box back and forth to see its effect.*

9. Position the Plain Effector's wireframe box on the left side of the viewport. Make sure all the 3D letter forms are raised higher vertically. This will be the starting point for the animation (Figure 1.56).

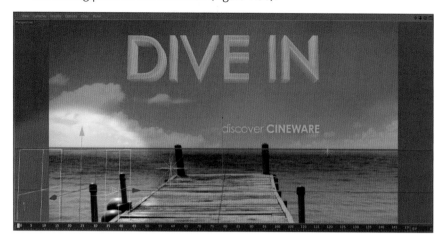

Figure 1.56: *Position the linear falloff box on the left side of the viewport.*

10. The Animation Palette is located under the viewport. It contains a Timeline Ruler with a Current Time Indicator similar to After Effects. Click and drag the green square to **frame 10** in the Timeline Ruler (Figure 1.57).

Figure 1.57: *Move the Current Time Indicator (green square) to frame 10.*

11. Make sure the **Plain** Effector is still selected in the Objects Manager. It is always important to make sure that you have the correct object selected before recording any keyframe.

12. Click on the **Record Active Objects** icon to record keyframes for the Plain Effector's position on frame 10 in the Timeline Ruler (Figure 1.58).

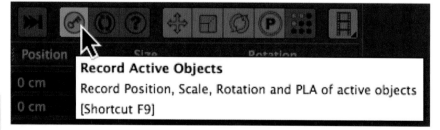

Figure 1.58: *Record keyframes for the Plain effector on frame 120.*

Figure 1.59: *Keyframes are displayed as blue squares in the Timeline panel.*

13. Click and drag the Current Time Indicator (green square) to **frame 110** in the Timeline Ruler. Note the blue square that appears at frame 10. This is the keyframe you recorded in the previous step (Figure 1.59).

14. Position the Plain Effector's wireframe box on the right side of the viewport. Make sure all the 3D letters are lowered to their final position. This will be the end point for the animation (Figure 1.60).

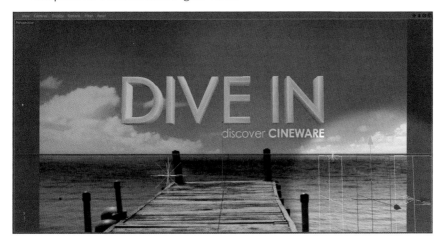

Figure 1.60: *Position the linear falloff box on the right side of the viewport.*

15. Click on the **Record Active Objects** icon to record keyframes for the new position on frame 110 in the Timeline Ruler (Figure 1.61).

Figure 1.61: *Record keyframes for the Plain effector on frame 110.*

16. Click the **Play Forwards** button to see the animated text drop into the scene (Figure 1.62). Note the motion path that is created between the two keyframes. This is similar to the motion path used for spatial interpolation in After Effects.

Figure 1.62: *Click on the Play Forwards button to preview the animation.*

As the Plain Effector animates across the viewport, each 3D letter form drops vertically as the effector moves to the right. The linear falloff takes place along the X-direction and creates a soft transition between areas not affected by the effector and areas affected by the effector. Let's make the animation more interesting and have the extruded text fly into the scene from behind the default camera. To do this, the Plain Effector's parameters must be modified.

17. Make sure the **Plain** Effector is still selected in the Objects Manager. Go to the Attributes Manager.

18. Click on the **Parameter** tab and make the following changes (Figure 1.63):

 ▸ Change the **Y-Position** value to **-225 cm**.

 ▸ Change the **Z-Position** value to **-900 cm**.

 ▸ Click on the checkbox for **Rotation**.

 ▸ Change the **Pitch (R.P)** value to **180 degrees**.

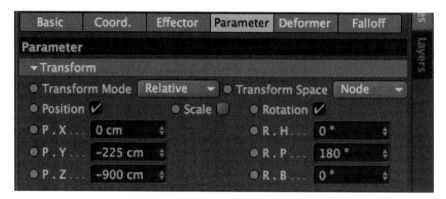

Figure 1.63: *Modify the Plain Effector's parameters in the Attributes Manager.*

19. Click the **Play Forwards** button to see the animated text fly into the scene.

20. The extruded text is a little dark as it enters the viewport. To fix this, add a final light object to the scene. Click on the **Light** icon.

21. Go to the Attributes Manager make the following changes (Figure 1.64):

 ▸ Click on the checkbox for **Ambient Illumination**. Now, all surfaces are lit with the same intensity.

 ▸ Decrease the **Intensity** value to **50%**.

 ▸ Change the **RGB Color** values to R = **0**, G = **191**, B = **255** to add a blue highlight to the extruded text to composite better with the sky.

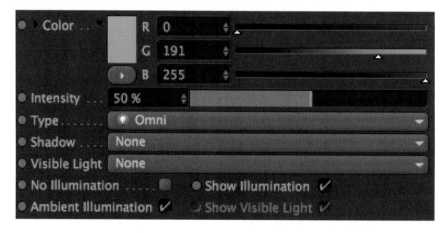

Figure 1.64: *Modify the Light object's parameters in the Attributes Manager.*

22. Even though the Background object does not render in CINEWARE, it can produce a white fringe around the extruded text due to the anti-aliasing. To prevent this, go to the Objects Manager and double-click on the bottom gray circle next to **Background** to change its color to red (Figure 1.65).

 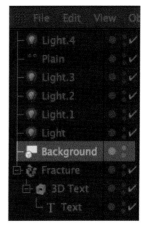

Figure 1.65: *To prevent a halo fringe around the 3D text in After Effects (left image) turn off the Background object's render view button in the Objects Manager.*

23. Locate the three clapboard icons in the top center of the user interface. Click on the icon to the right that has the sprocket (Figure 1.66).

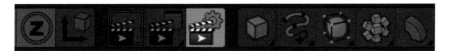

Figure 1.66: *Open the Render Settings in CINEMA 4D Lite.*

24. Click on **Anti-Aliasing** to modify its render settings on the right side of the dialog box. Change the **Filter** setting from **Cubic (Still Image)** to **Gauss (Animation)** (Figure 1.67). This will blur the image slightly to help soften the text's edges, reducing possible edge aliasing (flicker) in the animation.

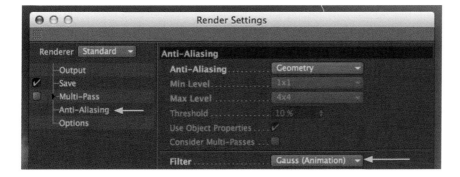

Figure 1.67: *Change the Anti-Aliasing render settings for the animation.*

25. When you are done, close the Render Settings dialog box.

26. Save your CINEMA 4D Lite file. Select **File > Save**.

Rendering in After Effects

An important concept to remember is that a 3D object built in CINEMA 4D Lite becomes a flat 2D layer inside an After Effects project. You cannot make any 3D adjustments to that 3D object directly inside After Effects. CINEWARE only renders the 3D scene in the Composition panel. This exercise focuses on rendering your composition to a movie file using CINEWARE and After Effects.

CINEWARE acts as a real-time interface between a composition in After Effects and the CINEMA 4D render engine. The edits you made to the Render Settings in CINEMA 4D Lite will translate into After Effects through the CINEWARE plug-in. In the end, you will use After Effects to render the composition.

Exercise 7: Rendering a Project

1. Jump back to After Effects. CINEWARE will automatically update any changes saved in the CINEMA 4D file.

2. Make sure the CINEWARE **Renderer** is set to **Standard (Final)** in the Effect Controls panel.

3. Make sure the **Ocean** comp is still open in the Timeline panel.

4. Select **Composition > Add to Render Queue**. This opens the Render Queue. It is a new tab that sits on top of the Timeline panel.

5. In the Output To dialog box select the **Chapter_01** folder on your hard drive as the final destination for the rendered movie. If this dialog box does not appear, click on **Ocean.mov** next to Output To.

6. Click on **Lossless** next to Output Module. This opens the Output Module Settings dialog box. Here you can change the file format and compression settings (Figure 1.68).

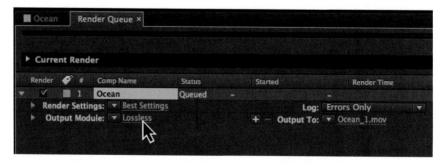

Figure 1.68: *Click on "Lossless" to launch the Output Module Settings.*

7. Set the format to **QuickTime** movie. Under Format Options, set the compression setting to **H.264** or **MPEG-4 Video**. H.264 is recommended for high-definition (HD) video. MPEG-4 offers a very good trade off on file size versus quality for digital television, animated graphics, and the web.

8. Set the Audio sampling at **44.100 kHz** using the drop-down menu (Figure 1.69).

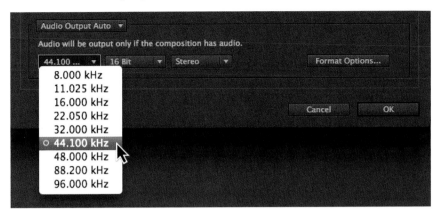

Figure 1.69: *Change the Audio sampling rate for the rendered QuickTime movie.*

9. Click **OK** to close the Output Module Settings dialog box.

10. Click the **Render** button. Your composition will start to render. The Render Queue provides feedback such as which frame is currently being rendered and approximately how much time is left.

11. When the render is done, go to the **Chapter_01** folder on your hard drive. Launch the QuickTime movie (Figure 1.70).

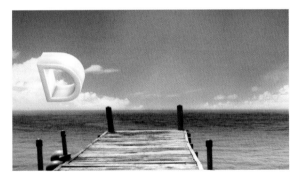

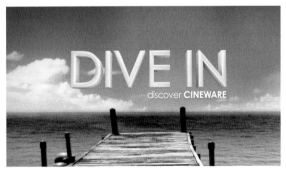

Figure 1.70: *The final QuickTime movie.*

Summary

Your journey has begun. This chapter introduced you to CINEMA 4D Lite, its workspace and workflow. Each of the seven exercises discussed the steps it takes to create a basic 3D project and integrate it into After Effects using the CINEWARE plug-in. This chapter only scratched the surface of the endless creative possibilities you now have at your fingertips with After Effects CC and CINEMA 4D Lite. The next chapter delves deeper into 3D modeling techniques and provides more in-depth exercises on materials, lighting, and animation in CINEMA 4D Lite.

Key Concepts to Remember:

▶ CINEMA 4D Lite is a completely separate software package installed automatically with After Effects CC.

▶ CINEWARE is a plug-in and serves as a bridge, connecting the two software packages together.

▶ CINEWARE displays in the Effect Controls panel in After Effects and acts as a real-time interface between a composition in After Effects and the CINEMA 4D render engine.

▶ The basic 3D workflow consists of creating and arranging 3D objects; applying color and texture; lighting the scene; viewing the scene with cameras; setting keyframes for animation; and rendering an image or animation.

▶ A 3D object built in CINEMA 4D Lite becomes a flat 2D layer inside an After Effects project. You cannot make any 3D adjustments to that 3D object directly inside After Effects.

▶ The CINEWARE workflow allows you to jump back and forth between both applications to adjust and fine tune your 3D objects without the need to render a file in CINEMA 4D.

▶ Whenever a change is made in the CINEMA 4D Lite file, you must save the file first in order to see the updates in After Effects.

CHAPTER 2

..

Modeling in CINEMA 4D

Creating 3D graphics in CINEMA 4D Lite involves building virtual models that are manipulated in a three-dimensional space. This chapter focuses on building an entire 3D animated scene from scratch.

The CINEMA 4D Workflow

MAXON CINEMA 4D is ideal for new 3D users who quickly want to expand their 2D skills in motion graphics and visual effects. The first chapter gave you a grand tour of how CINEMA 4D Lite and CINEWARE work with After Effects. Creating 3D models and manipulating them within a virtual space can take some time to get used to. As with learning any new skill, it takes patience, perserverance, and practice.

This chapter lets you step further into the creative realm of building 3D graphics. The modeling workflow is universal across many 3D software packages. In fact, you already completed a basic workflow example from the exercises in the first chapter (Figure 2.1). Even though the project was relatively simple in terms of animating extruded text, you were exposed to the following concepts:

- ► Models are objects created by the positioning of points in 3D space.
- ► Since a model is a wireframe object, it has a surface that can be colored using materials and textures. Several different materials can be applied to the same model.
- ► Light objects behave similarly to real world lights in illuminating a model.
- ► Animation brings a model to life. A basic technique involves changing the position, rotation, and scale of the object over a period of time.
- ► Rendering is the process of creating a 2D image that includes all of the visual information found in the world including: perspective and depth, light and shadow, form and texture, and motion.

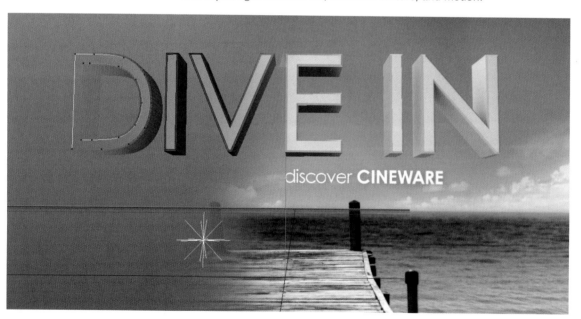

Figure 2.1: *A basic 3D workflow that can be applied to any 3D software package.*

Modeling with Primitives

Let's continue exploring how to navigate in 3D space, create complex models from primitive shapes, apply textures, set up lights, and position and animate cameras to transform your motion graphics. In this chapter, you will build an entire 3D scene in CINEMA 4D Lite. The exercises are broken into several steps that can be used as a guide when approaching a 3D project.

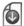 *Download (www.focalpress.com/9781138777934) the **Chapter_02.zip** file to your hard drive. It contains all the files needed to complete the exercises.*

To see what you will build, locate and play the **Bowlathon.mov** file in the **Completed** folder inside **Chapter_02** (Figure 2.2). The goal of this project is to explore how to model, assemble, and animate a camera around a scene in CINEMA 4D Lite. The final 3D animation will be rendered in After Effects.

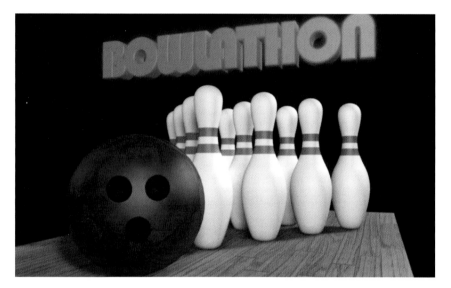

Figure 2.2: *The finished project is an entire 3D scene rendered using CINEWARE.*

Exercise 1: Understanding 3D Space

1. Launch **Adobe After Effects**. It opens an empty project by default. Save the project as **Bowlathon.aep** inside the downloaded **Chapter_02** folder.

2. Select **File > New > MAXON CINEMA 4D File...** (Figure 2.3).

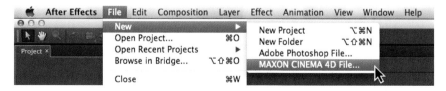

Figure 2.3: *CINEMA 4D Lite can only be opened through After Effects CC by creating a new file or a new layer within an existing composition.*

3. The first thing that you will see is a dialog box asking you to save your new MAXON CINEMA 4D file (Figure 2.4). Save the project as **Bowlathon.c4d** inside the **Chapter_02** folder. Click **Save**.

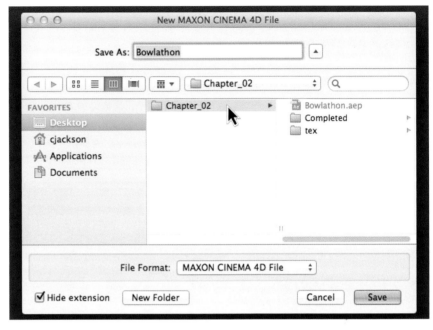

Figure 2.4: *Save your CINEMA 4D file into the same folder directory as your project file.*

After saving the file, CINEMA 4D Lite automatically launches and opens the new file. CINEMA 4D provides geometric primitive shapes that act as building blocks for 3D objects. These basic shapes include the cube, sphere, cone, and cylinder. Let's start by modeling the bowling ball for our 3D scene.

4. Locate the cube icon above the viewport window. Click and hold the icon to reveal the pop-up palette of primitive shapes. While this palette is open, left-click on the **Sphere** icon to add the shape to the scene (Figure 2.5).

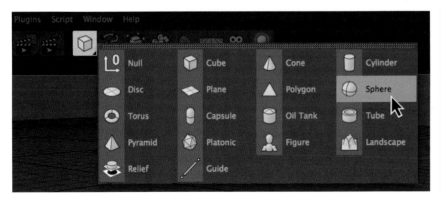

Figure 2.5: *Add a primitive sphere object to the 3D scene.*

Translating Objects in 3D Space

As you continue to explore CINEMA 4D, it is important to understand how its virtual 3D space and direction is represented on your 2D monitor. When you open a new file in CINEMA 4D Lite, you will see a perspective grid in the viewport. The center point presents the origin (0-0-0). All 3D modeling applications divide their screen coordinate systems into the X-Y-Z axes.

The sphere appears in the center of the viewport. All objects created by selecting a menu or icon command appear at the origin point, or center, of the 3D scene. Note that the X-Y-Z position for the primitive is zero in the Coordinates Manager (Figure 2.6).

Figure 2.6: *The sphere is added at the origin point of the 3D scene. The X-Y-Z coordinates are set to zero.*

5. Select the **Move** tool in the icon panel above the viewport and then click on the sphere. The sphere's axis will be visible in the viewport window. Each of the axis' arrows can be selected and dragged in its corresponding direction.

6. Click and hold down the mouse button on the red arrow, then drag the mouse. Notice that the sphere only moves along the X-axis (Figure 2.7).

Figure 2.7: *By clicking on an arrow you can move an object along a specific axis.*

7. Release the red arrow, then click and drag the cursor around in an empty area of the viewport. By not selecting any of the axes you can move the sphere in any direction (Figure 2.8).

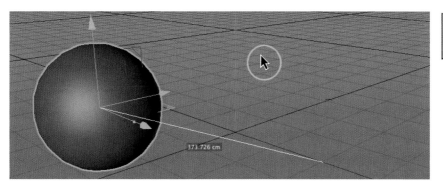

Figure 2.8: *Click and drag in an empty area of the viewport to move on any axes.*

There are other tools in the icon panel that allow you to modify more than just the position of the sphere. These tools help you quickly access functions that you will often use in CINEMA 4D without having to sort through the menus located at the top of the interface. Here is a breakdown of the tools.

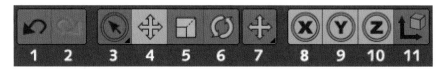

Undo/Redo Tools:
- ▶ 1. Undo
- ▶ 2. Redo

Translation Tools:
- ▶ 3. Live Selection tool
- ▶ 4. Move tool to reposition the selected object in 3D space
- ▶ 5. Scale tool to scale the selected object in X, Y, and Z direction
- ▶ 6. Rotate tool to rotate the selected object
- ▶ 7. Recently Used Tools provides a history of recent tools used

Axis Restriction Tools:
- ▶ 8. Restrict movement to X-axis
- ▶ 9. Restrict movement to Y-axis
- ▶ 10. Restrict movement to Z-axis
- ▶ 11. Use either the World or Object X-Y-Z coordinate system

8. Make sure the sphere is still selected in the viewport. Click on the **Scale** tool in the icon panel. The ends of the sphere's axis change from arrows to boxes.

9. In the viewport, click in an empty space and drag the mouse left and right to scale the sphere proportionally (Figure 2.9).

Figure 2.9: *Scale the sphere using the Scale tool.*

10. Click on the **Rotate** tool in the icon panel. A three-colored gimbal appears around the sphere that allows you to rotate it. Click and drag on these three colored coded wheels to rotate the sphere on a particular axis (Figure 2.10).

Figure 2.10: *Rotate the sphere along an axis using the Rotate tool.*

Even though it is hard to see the rotation occurring because the object is a sphere, it is important to understand the rotational coordinate system used within CINEMA 4D. The software works exclusively with the HPB system. HPB is an abbreviation for Heading, Pitch, and Bank (Figure 2.11).

▶ **Heading** is the direction axis. This axis tells you where your object is pointing, or following its nose.

▶ **Pitch** is the up and down axis of rotation, like nodding your head yes.

▶ **Bank** is the rotate along the center (heading) axis, like a plane lifting one wing and lowering the other.

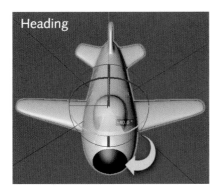
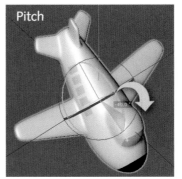
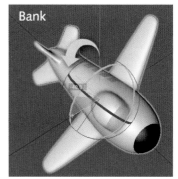

Figure 2.11: *CINEMA 4D rotates objects using the HPB system.*

11. Let's return your sphere's position to the scene's origin point and reset its original scale and rotation. Go to the Coordinates Manager (Figure 2.12):

- ► Enter **0 cm** for the X, Y, and Z Position values.
- ► Enter **200 cm** for the X, Y, and Z Size values. This is the sphere's default size.
- ► Enter **0** for the Heading (H), Pitch (P), and Bank (B) Rotation values.
- ► Click **Apply**.

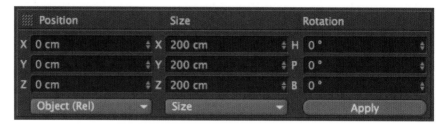

Figure 2.12: *Reset the sphere's position, scale, and rotation in the Coordinates Manager.*

Exercise 2: Modeling with Parametric Primitives

The goal of this exercise is to become familiar with modeling techniques to create 3D models in CINEMA 4D Lite. You will start by using the sphere for the basic shape of the bowling ball. Three primitive capsules will be added to create the holes using a Boolean modeling function. The Boole subtract mode will create the holes in the bowling ball. Let's get started.

1. Select the sphere in the viewport. The Attributes Manager displays the contextual information and properties for the selected object.

2. Go to the Attributes Manager and change the **Radius** property to **250 cm**. The sphere increases in size in the viewport (Figure 2.13).

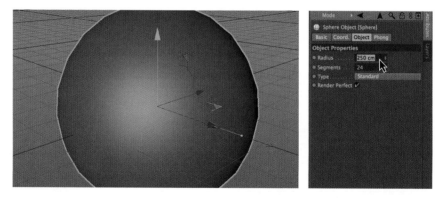

Figure 2.13: *Increase the value of the Radius property in the Attributes Manager.*

The sphere in CINEMA 4D is referred to as a **parametric** object. This means that its default shape is generated mathematically to determine what it looks like. Its parameters can be modified in the Attributes Manager, such as, its radius.

Chapter 2: Modeling in CINEMA 4D

3. Primitive shapes consist of an underlying wireframe structure. In the viewport, select **Display > Gouraud Shading (Lines)**. By changing the display setting in the viewport, you can now see the structure of the sphere (Figure 2.14).

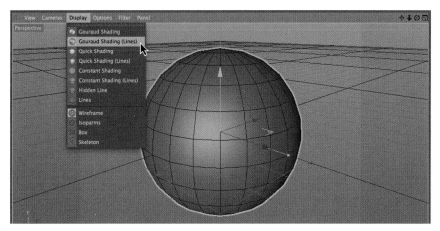

Figure 2.14: *Change the display setting in the viewport to see the wireframe structure.*

4. Go to the Attributes Manager and make the following changes:

- ▸ Increase the value of the **Segments** property to **48**. This will smooth out the sphere by adding more wireframe segments to the object.

- ▸ Change the **Type** to **Octahedron** using the drop-down menu (Figure 2.15).

While you can increase the number of segments in the sphere to make it smoother, be careful not to increase the value too much. Stick to values of 24, 36, or 48 for the number of segments in a sphere. Remember that the more segments added, the more time it will take to render the 3D object.

Figure 2.15: *Modify the sphere's parameters in the Attributes Manager.*

5. Change the viewport to see all four views. Click on the toggle views icon ▦ in the upper right corner of the viewport (Figure 2.16).

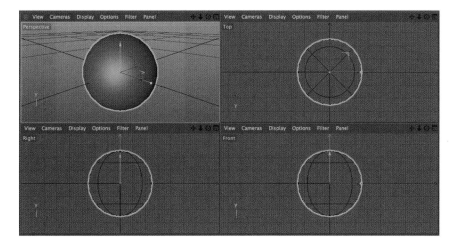

Figure 2.16: *The four views allow you to see your object from several angles.*

6. Click and hold the cube icon above the viewport to reveal the pop-up palette of primitive shapes. While this palette is open, left-click on the **Capsule** icon to add the shape (Figure 2.17). The Capsule will appear in the center of the 3D scene, inside the sphere.

Figure 2.17: *Add a Capsule primitive to the 3D scene.*

7. Make sure the Capsule is selected. Go to the Attributes Manager and make the following changes:
 ▸ Decrease the value of the **Radius** property to **40 cm**.
 ▸ Increase the value of the **Height** property to **250 cm**.

8. Go to the Coordinates Manager and change the **Pitch** rotation to **90** degrees.

9. Go to the viewport. In the Right view, click and drag the green arrow to the left with the Move tool. This will bring the capsule out of the sphere. Don't drag it all the way out (Figure 2.18).

Figure 2.18: *Reposition the Capsule in the Right view of the viewport.*

10. Copy (Command + C) and paste (Command + V) the capsule two times.

Chapter 2: Modeling in CINEMA 4D

11. In the Front view, use the Move tool to reposition the three capsules to create the holes for the bowling ball (Figure 2.19). Use all four views to fine tune the positioning of each capsule.

Figure 2.19: *Reposition all three Capsules in the Front view of the viewport.*

12. Go to the Objects Manager. This lists all of the elements in the scene. Select all three capsules by clicking on each while holding down the Shift key, or drag a marquee box over the three capsules. With the three capsules highlighted:

▶ Select **Objects > Group Objects** in the Object Manager. This will place all three capsules inside a Null object.

▶ Double-click on the **Null** name.

▶ Rename it to **Holes**. Press **Return**.

▶ Click on the **plus icon** to reveal the capsules nested inside (Figure 2.20).

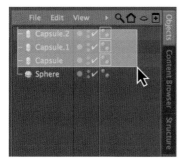
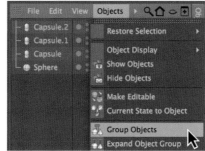
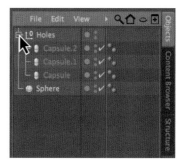

Figure 2.20: *Select all three capsules and group them together in the Objects Manager.*

The next step is to use a **Boole** model to combine the overlapping shapes. You will use the subtractive function that allows the group capsules to "take a bite" out of the sphere, thus creating the bowling ball holes. There is also a union operation that fuses overlapping shapes together into one object.

13. Click and hold the array icon above the viewport to reveal the pop-up palette of modeling objects. While this palette is open, left-click on the **Boole** icon to add it to the Objects Manager (Figure 2.21).

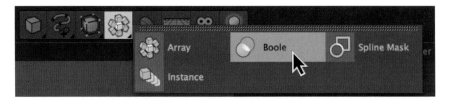

Figure 2.21: *Add a Boole modeling object to the scene.*

14. Note that you only see the three axes for the Boole object in the viewport. In order for the subtraction function to work you need to place the overlapping objects inside the Boole object in the Objects Manager. The order is important:

▸ Click and drag the **Holes** null object into the **Boole** object.

▸ Click and drag the **Sphere** into the **Boole** object. In the viewport, you will see that the capsules are now cutting holes into the sphere (Figure 2.22).

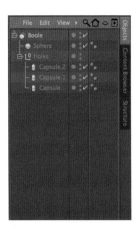
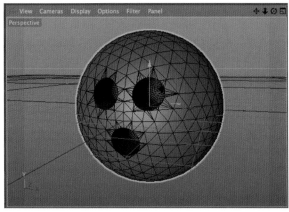

Figure 2.22: *The Boole object automatically subtracts the capsules from the sphere.*

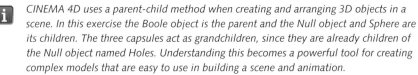

CINEMA 4D uses a parent-child method when creating and arranging 3D objects in a scene. In this exercise the Boole object is the parent and the Null object and Sphere are its children. The three capsules act as grandchildren, since they are already children of the Null object named Holes. Understanding this becomes a powerful tool for creating complex models that are easy to use in building a scene and animation.

Figure 2.23: *Rename the Boole object to Bowling Ball.*

15. Go to the Object Manager and double-click on the **Boole** name. Enter **Bowling Ball** for a name and press **Return**. It is always a good habit to name your objects in the Objects Manager (Figure 2.23).

As your scene gets more complex, your naming convention will assist you in finding and selecting your objects more quickly. Let's see how our scene looks. First, the viewport needs to be toggled back to the perspective view.

16. In the viewport, click on the toggle views icon ▣ in the top-left perspective view to toggle back to the perspective camera view of the bowling ball. Use the navigation icons ✥ ↕ ⟳ to change the default camera view to frame the bowling ball model better.

17. Click on the **Render View** icon above the viewport to render the bowling ball in the viewport window. This is a quick preview of what the final render will look like in CINEWARE (Figure 2.24).

Figure 2.24: *Click on the Render View icon to preview the scene in the viewport.*

18. Save your CINEMA 4D file. Select **File > Save**.

19. Jump back to After Effects. Click and drag the **Bowlathon.c4d** footage file to the **Create a new Composition** icon at the bottom of the Project panel (Figure 2.25).

 A new composition is created displaying your 3D model using the CINEWARE effect. Note that the CINEMA 4D file is displayed with the wireframes visible. This is the default Renderer setting called **Software** (Figure 2.26).

Figure 2.25: *Create a new composition using the CINEMA 4D footage file.*

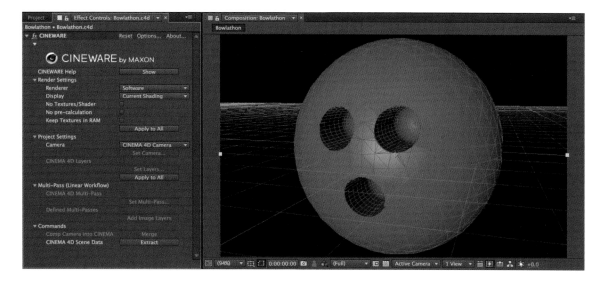

Figure 2.26: *The default renderer in CINEWARE is called Software.*

20. In the CINEWARE panel, change the Renderer from **Software** to **Standard (Final)**. This will render the bowling ball in the Composition panel similar to the Render View function in CINEMA 4D. Save the project file.

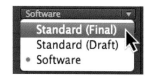

Generating Objects with NURBS

Virtually all 3D applications include primitive objects – a cube, sphere, cone, cylinder, capsule, etc. These ready-made shapes take the least amount of memory and render the fastest of any objects. That makes them ideal as a starting point in building a 3D object, but it is not the only way to model in CINEMA 4D Lite.

As you learned in Chapter 1, you can also create 3D models using splines and NURBS. Splines are vertices (dots) connected by lines in 3D space. The shape of the line is called the interpolation. A spline has no three-dimensional depth, but with the combination of NURBS you can create 3D objects (Figure 2.27).

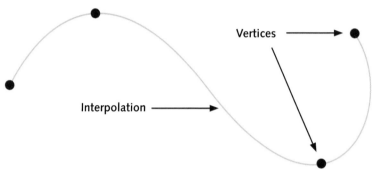

Figure 2.27: *A spline is made up of vertices.*

NURBS are generators. They use splines to create new 3D objects. Common types of NURBS are extrude, lathe, loft, and sweep. An **extruded NURB** takes a two-dimensional spline – a circle, square, or letterform – and extends the shape along a path creating a solid object. A **lathed NURB** is created by rotating a spline around an axis to produce a solid, symmetrical object. A simple example of a lathed object is a vase, or for this exercise, a bowling pin (Figure 2.28).

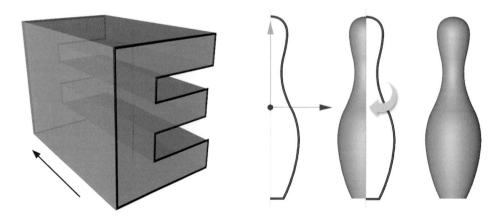

Figure 2.28: *The extruded letterform creates a solid 3D shape (left image). The bowling pin spline is rotated around its Y-axis to create the 3D symmetrical object (right image).*

Exercise 3: Using Splines and NURBS

1. Jump back to CINEMA 4D Lite. Let's continue to build our 3D scene by creating the bowling pins. The pin will be generated using a spline created in Adobe Illustrator. To import the spline, go to the Objects Manager.

 ▸ Select **File > Merge Objects**. Note that you are using the File menu located in the Objects Manager not the File menu located at the top of the CINEMA 4D Lite's user interface.

 ▸ Locate and select the **Pin.ai** file inside the **tex** folder in **Chapter_02**.

 ▸ Click **Open**. The Adobe Illustrator Import dialog box appears.

 ▸ Click **OK**. The spline for the bowling pin appears in the center of the 3D scene (Figure 2.29).

Figure 2.29: *Import the Adobe Illustrator spline for the bowling pin.*

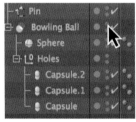

2. To see the modeling of the bowling pin a little better, we need to hide the bowling ball in the viewport. Go to the Objects Manager and double-click on the top gray circle next to Bowling Ball to change it to red (Figure 2.30).

3. To make it easier to see the spline and the effects of the lathe NURB, go to the viewport and select **Cameras > Front** (Figure 2.31). Think of the viewport now as a sheet of drawing paper.

Figure 2.30: *You can control the visibility of an object in the Objects Manager. The top gray circle controls its visibility in the viewport. The bottom gray circle controls its visibility in the renderer. The color red indicates that the object is hidden. The color gray indicates that the object is visible.*

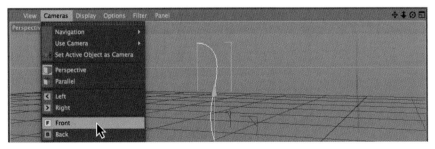

Figure 2.31: *Change the viewport camera view to Front.*

4. Go to the Objects Manager and click on imported Pin spline. In the viewport the spline is highlighted and its axis point appears. In order for the lathe NURB to work correctly you will need to reposition the axis point from the center of the spline object to the left edge. This is similar to changing the anchor point in After Effects. The lathe NURB uses the axis point to create the solid shape.

5. Click on the **Enable Axis** icon located on the left side of the viewport. This tool allows you to reposition the axis point without moving the entire model. This is similar to the Pan Behind tool in After Effects (Figure 2.32).

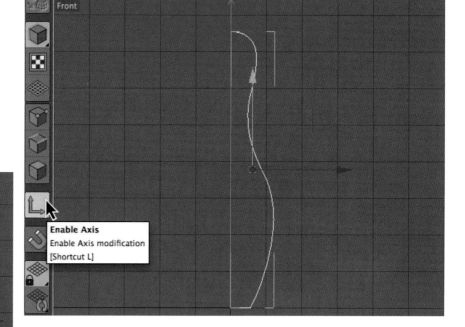

Figure 2.32: *Reposition the spline's axis point using the Enable Axis tool.*

6. Go to the Coordinates Manager and enter **0** for the **X** Position. Click **Apply**. This will position the spline's axis point to the left edge of the spline (Figure 2.33).

Figure 2.33: *Position the X-axis point to the left edge of the spline.*

7. When you are done, click on the **Enable Axis** icon again to deactivate it. Always make sure you have the correct tool selected before you modify your 3D model(s) in the viewport.

8. Select the **Lathe NURBS** from the NURBS object palette above the viewport (Figure 2.34). In the Objects Manager, a Lathe NURBS object appears above the imported Pin spline.

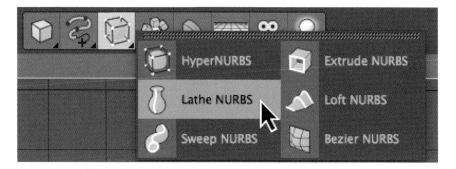

Figure 2.34: *Add a Lathe NURBS object to the scene.*

9. Go to the Objects Manager. Click and drag the Pin spline into the Lathe NURBS. In the viewport, you should see what looks like a bowling pin (Figure 2.35). The NURB automatically rotates the spline around its Y-axis.

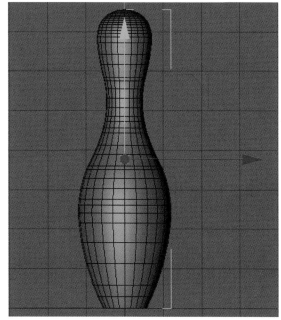

Figure 2.35: *Make the Pin spline a child of the Lathe NURBS to create the 3D object.*

Figure 2.36: *Rename the Lathe NURBS in the Objects Manager to Bowling Pin.*

10. Go to the Objects Manager and double-click on the **Lathe NURBS** name. Rename it **Bowling Pin** and press **Return** (Figure 2.36). Now that you have created one bowling pin, you will duplicate this object nine times to create the standard bowling pin set.

11. Select the Lathe NURBS object in the Objects Manager. Copy (Command + C) and paste (Command + V). The pasted item is placed directly on top of the original pin in the viewport. Duplicate the pin eight more times.

12. In the Viewport, select **Cameras > Top**. Your view will now be looking down on the pins. Use the Move tool to arrange the pins (Figure 2.37).

Figure 2.37: *From the Top view, reposition the ten bowling pins in the viewport.*

13. Go to the Objects Manager and select all the bowling pins. Press **Option + G** to group them together into a Null object. Remember that Null objects act like empty folders that allow you organize your 3D models together into groups.

14. Double-click on the **Null** object name. Rename it **Bowling Pins** and press **Return** (Figure 2.38).

15. Turn on the visibility of the bowling ball object. Go to the Objects Manager and single-click on its red circle. The bowling ball will appear in the viewport.

16. Select the **Bowling Pins** Null object in the Objects Manager. Go to the viewport and move all the pins back along the Z-axis using the Move tool (Figure 2.39).

Figure 2.38: *Rename the Null object in the Objects Manager to Bowling Pins. Add all the Lathe NURBS as children of the Null object.*

Figure 2.39: *Move the Null object back along the Z-axis.*

17. Go to the viewport and select **Cameras > Front**. Notice that the bowling ball is too low. You need to raise it up vertically along its Y-axis.

 ▸ Go to the Objects Manager and select the **Bowling Ball** Boole object.

 ▸ Go to the Coordinates Manager and enter **250 cm** for the **Y** Position. Remember, you set the radius of the sphere to 250 cm. By vertically moving the Boole object up 250 cm, the bowling ball will be on the same level as the bowling pins (Figure 2.40).

Figure 2.40: *Move the bowling ball up along its Y-axis to align with the pins.*

18. You have the pins and the bowling ball modeled. The next item that you will need is a floor for the objects to sit on. Click and hold the cube icon above the viewport to reveal the pop-up palette of primitive shapes. While this palette is open, left-click on the **Plane** icon to add the shape (Figure 2.41).

Figure 2.41: *Add a Plane primitive object to the scene. This will act as the bowling lane.*

19. Go to the viewport and select **Cameras > Perspective**. The Plane object appears under the sphere. Many objects in CINEMA 4D have orange handles. These handles let you interactively change certain parameters of objects. In this case, we can change the dimensions of the plane directly in the viewport.

20. The two outer orange handles on the edges of the plane change its width and height. Click and hold down the mouse button on an orange handle, then drag to change the dimensions of the plane. You can also see these parameter changes in the Attributes Manager (Figure 2.42).

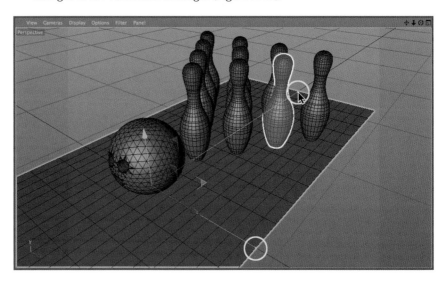

Figure 2.42: *Use the interactive orange handles to resize the plane object.*

21. The last object that needs to be created is the logotype. Select the **Text** spline from the spline palette above the viewport window (Figure 2.43). The text is added in the center of the scene. You will move it later.

Figure 2.43: *Add a text spline to the scene.*

22. Make sure the Text spline is selected. The Attributes Manager displays the contextual information and properties for the Text object.

- ▸ Type in **BOWLATHON** in the **Text** entry dialog box.
- ▸ Change the **Font** to **Bauhaus 93** or whatever typeface you want.
- ▸ Increase the **Height** value to **300 cm**.
- ▸ Decrease the **Horizontal Spacing** to **-15 cm**. This will tighten up the letterspacing (Figure 2.44).

23. Select the **Extrude NURBS** from the NURBS object palette above the viewport (Figure 2.45). In the Objects Manager, click and drag the Text object into the Extrude NURBS. The NURB automatically extends the spline along its Z-axis.

Figure 2.44: *Change the Text object's parameters in the Attributes Manager.*

Figure 2.45: *Add an Extrude NURBS object to the scene.*

24. Select the **Extrude NURBS** in the Objects Manager. Go to the Attributes Manager and increase the **Z-Movement** value to **100 cm** (Figure 2.46). This will increase the thickness of the 3D logotype.

Figure 2.46: *Increase the Z-Movement of the extruded text to make it thicker.*

25. Click on the **Caps** tab. Change the **Start/End Caps** to **Fillet Cap** to add a beveled edge, and increase the **Steps** value to **2** (Figure 2.47).

The Extrude NURBS are the simplest types of NURBS objects. The most common usage is for extruded text. The Filet Cap parameter provides a quick way to add a beveled edge. The Steps value controls the roundness of the beveled edge. The higher the number, the smoother the edge.

Figure 2.47: *Add a beveled edge to the logotype.*

Position

X 0 cm
Y 880 cm
Z 690 cm

Figure 2.48: *Reposition the Extruded NURBS object using the Coordinates Manager.*

26. While the Extrude NURBS is still selected, go to the Coordinates Manager.
 ▸ Set the **Y** Position value to **880 cm**.
 ▸ Set the **Z** Position value to **690 cm** (Figure 2.48).
 ▸ Click **Apply** and the extruded logotype will reposition above the pins.

27. Go to the Objects Manager. Rename the Extrude NURBS to **Logotype**.

28. Go to the viewport. Use the navigation icons to change the camera view to frame your scene better. Use the Rotate tool to turn the bowling ball to face the default camera (Figure 2.49).

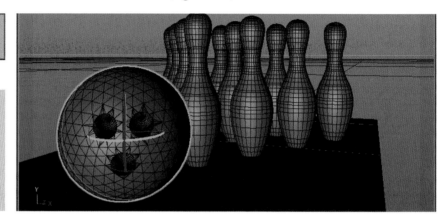

Figure 2.49: *Frame your 3D scene using the navigation icons in the viewport.*

29. Save your CINEMA 4D file. Select **File > Save**. Jump back to After Effects. The CINEWARE effect automatically updates the Composition panel (Figure 2.50).

Figure 2.50: *View the 3D models in After Effects.*

Defining Surface Properties

The word material and texture are often used interchangeably in the 3D industry. New objects are textured gray by default in CINEMA 4D. To change this you need to create a material in the Materials Manager. In this next exercise we will explore the process of creating materials and examine the different surface channels available to make objects look like glass, wood, or metal.

Exercise 4: Creating New Materials

1. Jump back to CINEMA 4D Lite.

2. Go to the Materials Manager. Select **Create > New Material**. You can also double-click anywhere in the Materials Manager to create a new material. A preview of the new material appears in the manager's panel (Figure 2.51).

All new materials are displayed as a gray sphere in the Materials Manager with the default name of Mat. You can change the sphere to different shapes by right-clicking on its icon in the Attributes Manager.

3. Double-click on the **Mat** icon to open the Material Editor dialog box. The dialog box is divided into two columns. The left column shows all the channels you can add to a material to change its appearance. By default, two channels are activated, **Color** and **Specular** (Figure 2.52).

Figure 2.51: *Create a new material in the Materials Manager.*

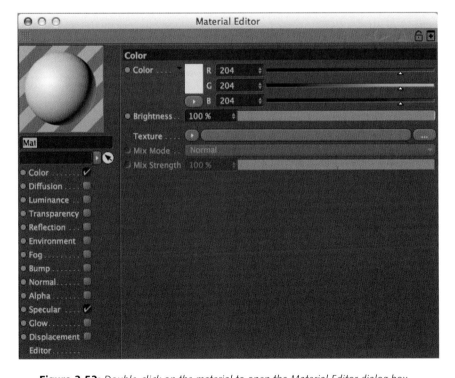

Figure 2.52: *Double-click on the material to open the Material Editor dialog box.*

The Color channel is rather self-explanatory, it defines the color of the material. The right column of the Material Editor provides contextual information and properties for the selected channel. The default color mode is RGB. You can select another mode by clicking on the arrow under the color preview. The sliders allow you to interactively adjust the red, green, and blue color channels to create the desired color.

4. While the **Color** channel is selected in the left column, change the **RGB Color** values to R = **255**, G = **45**, B = **200** in the right column. This will create a pink color for your logotype. The sphere icon updates with the new color.

5. Click on the checkbox next to the **Glow** channel to activate it. Change the Glow properties to the following values (Figure 2.53):

 ▶ Decrease the **Inner Strength** value to **50%**.

 ▶ Decrease the **Outer Strength** value to **100%**.

6. Double-click on the **Mat** name. Rename it to **Neon** and press **Return**.

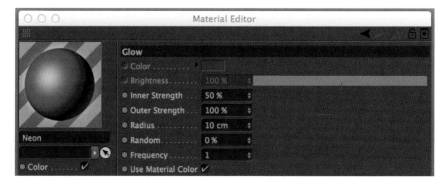

Figure 2.53: *Change the Glow channel's properties in the Material Editor dialog box.*

7. Go to the Materials Manager. Select **Create > New Material** to add a second new material to the manager's panel. This material will be applied to the bowling ball. Instead of an RGB color, you will create a marble texture.

8. Go to the Material Editor dialog box. While the **Color** channel is selected, click on the **Texture** arrow to open the drop-down menu (Figure 2.54).

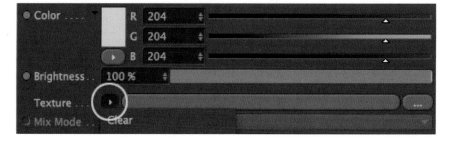

Figure 2.54: *Add a texture to the Color channel.*

9. Select **Surfaces > Marble** from the pop-up menu (Figure 2.55).

Figure 2.55: *Add a marble texture to the Color channel.*

10. To edit the colors of the marble texture, click on the **Marble** button to open the Shader Properties. This surface is a **procedural shader**. This means that the texture is generated mathematically similarly to primitive objects.

▶ Under the color gradient, double-click on the white (left) color pointer.

▶ In the Color Picker dialog box, change the **RGB Color** values to R = **45**, G = **67**, B = **160** (Figure 2.56).

▶ Click **OK** to close the Color Picker dialog box.

Figure 2.56: *Adjust the color gradient for the marble texture.*

11. Click on the checkbox for the **Reflection** channel. When you activate this channel, its default brightness value of 100% turns the material into a mirror. Let's change the channel's properties to something more realistic for the ball:

- ▸ Decrease the **Brightness** value to **5%**.
- ▸ Click on the **Texture** arrow and select **Fresnel** from the pop-up menu.
- ▸ Decrease the **Mix Strength** value to **10%**.
- ▸ Increase the **Blurriness** to **2%**.
- ▸ Rename the material from **Mat** to **Ball** and press **Return** (Figure 2.57).

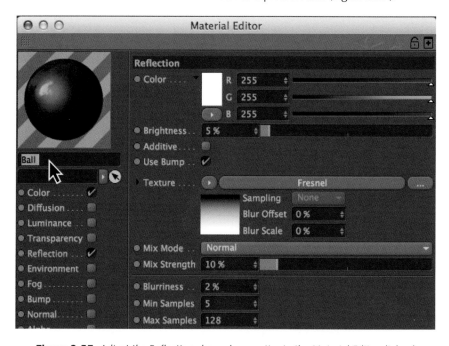

Figure 2.57: *Adjust the Reflection channel properties in the Material Editor dialog box.*

 The Fresnel shader will allow the material to reflect its surroundings, but not equally in all directions. Perpendicular views to the surface result in low reflectance. As the angle becomes more parallel to the surface, reflectance increases. Adding a small blur makes the material more realistic as the reflections will not be perfectly mirrored.

12. Go to the Materials Manager. Select **Create > New Material** to add a third new material to the manager's panel. This material will be applied to the pins. For this material, you will import a bitmap image for a texture.

13. Go to the Material Editor dialog box. While the **Color** channel is selected, make the following changes (Figure 2.58):

- ▸ Click on the **Texture** arrow and select **Load Image** from the pop-up menu.
- ▸ Locate the **pinTexture.tif** file in the **tex** folder in **Chapter_02**. Click **Open**.
- ▸ Double-click on the **Mat** name. Rename the texture to **Pin** and press **Return**.

Figure 2.58: *Load a raster image into the Color channel.*

14. Go to the Materials Manager. Select **Create > New Material** to add the final material you will need to the manager's panel.

15. Go to the Material Editor dialog box. While the **Color** channel is selected, make the following changes:

 ▸ Click on the **Texture** arrow and select **Load Image** from the pop-up menu.

 ▸ Locate the **Wood.tif** file in the **tex** folder in **Chapter_02**. Click **Open**.

16. Click on the checkbox for the **Bump** channel. Bump maps use grayscale images to artificially create raised textures without having to model all of the individual details. To give the bowling lane a more tactile look, you will import a grayscale version of the wood texture (Figure 2.59).

 ▸ Click on the **Texture** arrow and select **Load Image** from the pop-up menu.

 ▸ Locate the **WoodBump.tif** file in the **tex** folder in **Chapter_02**. Click **Open**.

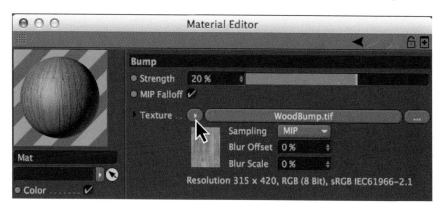

Figure 2.59: *Load a raster image into the Bump channel.*

17. Double-click on the **Mat** name. Rename it to **Wood** and press **Return**.

Exercise 5: Mapping Materials

Materials are applied to the wireframe surface of a 3D object. It is important to understand how a material is mapped so you can choose an appropriate method for the object you are texturing. The easiest mapping method is called **projection mapping** where the material is projected onto the surface based on a primitive shape that is closest to the shape of your 3D object.

The basic projection mapping methods are cubical, cylindrical, and spherical. **Cubical mapping** applies the material from six directions and the texture is on each side. **Cylindrical mapping** wraps the texture around an object as though it were a tube. **Spherical mapping** wraps a texture around an object with the texture gathered at the top and bottom poles (Figure 2.60).

Figure 2.60: *Projection mapping includes cylindrical, cubical, and spherical methods.*

The default projection method is **UVW mapping**. This method uses a coordinate system where the textured pixels retain their relative positions on the object's surface. Two other methods include **Flat** where the texture is pushed straight through an object, and **Shrink Wrap** where the texture comes together in one location, similar to wrapping a ball with a piece of paper (Figure 2.61).

Figure 2.61: *Other mapping methods include UVW, Flat, and Shrink Wrap.*

1. Click and drag the **Ball** material from the Materials Manager and drop it onto the **Bowling Ball** (Boole Object) **name** in the Objects Manager (Figure 2.62).

Figure 2.62: *Drag and drop a material onto an object's name in the Objects Manager.*

2. The bowling ball changes color in the viewport. Click on the **Texture Tag** that appears to the right of the **Bowling Ball** object in the Objects Manager.

3. The Attributes Manager displays the contextual information and properties for the selected tag. Change the **Projection** property from **UVW Mapping** to **Spherical** (Figure 2.63).

Figure 2.63: *Change the projection map from UVW to spherical.*

4. Click on the **Coordinates** tab and increase the scale of the marble texture to **300 cm** for X, Y, and Z (Figure 2.64).

Figure 2.64: *Change the scale of the material in the Attributes Manager.*

5. Click and drag the **Pin** material from the Materials Manager and drop it onto the **Bowling Pins** (Null Object) **name** in the Objects Manager.

6. The bowling pins changes color in the viewport. Click on the **Texture Tag** that appears to the right of the **Bowling Pins** object in the Objects Manager.

7. Go to the Attributes Manager and change the **Projection** property from **UVW Mapping** to **Cylindrical** (Figure 2.65).

Figure 2.65: *Change the projection map from UVW to cylindrical.*

8. The stripes on the bowling pins repeat vertically and need to be scaled only on the Y-axis. Click on the **Coordinates** tab and increase the scale on the Y-axis to **300 cm.** Leave the scale for X and Z at 100 cm (Figure 2.66).

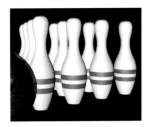
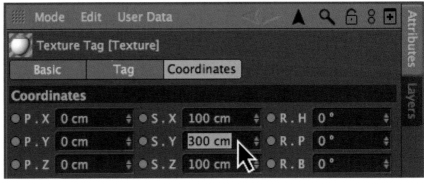

Figure 2.66: *Change the Y-axis scale of the material in the Attributes Manager.*

9. The stripes are too low on the pin models. CINEMA 4D Lite allows you to interactively adjust textures using the **Texture** tool located on the left side of the viewport. Click on the checkerboard icon to activate texture mode. A cage appears to give you an idea of how the material is positioned on the actual bowling pins.

10. Select the **Move** tool in the icon panel above the viewport.

11. Click and hold down the mouse on the green arrow, then drag the mouse up. Notice that the material only moves up along the Y-axis. Position the material so that the stripes are at the neck of the bowling pins (Figure 2.67).

Chapter 2: Modeling in CINEMA 4D

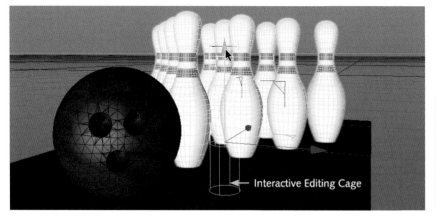

Interactive Editing Cage

Figure 2.67: *Use the Texture tool to resposition the material on the object.*

12. When you are done, click on the **Model** tool (icon above the Texture tool) to return to modeling mode. Always make sure you have the correct tool selected before you modify your 3D model(s) in the viewport.

13. Click and drag the **Neon** material from the Materials Manager and drop it onto the **Logotype** (Extruded Object) **name** in the Objects Manager. Since this material is a solid color, leave the default projection of UVW Mapping.

14. Click and drag the **Wood** material from the Materials Manager and drop it onto the **Plane name** in the Objects Manager.

15. Click on the **Texture Tag** that appears to the right of the **Plane** object in the Objects Manager. Go to the Attributes Manager and decrease the **Length U** and the **Length V** values from **100%** to **40%** (Figure 2.68).

Figure 2.68: *Change the scale of the material in the Attributes Manager.*

16. Save your CINEMA 4D file. Select **File > Save**. Jump back to After Effects. The CINEWARE effect automatically updates the Composition panel (Figure 2.69).

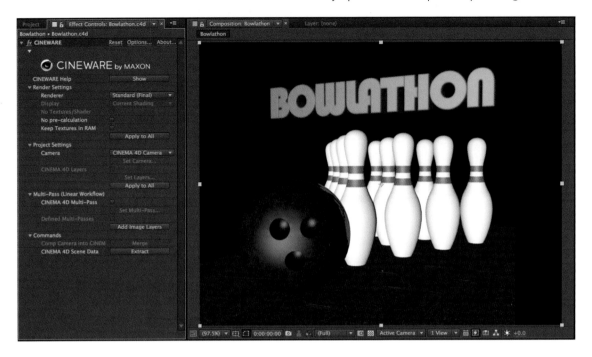

Figure 2.69: *View the 3D models in After Effects using the CINEWARE effect.*

Lighting a Scene

The modeling and texturing is done, but the scene looks rather flat with the default light in CINEMA 4D. You can add your own lights to create some drama by illuminating your models and materials and enhancing the overall depth. For this part of the exercise, you will build a three-point lighting system.

In three-point lighting, the primary light source comes from the **key light**. It is a single source of light that is bright enough to assure proper overall exposure. Since this light is the most dominant and usually shines down on the subject, it generates highlights and casts shadows. To reduce the contrast between light and dark, add a fill and rim light to the scene.

A **fill light** is a weaker light source that helps soften and extend the lighting created by the key light. It is generally positioned at an angle opposite that of the key light. For example, if the key light is on the right, the fill light should be on the left (Figure 2.70).

The fill light lightens the shadow areas, bringing out the detail in the subject and making it more visible to our eyes. Fill lights give the appearance of ambient light. Typically they act as secondary light sources that can come from lamps, or reflected light in the scene.

Chapter 2: Modeling in CINEMA 4D

The last light positioned is the **rim light**. The rim light (also called back light) highlights the edges of the object. This visually separates the object from the background. The rim light (or back light) shines down on the subject from behind and helps give depth to the image (Figure 2.70).

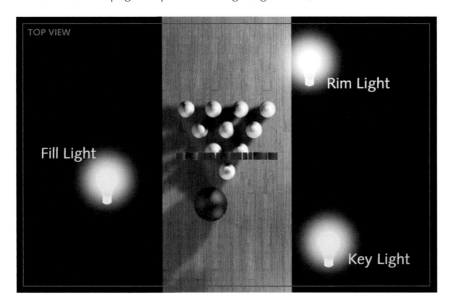

Figure 2.70: *Three-point lighting is the standard used in Hollywood movies.*

Exercise 6: Light My World

1. Jump back to CINEMA 4D. Click on the **Light** icon to add a light source to your 3D scene (Figure 2.71). The default lighting is turned off as soon as you add the Light object. This will be the key light.

Figure 2.71: *Add a Light object to the 3D scene. The default lighting will turn off.*

2. With the Light object selected in the Objects Manager, go to the Attributes Manager and click on the **Coord.** tab (Figure 2.72).

 ▸ Set the **X-Position** to **1000 cm**.

 ▸ Set the **Y-Position** to **1000 cm**.

 ▸ Set the **Z-Position** to **-1500 cm**.

3. Click on the **General** tab and decrease the **Intensity** value to **90%**. Change the **RGB Color** values to R = **245**, G = **220**, B = **255**.

Figure 2.72: *Position the key light in the 3D scene.*

4. By default, lights in CINEMA 4D do not cast shadows. To turn on the shadows, select **Shadows Maps (Soft)** from the **Shadow** drop-down menu (Figure 2.73).

Figure 2.73: *Turn on the shadows for the key light object in the Attributes Manager.*

5. Add another Light object to your 3D scene. With the Light object selected in the Objects Manager, go to the Attributes Manager. Click on the **Coord.** tab and make the following changes:
 ▸ Set the **X-Position** to -2000 cm.
 ▸ Set the **Y-Position** to 1000 cm.
 ▸ Set the **Z-Position** to 200 cm.

6. Click on the **General** tab and decrease the **Intensity** value to **80%** as this will be the fill light. Change the **RGB Color** values to R = **100**, G = **150**, B = **255**.

7. Turn on the light's shadows by selecting **Shadows Maps (Soft)** from the **Shadow** drop-down menu.

8. Add the final Light object to your 3D scene. With the Light object selected in the Objects Manager, go to the Attributes Manager. Click on the **Coord.** tab and make the following changes:
 ▸ Set the **X-Position** to 1500 cm.
 ▸ Set the **Y-Position** to 1500 cm.
 ▸ Set the **Z-Position** to 2000 cm.

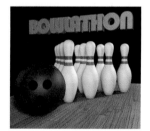

9. Click on the **General** tab and decrease the **Intensity** value to **90%** as this will be the rim light. Change the **RGB Color** values to R = **250**, G = **250**, B = **190**.

10. Turn on the light's shadows by selecting **Shadows Maps (Soft)** from the **Shadow** drop-down menu.

Chapter 2: Modeling in CINEMA 4D

11. Save your CINEMA 4D file. Select **File > Save**.

12. Jump back to After Effects. The CINEWARE effect automatically updates the Composition panel to reflect the saved changes made in CINEMA 4D Lite (Figure 2.74).

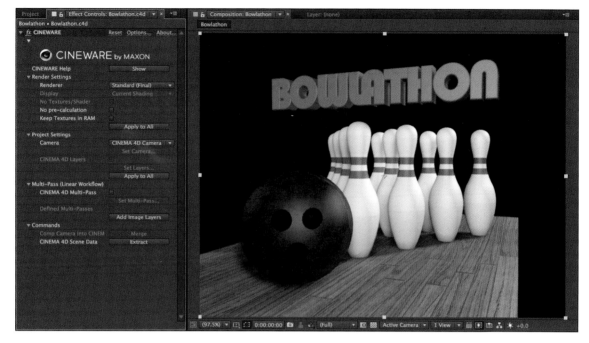

Figure 2.74: *View the 3D models in After Effects using the CINEWARE effect.*

Working with Cameras

A 3D scene is viewed through a camera. CINEMA 4D Lite provides a default perspective camera in the viewport. This camera is not listed in the Objects Manager nor can you see it or select it. If you want to be able to select and animate a camera moving around your scene, you need to add a camera object.

Exercise 7: Animating a Camera Object

Cameras in CINEMA 4D Lite can be placed anywhere in a scene and pointed at any object. As with any other objects, cameras can be moved or rotated by dragging with the mouse or entering numeric values in the Coordinates tab of the Attributes Manager. This exercise focuses on animating a camera.

1. Jump back to CINEMA 4D.

2. Go to the viewport. Use the navigation icons to change the default camera view to frame your scene better. Use the Rotate tool to turn the bowling ball to face the default camera. This will be the final scene in the animation.

3. Since you cannot animate the default camera in the viewport, click on the **Camera** icon to add new camera object to your 3D scene (Figure 2.75). The placed camera is automatically positioned at the same coordinates as the default camera.

Figure 2.75: *Add a camera object to the 3D scene.*

4. To view what the new camera is looking at in the viewport, go to the Objects Manager. Click on the **target** to the right of the **Camera name**. The target will turn white (Figure 2.76).

Figure 2.76: *Change the viewport camera to the new camera's view.*

5. Go to the Animation Palette located under the viewport. Click and drag the Current Time Indicator (green square) to **frame 80** in the Timeline Ruler (Figure 2.77).

Figure 2.77: *Move the Current Time Indicator (green square) to frame 80.*

6. Make sure the **Camera** is selected in the Objects Manager. Click on the **Record Active Objects** icon to record keyframes for the camera's position on frame 80 in the Timeline Ruler (Figure 2.78).

Figure 2.78: *Record keyframes for the extruded object on frame 80.*

7. Click and drag the Current Time Indicator (green square) back to **frame 0** in the Timeline Ruler.

8. Go to the viewport. Use the navigation icons ![icons] to change the new camera's view (Figure 2.79).

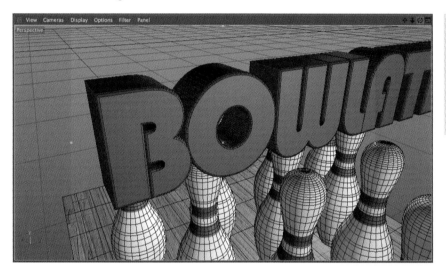

Keyboard Shortcuts

1 to **Pan** the Camera

2 to **Dolly** the Camera

3 to **Orbit** the Camera

Cmd + Shift + Z to undo a camera move

Figure 2.79: *Use the viewport's navigation icons to change the view on frame 0.*

9. Click on the **Record Active Objects** icon to record keyframes for the camera's position on frame 0 in the Timeline Ruler.

10. Click the **Play Forwards** button to see the camera movement (Figure 2.80).

Figure 2.80: *Click on the Play Forwards button to preview the animation.*

11. Let's adjust the camera's motion path. Click and drag the Current Time Indicator (green square) to **frame 40** in the Timeline Ruler. Go to the viewport. Use the navigation icons ![icons] to change the new camera's view (Figure 2.81).

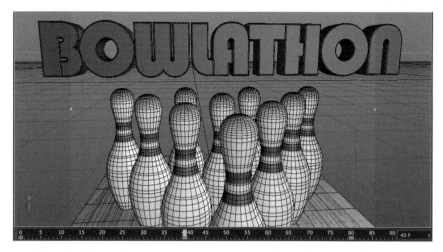

Figure 2.81: *Use the viewport's navigation icons to change the view on frame 40.*

12. Click on the **Record Active Objects** icon to record keyframes for the camera's position on frame 40 in the Timeline Ruler.

13. Click the **Play Forwards** button to see the camera movement.

14. Change the viewport to see all four views. Click on the toggle views icon in the upper right corner of the viewport. If you want to edit the camera's motion path use the views to click and drag it to a new position. To record the keyframe click on the **Record Active Objects** icon (Figure 2.82).

Figure 2.82: *The four views allow you to fine tune your camera's motion path.*

Chapter 2: Modeling in CINEMA 4D

15. When you are done with the camera animation, click on the toggle views icon in the top-left perspective view to toggle back to the single camera view.

16. Save your CINEMA 4D file. Select **File > Save**.

17. Jump back to After Effects. The CINEWARE effect automatically updates the Composition panel to reflect the saved changes made in CINEMA 4D.

18. Click on the **RAM Preview** to see the final 3D animation (Figure 2.83).

Figure 2.83: *Preview the 3D animation in After Effects using the CINEWARE plug-in.*

Adding Visual Effects and Rendering

Effects can greatly enhance the compositing of your 3D renders in CINEWARE. Remember, a 3D object built in CINEMA 4D Lite becomes a flat 2D layer inside an After Effects project. Since the CINEMA 4D file is a layer in a composition, effects can be applied to it just like any other layer. In this exercise you will apply a Glow effect that will add the finishing touch to your 3D scene.

Exercise 8: Creating an Adjustment Layer

1. With the Timeline panel still highlighted, select **Layer > New > Adjustment Layer**. An adjustment layer is added at the top of the Timeline. The footage item is also stored inside the **Solids** folder in the Projects panel.

 Adjustment layers in After Effects work just like they do in Photoshop. This type of layer holds effects, not footage. Any effect applied to an adjustment layer is also applied to all the layers below it.

2. While the Adjustment Layer is highlighted in the Timeline, select **Effects > Stylize > Glow**. The effect adds a glow to the 3D animation.

3. In the Effect Controls panel change the **Glow Threshold** property to **70%**. Change the **Glow Radius** property to **25**.

4. Make sure the Current Time Indicator (CTI) is at the beginning of the Timeline (00:00). Click on the **stopwatch** icon next to **Glow Threshold** to activate keyframes (Figure 2.84).

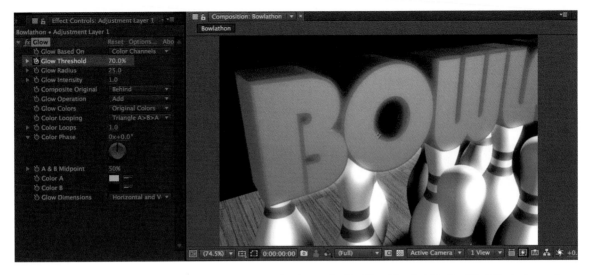

Figure 2.84: *Activate keyframes for the Glow Threshold in the Effect Controls panel.*

5. Move the Current Time Indicator (CTI) to three seconds (03:00).

6. In the Effect Controls panel change the **Glow Threshold** property to **95%**. Keep the **Glow Radius** property at **25**.

Exercise 9: Rendering the Project

1. Before you render the composition, make sure the render settings are set correctly in the CINEMA 4D file. Jump back to CINEMA 4D Lite.

2. Locate the three clapboard icons in the top center of the user interface. Click on the icon to the right that has the sprocket (Figure 2.85).

Figure 2.85: *Open the Render Settings in CINEMA 4D Lite.*

3. Click on **Anti-Aliasing** to modify its render settings on the right side of the dialog box. Change the **Anti-Aliasing** setting from **Geometry** to **Best**. Change the **Filter** setting from **Cubic (Still Image)** to **Gauss (Animation)** (Figure 2.86).

Figure 2.86: *Change the Anti-Aliasing render settings for the animation.*

4. Let's also smooth out the wireframe mesh of the bowling pins a little. Go to the Objects Manager and select the **Bowling Pins Null Object**.

5. Hold down the Option key and select the **HyperNURBS** from the NURBS object palette above the viewport (Figure 2.87). Holding down the Option key automatically makes the Null Object a child of the HyperNURBS.

Figure 2.87: *Add a HyperNURBS object to the scene.*

What does a HyperNURBS object do? It provides a smooth function that subdivides and smooths a model. Take a look at the figure below. The left image is the original Lathe NURB of the bowling pin, and the right image shows the smoothing function from the HyperNURBS object (Figure 2.88).

Figure 2.88: *HyperNURBS provide a smooth function for a model.*

6. Save your CINEMA 4D Lite file. Select **File > Save**. Jump back to After Effects. CINEWARE will automatically update any changes saved.

7. Make sure the CINEWARE **Renderer** is set to **Standard (Final)** in the Effect Controls panel.

8. Make sure the **Bowlathon** comp is still open in the Timeline panel.

9. Select **Composition > Add to Render Queue**. This opens the Render Queue. It is a new tab that sits on top of the Timeline panel.

10. In the Output To dialog box select the **Chapter_02** folder on your hard drive as the final destination for the rendered movie. If this dialog box does not appear, click on **Bowlathon.mov** next to Output To.

11. Click on **Lossless** next to Output Module.

12. Set the format to **QuickTime** movie. Under Format Options, set the compression setting to **H.264** or **MPEG-4 Video**.

13. Click **OK** to close the Output Module Settings dialog box.

14. Click the **Render** button. Your composition will start to render. The Render Queue provides feedback such as which frame is currently being rendered and approximately how much time is left.

15. When the render is done, go to the **Chapter_02** folder on your hard drive. Launch the QuickTime movie (Figure 2.89).

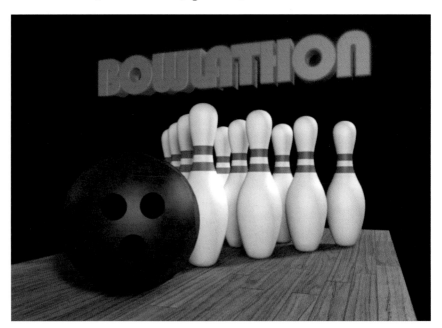

Figure 2.89: *The final QuickTime movie.*

Summary

In this chapter you built an entire scene in CINEMA 4D Lite. You followed the basic modeling workflow of creating complex models from primitives, applying textures, setting up lights, and positioning and animating cameras to transform your final motion graphics project. Keep practicing with the modeling techniques you just learned. Experiment with the 3D animation. Animate the bowling ball rolling into the scene.

Don't stop with CINEMA 4D. Remember that the CINEMA 4D file is a layer in an After Effects composition. Just like any other layer, visual effects can be applied to it. Experiment with other effects to enhance your project. Add some music to the After Effects project.

3D Camera Tracking and Compositing with CINEWARE

The powerful workflow between After Effects and CINEMA 4D is made possible with CINEWARE. This chapter focuses on how to track and composite 3D text into live footage using After Effects 3D Camera Tracker, CINEMA 4D Lite, and CINEWARE.

CINEWARE Render Settings

CINEWARE is an integral part of the entire After Effects and CINEMA 4D Lite workflow. As you have read in the previous chapters, it displays in the Effect Controls panel in After Effects and acts as a real-time interface between a composition in After Effects and the CINEMA 4D render engine. Let's explore the **Render Settings** provided in the CINEWARE effect and how they can be used to speed up the workflow.

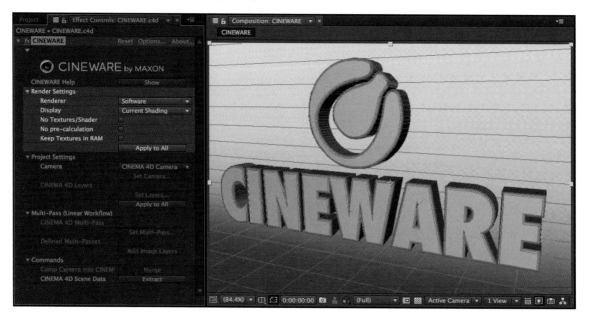

Figure 3.1: *The default Software render mode displays a low resolution image.*

The CINEWARE **Renderer** controls how the CINEMA 4D file is displayed in the Composition panel in After Effects. The default setting is **Software**. This mode is the quickest to render in After Effects and displays a low resolution version of the 3D scene (Figure 3.1). Use this mode for quick previews of complex 3D models and animation while you work in the composition.

The Software renderer also allows you to change the **Display** mode. The default setting is **Current Shading**. In this mode, CINEWARE uses the viewport's display settings from CINEMA 4D Lite. There are two other display modes, **Wireframe** and **Box**, that can be selected through a drop-down menu (Figure 3.2). These modes provide a simplified representation of the 3D scene and render even faster than the Current Shading mode.

Directly under the Display settings are three checkboxes. The **No Textures/ Shader** option will speed up your render by not rendering any textures and shaders. The **No Pre-calculation** option disables memory intensive calculations needed for CINEMA 4D's MoGraph objects and effectors or particle simulations.

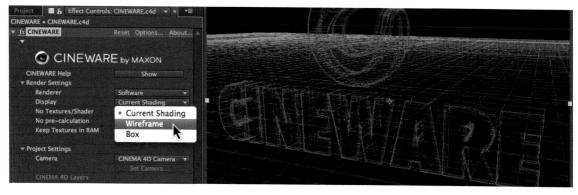

Figure 3.2: *The Wireframe display setting provides a simplified representation of the CINEMA 4D scene for a faster preview while working in a composition.*

The last option, **Keep Textures in RAM**, caches textures in the RAM so that they are not reloaded every frame during rendering and can be accessed more quickly. While this option is a great time saver for smaller textures, be careful as it will lead to a reduction in available RAM. Click the **Apply to All** button to set the current settings to all other CINEMA 4D layers in the composition.

The **Standard (Draft)** render mode provides a better image of the 3D scene but turns off slower settings like anti-aliasing for faster rendering. The **Standard (Final)** render mode uses the render settings from the CINEMA 4D file. It provides the best resolution for the final rendering in After Effects (Figure 3.3).

Figure 3.3: *The Standard (Draft) render mode does not apply anti-aliasing (left image). The Standard (Final) render mode uses the CINEMA 4D render settings to provide the best image for the final rendering in After Effects (right image).*

The CINEWARE render settings determine how to render the CINEMA 4D layer in After Effects. Directly under the render settings are the **Project Settings** which allow you to choose the camera used for rendering. The following exercises focus on using these settings to track and composite 3D objects into live footage.

Using the 3D Camera Tracker in After Effects

After Effects provides a 3D Camera Tracker effect that analyzes each frame of a video and extracts the camera motion and 3D scene data. This data allows you to accurately composite 3D objects from CINEMA 4D Lite over your 2D video footage. In this chapter, you will explore how to use the 3D Camera Tracker with CINEWARE.

 Download (www.focalpress.com/9781138777934) the **Chapter_03.zip** *file to your hard drive. It contains all the files needed to complete the exercises.*

Let's start by demonstrating how to import a 3D object and motion track it into an After Effects composition. Locate and play the **Track.mov** file in the **Completed** folder inside **Chapter_03** (Figure 3.4). The following exercise provides an introduction to using the 3D Camera Tracker effect and integrating the tracked data with CINEWARE and CINEMA 4D Lite.

Figure 3.4: *The finished project tracks a 3D object over 2D video footage.*

Exercise 1: Tracking Motion in After Effects

You can track camera motion directly in After Effects and then composite a 3D object from CINEMA 4D into the moving scene relatively quickly. The 3D Camera Tracker is very simple to use in After Effects. Let's see how it works.

1. Launch **Adobe After Effects**. It opens an empty project by default. Save the project as **CameraTrack.aep** inside the downloaded **Chapter_03** folder.

2. Double-click in the Project panel to open the Import File dialog box. Locate the **Tracks.mov** QuickTime movie in the **Footage** folder inside **Chapter_03**. Click **Open** to import the footage into the Project panel (Figure 3.5).

3. Click and drag the imported file to the **Create a new Composition** icon at the bottom of the Project panel (Figure 3.6). A new composition is created.

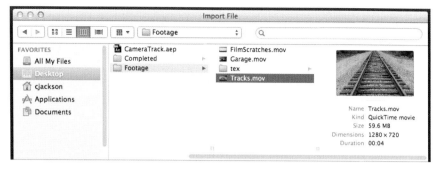

Figure 3.5: *Import the QuickTime movie into After Effects.*

Figure 3.6: *Create a new Composition in the Project panel using the imported QuickTime movie.*

4. To track the motion, make sure the video layer is selected in the Timeline.

5. Select **Animation > Track Camera**. The 3D Camera Tracker effect is applied to the layer and it automatically begins analyzing each frame of the video. After Effects does all the hard work for you. The status of the tracker analysis appears as a banner on the footage in the Composition panel (Figure 3.7).

Figure 3.7: *The 3D Camera Tracker examines each frame in the video footage.*

Once the automatic analysis is complete, tiny cross track points appear on top of the video. These track points are scaled to reflect their relative distance from the camera. Move the mouse cursor over the points and you will see a red bullseye target that reveals their orientation in the moving scene (Figure 3.8).

Figure 3.8: *3D track points display the tracked motion in the Composition panel.*

6. To position the target, you need to select at least three track points. You can also drag a selection around specific points. For this exercise, hold down the Shift key and Shift-select three track points near in the middle of the tracks (Figure 3.9).

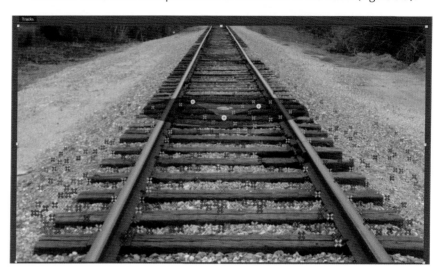

Figure 3.9: *Select at least three track points to position the bullseye target.*

7. With the target positioned, you can define a ground plane (reference plane) and origin (the 0-0-0 point) of the coordinate system within the 3D Camera Tracker effect. Right-click (Windows) or Control-click (Mac OS) on the bullseye target and choose **Set Ground Plane and Origin** (Figure 3.10).

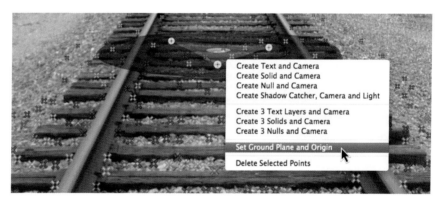

Figure 3.10: *Record a ground plane and origin point for the 3D Camera Tracker effect.*

You will not see any visible results, but the reference plane and origin of the coordinate system are saved for this scene. This is a very important step as it will allow you to correctly place a CINEMA 4D object on top of the video using this plane and origin point. The last step is to create a 3D camera.

8. Go to the Effect Controls panel and click on the **Create Camera** button (Figure 3.11). This creates the 3D Camera Tracker layer in the Timeline.

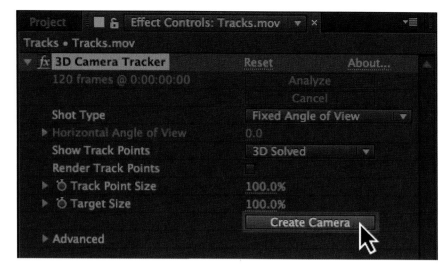

Figure 3.11: *Create a camera using the 3D Camera Tracker effect.*

Compositing a 3D Object With CINEWARE

As you can see, tracking 3D motion in a 2D video is rather simple. The next step is to create the 3D extruded text in CINEMA 4D Lite. This 3D object will be positioned in After Effects using both the saved 3D camera tracking data and the CINEWARE Project Settings.

1. To create a CINEMA 4D layer, make sure the Timeline panel is active and highlighted. Select **Layer > New > MAXON CINEMA 4D File**.

2. Save the project as **TrackText.c4d** in the **Footage** folder inside the **Chapter_03** folder. Click **Save** (Figure 3.12).

Figure 3.12: *Save the CINEMA 4D file.*

3. After saving the file, CINEMA 4D Lite automatically launches and opens the new file. Locate the three clapboard icons in the top center of the user interface. Click on the icon to the right that has the sprocket. This will open the Render Settings dialog box. Since this CINEMA 4D file will be rendered out of After Effects, you need to set the output to match the video's resolution.

4. Click on the arrow icon under **Output**. From the preset pop-up menu, select **Film/Video> HDV/HDTV 720 29.97** (Figure 3.13). The resolution is changed and the frame rate is reset to 29.97 frames-per-second. When you are done, close the Render Settings dialog box.

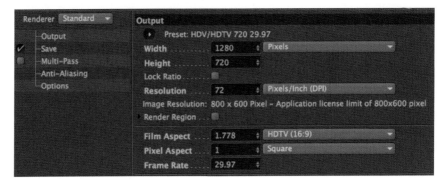

Figure 3.13: *Reset the output to a higher resolution to match the After Effects file.*

5. Go to the Timeline Ruler under the viewport window editor. The default duration for an animation in CINEMA 4D Lite is 90 frames. Type in **120** in the text entry dialog box. To see all frames in the Timeline Ruler, click on the right arrow icon next to **120 F** and drag to the right (Figure 3.14).

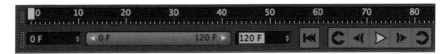

Figure 3.14: *Change the duration of the Timeline Ruler to 120 frames.*

6. Locate the spline icon above the viewport window (Figure 3.15). Click and hold the icon to reveal the pop-up palette of spline shapes. While this palette is open, left-click on the **Text** icon to add a text spline.

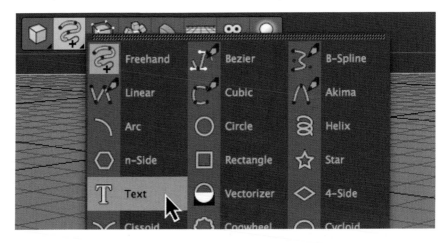

Figure 3.15: *Locate the spline icon in the icon panel above the viewport.*

7. Make sure the Text spline is selected. The Attributes Manager displays the contextual information and properties for the selected object. Go to the Attributes Manager and make the following changes (Figure 3.16):

 ▸ Change the text to **TRACK**.
 ▸ Change the font to **Rockwell Extra Bold**.
 ▸ Decrease the value of the **Horizontal Spacing** property to **-6 cm**.

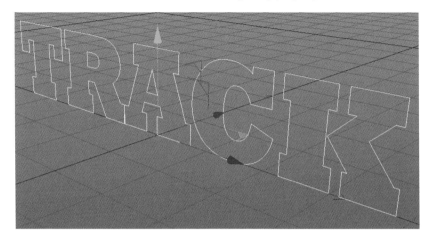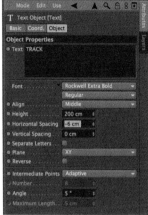

Figure 3.16: *Use the Attributes Manager to modify the Text spline object.*

8. Select the **Extrude NURBS** from the NURBS object palette above the viewport (Figure 3.17). In the Objects Manager, an Extrude NURBS object appears above the Text spline.

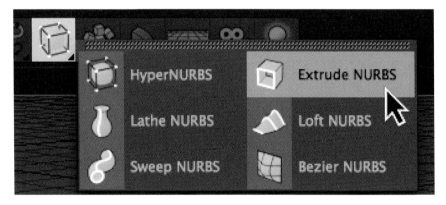

Figure 3.17: *Add an Extrude NURB to the 3D scene.*

9. Go to the Objects Manager. Click and drag the Text spline into the Extrude NURBS object. In the viewport, the 2D text becomes a 3D extruded object. The NURB automatically extends the Text spline along its Z-axis.

10. Make sure the Extrude NURBS is selected in the Object Manager. Go to the Attributes Manager and increase the **Z-Movement** value to **100**.

Compositing a 3D Object With CINEWARE **83**

11. Go to the Objects Manager and double-click on the **Extrude NURBS** name. Rename it **3D Text** and press **Return** (Figure 3.18).

Figure 3.18: *Name the extruded text object in the Objects Manager.*

12. Go to the Materials Manager. Select **Create > New Material**. A preview of the new material appears in the manager's panel.

13. Double-click on the **Mat** icon to open the Material Editor dialog box.

14. In the **Color** channel, make the following changes (Figure 3.19):

 ▸ Change the **RGB Color** values to R = **255**, G = **236**, B = **180**.

 ▸ Double-click on the **Mat** name. Rename the texture to **Text** and press **Return**.

 ▸ When you are done, close the Material Editor dialog box.

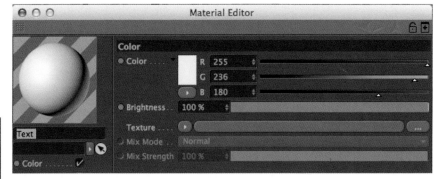

Figure 3.19: *Change the RGB color settings for the new material.*

Figure 3.20: *Drag and drop the material onto the extruded object in the Objects Manager.*

15. Click and drag the **Text** material from the Materials Manager and drop it onto the **3D Text** (Extrude NURBS) **name** in the Objects Manager (Figure 3.20). The object changes color in the viewport. A Texture Tag appears to the right of the 3D Text object in the Objects Manager.

16. Save your CINEMA 4D file. Jump back to After Effects to see the updates.

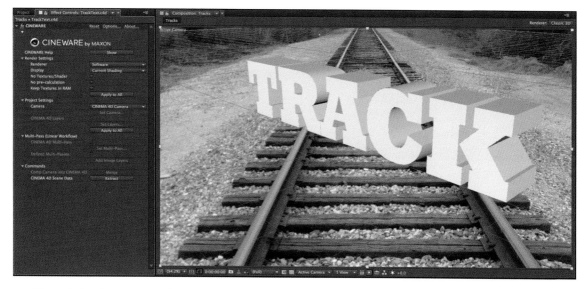

Figure 3.21: *CINEWARE updates the Composition panel in After Effects.*

The extruded text appears in the Composition panel (Figure 3.21). Its position and orientation does not match the video footage. In order to fix this problem, you need to switch the camera from the default CINEMA 4D Camera to the Comp Camera in the CINEWARE effect.

17. Make sure the CINEMA 4D layer is selected in the Timeline.

18. Go to the CINEWARE panel and change the Project Settings **Camera** option from **CINEMA 4D Camera** to **Comp Camera** using the drop-down menu. The 3D text instantly snaps to where the bullseye target recorded the origin point (Figure 3.22). The Comp Camera option is used for cameras that are added to After Effects by using either **Layer > New > Camera** command or through the 3D Camera Tracker effect.

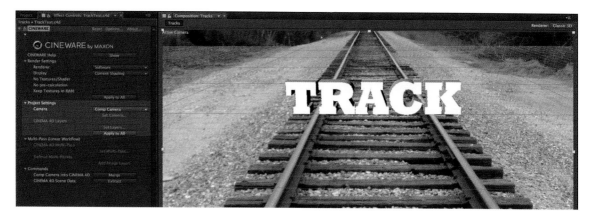

Figure 3.22: *Change the camera to Comp Camera to reposition the 3D object.*

Compositing a 3D Object With CINEWARE

19. After you changed the frame duration in the CINEMA 4D file, a ghosted bar now extends to the end of the composition in the Timeline. Retrim its Out Point by clicking and dragging it to the end of the composition (Figure 3.23).

Figure 3.23: *Retrim the Out Point to extend to the end of the composition.*

20. Change the CINEWARE Renderer from **Software** to **Standard (Final)**.

21. Go to the Timeline and single-click on the **Tracks.mov** layer to select it.

22. Select **Effect > Color Correction > Tint**. Go to the Effect Controls panel and decrease the **Amount to Tint** value to **50%** (Figure 3.24).

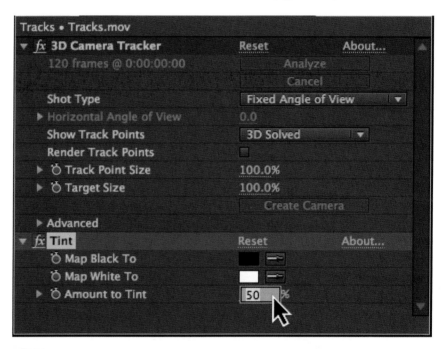

Figure 3.24: *Add a Tint effect to the video layer.*

FilmScratches.mov

23. Double-click in the Project panel to open the Import File dialog box. Locate the **FilmScratches.mov** QuickTime movie in the **Footage** folder inside **Chapter_03**. Click **Open** to import the footage.

24. Click and drag the **FilmScratches.mov** footage from the Project panel to the Timeline. Position it as the top layer in the Timeline (Figure 3.25). You are going to use the layer's blending modes to give the final project a vintage film look.

Figure 3.25: *Add another QuickTime movie to the Timeline.*

25. In the Timeline, click on the **Toggle Switches/Modes** button to display the Mode options. Change the layer's mode from **Normal** to **Overlay** (Figure 3.26).

Figure 3.26: *Change the layer's blending mode to Overlay.*

26. Press **T** on the keyboard to reveal the layer's **Opacity** property. Decrease the Opacity value to **50%** (Figure 3.27).

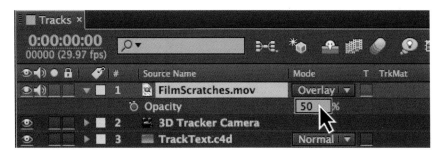

Figure 3.27: *Decrease the layer's opacity.*

27. Save the After Effects project. Click on the RAM Preview to see the final track and composite using the 3D Camera Tracker and CINEWARE effect.

28. Select **Composition > Add to Render Queue**. This opens the Render Queue. It is a new tab that sits on top of the Timeline panel.

29. In the Output To dialog box select the **Chapter_03** folder on your hard drive as the final destination for the rendered movie. If this dialog box does not appear, click on **Tracks.mov** next to Output To.

30. Click on **Lossless** next to Output Module.

31. Set the format to **QuickTime** movie. Under Format Options, set the compression setting to **H.264** or **MPEG-4 Video**.

32. Set the Audio sampling at **44.100 kHz** using the drop-down menu (Figure 3.28).

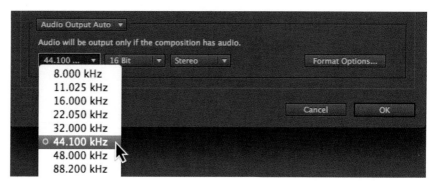

Figure 3.28: *Change the Audio sampling rate for the rendered QuickTime movie.*

33. Click **OK** to close the Output Module Settings dialog box.

34. Click the **Render** button. Your composition will start to render. The Render Queue provides feedback such as which frame is currently being rendered and approximately how much time is left.

35. When the render is done, go to the **Chapter_03** folder on your hard drive. Launch the QuickTime movie (Figure 3.29).

Figure 3.29: *The 3D text tracks the camera movement in the rendered video.*

The goal of this exercise was to demonstrate a quick and efficient workflow for placing a 3D object on an origin point that was tracked in After Effects. For more complex motion tracking, there is an alternate method in which you export the 3D Camera Tracker data to CINEMA 4D. Let's see how that works.

Exporting a CINEMA 4D File from After Effects

To see what you will create, locate and play the **TheHeist.mov** file in the **Completed** folder inside **Chapter_03** (Figure 3.30). This exercise expands on the previous workflow for integrating tracked data with CINEMA 4D. You will again use the 3D Camera Tracker in After Effects to record the camera's motion and then export the data directly to CINEMA 4D. This will allow for better fine-tuning of the 3D object's position and orientation in relation to the captured perspective in the live footage.

Figure 3.30: *The finished project is a title sequence for a fictitious action movie.*

Exercise 2: Exporting Tracked Camera Data to CINEMA 4D

1. Create a new project in **Adobe After Effects**. Save the project as **TheHeist.aep** inside the downloaded **Chapter_03** folder.

2. Double-click in the Project panel to open the Import File dialog box. Locate the **Garage.mov** QuickTime movie in the **Footage** folder inside **Chapter_03**. Click **Open** to import the footage into the Project panel (Figure 3.31).

3. Click and drag the imported file to the **Create a new Composition** icon at the bottom of the Project panel. A new composition is created.

Figure 3.31: *Import the QuickTime movie into After Effects.*

4. To track the motion, make sure the video layer is selected in the Timeline.

5. Select **Animation > Track Camera**. The 3D Camera Tracker effect is applied to the layer and it automatically begins analyzing the video (Figure 3.32).

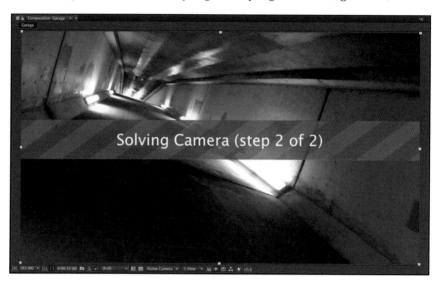

Figure 3.32: *The 3D Camera Tracker examines each frame in the video footage.*

When analyzing the video, the 3D Camera Tracker first looks for all the points that it wants to track. This occurs in the background allowing you to work on other compositions during its analysis. Once the tracking process has finished, the second step is solving the 2D camera track and creating the 3D data from it. The tracking data is displayed as tiny crosses, or track points, on top of the video.

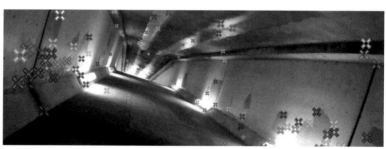

Figure 3.33: *Increase the track point size in the Effect Controls panel.*

6. To see the track points better, go to the Effect Controls panel. Increase the **Track Point Size** value to **150%** (Figure 3.33). When the mouse cursor hovers over these points, a red bullseye target appears displaying the point's orientation.

7. The 3D object needs to appear half way through the video, not on the first frame (Figure 3.34). Go to the Timeline and move the Current Time Indicator (CTI) to four seconds (4:00).

Figure 3.34: *Move the Current Time Indicator to four seconds (4:00).*

8. To position the target, you need to select at least three track points. You are basically triangulating these three points to create a 2D reference plane. For this exercise, hold down the Shift key and Shift-select the track points on the left side of the scene (Figure 3.35).

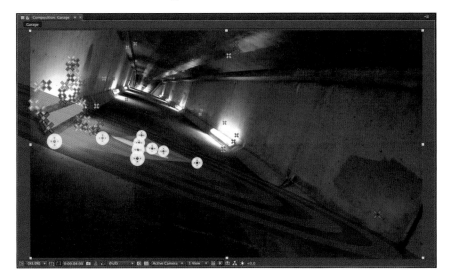

Figure 3.35: *Select the track points to position the bullseye target.*

9. If your target is too big, go to the Effect Controls panel and decrease the **Target Size** value to **60%** (Figure 3.36).

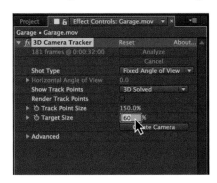

Figure 3.36: *Decrease the target size in the Effect Controls panel.*

10. The center of the bullseye target will become the origin point for the 3D Camera Tracker. To move the target, position the mouse cursor over the center of the bullseye. The cursor changes to an arrow with a pan cross-hair target. Click and drag the target to the right (Figure 3.37).

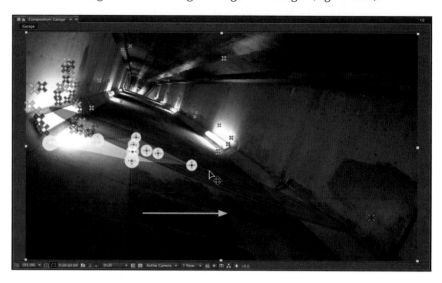

Figure 3.37: *Reposition the bullseye target in the Composition panel.*

11. Once the target is in position, you need to create the ground plane and store its origin point to use with CINEMA 4D. Right-click (Windows) or Control-click (Mac OS) on the bullseye target and choose **Set Ground Plane and Origin** (Figure 3.38).

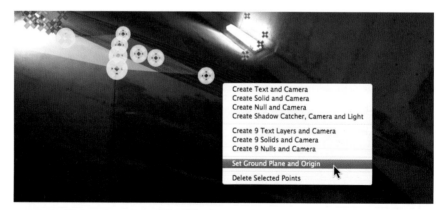

Figure 3.38: *Record a ground plane and origin point for the 3D Camera Tracker effect.*

12. Right-click (Windows) or Control-click (Mac OS) on the bullseye target again. This time select **Create Null and Camera** (Figure 3.39). The 3D Camera Tracker will create a 3D camera and null layer in the Timeline. These elements will be exported from After Effects to CINEMA 4D Lite.

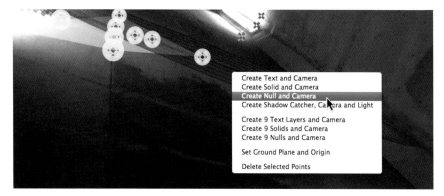

Figure 3.39: *Create a Null and Camera layer using the 3D Camera Tracker effect.*

13. Go to the Timeline and single-click on the **3D Tracker Camera** layer to select it. Press the **U** key to reveal all keyframes. After Effects has set all the keyframes that track the movement of the camera used in the footage (Figure 3.40). This allows you to match your CINEMA 4D models into the scene.

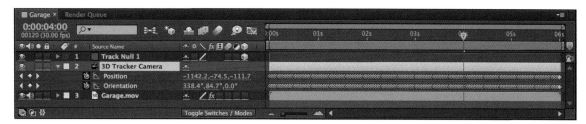

Figure 3.40: *The 3D Camera Tracker effect sets all the keyframes for the camera layer.*

14. What makes this workflow even more flexible is that you can export all of this tracked data from After Effects into CINEMA 4D. To do this, select **File > Export > MAXON CINEMA 4D Exporter**.

15. Save the project as **AE_3DCameraTracker.c4d** in the **Footage** folder inside the **Chapter_03** folder. Click **Save** (Figure 3.41).

Figure 3.41: *Save the CINEMA 4D file.*

16. In order to match the perspective in the video, let's export the current frame from After Effects. Make sure the Current Time Indicator (CTI) is still at four seconds (4:00).

17. Select **Composition > Save Frame As > Photoshop Layers** (Figure 3.42). In the Save dialog box, save the file in the **Footage** folder. Click **Save**.

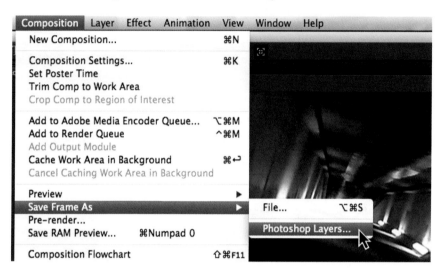

Figure 3.42: *Save the current frame of the composition as a Photoshop file.*

18. Save your After Effects project file.

19. Double-click in the Project panel to open the Import File dialog box. Locate the **AE_3DCameraTracker.c4d** exported file in the **Footage** folder inside **Chapter_03**. Click **Open** to import the footage into the Project panel.

20. To open this file in CINEMA 4D Lite, single-click on the footage to highlight it in the Project panel. Select **Edit > Edit Original**.

You can easily export a composition in After Effects as a CINEMA 4D file. This exercise demonstrates the extremely powerful and flexible workflow between the two applications. The last part of the exercise is to integrate the 3D model into the scene. Instead of doing this in After Effects, you will use the exported data to create the final composite in CINEMA 4D Lite.

Using Null and Camera Objects in CINEMA 4D

Figure 3.43: *The exported data is displayed in the Objects Manager.*

Let's jump over to CINEMA 4D Lite and take a look at the exported file from After Effects. In the Objects Manager there is a null object with the same name as the After Effects composition. Inside the null object is the **3D Tracker Camera** and **Track Null 1** object (Figure 3.43). The viewport is automatically set to display what the exported camera object is seeing. To view the tracked motion for the camera, click on the **Play Forwards** button in the Timeline panel.

1. The only thing that is missing is the 3D extruded text. Rather than build it in this file, let's create a new CINEMA 4D file just for the extruded text. After the 3D object has been built, you can easily merge it into this exported file from After Effects. Go to the File menu in the top left corner. Select **File > New**.

> ℹ️ *When creating complex scenes or animation in CINEMA 4D, it is sometimes easier to create each model in a separate CINEMA 4D file and then merge them all together. This is similar to working with multiple compositions in After Effects.*

2. Select **File > Save**. Save the new CINEMA 4D file as **HeistLogotype.c4d** in the **Footage** folder inside the **Chapter_03** folder. Click **Save (**Figure 3.44).

Figure 3.44: *Save the new CINEMA 4D file into the Chapter_03 Footage folder.*

3. Locate the spline icon above the viewport window (Figure 3.45). Click and hold the icon to reveal the pop-up palette of spline shapes. While this palette is open, left-click on the **Text** icon to add a text spline.

Figure 3.45: *Locate the spline icon in the icon panel above the viewport.*

4. Make sure the Text spline is selected. The Attributes Manager displays the contextual information and properties for the selected object.

5. Go to the Attributes Manager and make the following changes:

 ▸ Change the text to **HEIST**.

 ▸ Change the font to **Impact**.

 ▸ Decrease the value of the **Height** property to **120 cm**.

 ▸ Decrease the value of the **Horizontal Spacing** property to **-4 cm**.

6. Add another **Text** spline to the scene. Go to the Attributes Manager and make the following changes (Figure 3.46):

 ▸ Change the text to **THE**.

 ▸ Change the font to **Impact**.

 ▸ Decrease the value of the **Height** property to **45 cm**.

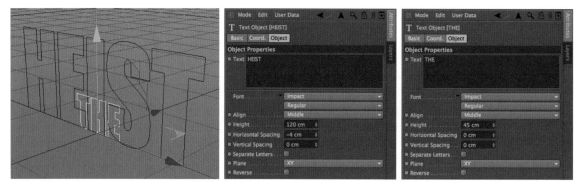

Figure 3.46: *Use the Attributes Manager to modify the Text spline objects.*

7. Go to the viewport and select **Cameras > Front**.

8. Select the **Move** tool in the icon panel above the viewport and then click on the "THE" text spline. Use the X- and Y-axis to position it above the "H" in the "HEIST" spline (Figure 3.47).

Figure 3.47: *Use the Move tool to position the text spline in the viewport.*

9. Go to the viewport and select **Cameras > Perspective** to change the view.

10. Select the **Extrude NURBS** from the NURBS object palette above the viewport (Figure 3.48). In the Objects Manager, an Extrude NURBS object appears above the Text splines.

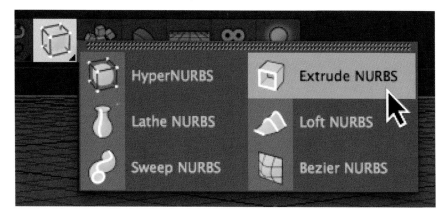

Figure 3.48: *Add an Extrude NURB to the 3D scene.*

11. Go to the Objects Manager. Click and drag the "HEIST" text spline into the Extrude NURBS object. Go to the Attributes Manager and increase the **Z-Movement** value to **100**.

12. Add another **Extrude NURBS** from the NURBS object palette.

13. Go to the Objects Manager. Click and drag the "THE" text spline into the Extrude NURBS object. Go to the Attributes Manager and decrease the **Z-Movement** value to **20** (Figure 3.49).

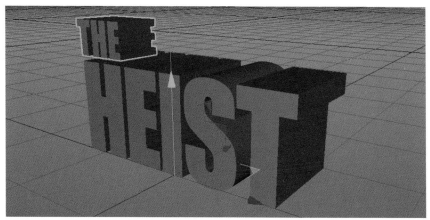

Figure 3.49: *Add the text splines to the Extruded NURBS.*

14. Go to the Materials Manager. Select **Create > New Material**. A preview of the new material appears in the manager's panel.

15. Double-click on the **Mat** icon to open the Material Editor dialog box.

16. Go to the Material Editor dialog box. While the **Color** channel is selected, make the following changes:

- ▸ Click on the **Texture** arrow and select **Load Image** from the pop-up menu.
- ▸ Locate the **Concrete.psd** file in the **tex** folder in **Chapter_03**.
- ▸ Click **Open**.

17. Click on the checkbox for the **Bump** channel. To give the concrete texture a more tactile look, you will import a grayscale version of it (Figure 3.50).

- ▸ Click on the **Texture** arrow and select **Load Image** from the pop-up menu.
- ▸ Locate the **ConcreteBump.psd** file in the **tex** folder in **Chapter_03**.
- ▸ Click **Open**.
- ▸ Increase the **Strength** value to **50%**.

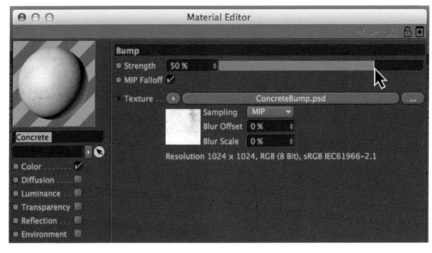

Figure 3.50: *Load a raster image into the Bump channel.*

Figure 3.51: *Change the Texture Tag properties.*

18. Double-click on the **Mat** name. Rename it to **Concrete** and press **Return**.

19. Click and drag the **Concrete** material from the Materials Manager and drop it onto both **Extrude names** in the Objects Manager.

20. Click on the **Texture Tag** for the "HEIST" extruded object in the Objects Manager. Go to the Attributes Manager and change the following settings to adjust the placement of the texture on the 3D object:

- ▸ Decrease the **Offset U** to **-15%**.
- ▸ Increase the **Length U** value from **100%** to **130%**.
- ▸ Change the **Projection** to **Cubic** (Figure 3.51).

21. Click on the **Texture Tag** for the "THE" extruded object in the Objects Manager. Go to the Attributes Manager and change the **Projection** to **Cubic**.

22. Go to the Objects Manager. Select all the objects by clicking on each while holding down the Shift key, or drag a marquee box over the objects. With all the objects highlighted:

- Select **Objects > Group Objects** in the Object Manager.
 This will place everything inside a Null object.

- Double-click on the **Null** name.

- Rename it to **Logotype**. Press **Return**.

- Click on the **plus icon** to reveal the objects nested inside (Figure 3.52).

Figure 3.52: *Select all the objects and group them together in the Objects Manager.*

23. Save the CINEMA 4D File. Now that the 3D object is complete, the next step is to merge it into the exported file from After Effects (Figure 3.53).

Figure 3.53: *The final 3D logotype.*

24. Select **Window > AE_3DCameraTracker.c4d** to jump back to the exported CINEMA 4D file. Unlike After Effects, CINEMA 4D allows you to have multiple projects open at one time. If you accidentally closed this file, you can open it again by selecting **File > Open** and then locate the CINEMA 4D file.

25. To import the 3D logotype, go to the Objects Manager.

- ► Select **File > Merge Objects**. Note that you are using the File menu located in the Objects Manager not the File menu located at the top of the CINEMA 4D Lite's user interface.
- ► Locate and select the **HeistLogotype.c4d** file inside the **Footage** folder in **Chapter_03**.
- ► Click **Open** (Figure 3.54).

Figure 3.54: *Merge the final 3D logotype into the exported CINEMA 4D file.*

Figure 3.55: *Nest the Logotype null object inside the Track Null 1 object exported from After Effects.*

26. The 3D object is added to the Objects Manager and the concrete material is added to the Materials Manager. Go to the Objects Manager and click and drag the **Logotype** null object into the **Track Null 1** object (Figure 3.55). This will reposition the extruded text to the correct location for the final composite with the video footage.

27. Go to the Materials Manager. Select **Create > New Material** to add a new material to the manager's panel. This will be the background reference image.

28. In the **Color** channel, make the following changes (Figure 3.56):

- ► Click on the **Texture** arrow and select **Load Image** from the pop-up menu.
- ► Locate the **Garage.psd** file in the **footage** folder in **Chapter_03**. Click **Open**.
- ► Double-click on the **Mat** name. Rename the texture to **Background** and press **Return**.
- ► When you are done, close the Material Editor dialog box.

Figure 3.56: *Load an image as a material using the texture parameter.*

29. Locate the Floor icon above the viewport window (Figure 3.57). Click and hold the icon to reveal the pop-up palette. While this palette is open, left-click on the **Background** icon to add the object to the Objects Manager.

Figure 3.57: *Add a Background object to the Objects Manager.*

30. Click and drag the **Background** material from the Materials Manager and drop it onto the **Background name** in the Objects Manager. The viewport displays the rendered frame from After Effects. You will use this as a reference to orient the 3D logotype to match the video's perspective.

31. Go to the Timeline panel. Click and drag the green square to **frame 120**. This frame is at the four second mark, the same frame as the exported Photoshop background image saved from After Effects.

32. Even though the 3D object is positioned at the tracked origin point, its orientation is not correct. Use the **Rotate** tool to turn the logotype to face the 3D Camera Tracker. Use the **Move** tool to change its horizontal (X) position. Move it slightly to the right in the viewport (Figure 3.58).

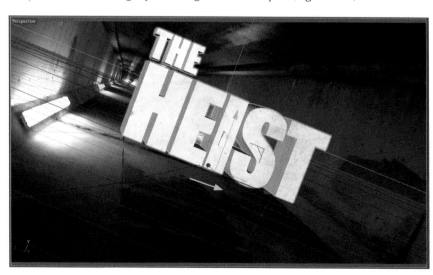

Figure 3.58: *Rotate and move the 3D logotype slightly to the right in the viewport.*

33. Click the **Play Forwards** button to preview the tracked motion with the 3D object (Figure 3.59). The 3D Tracker Camera is animating through the scene. The logotype is positioned at the recorded origin point for the Null object.

Figure 3.59: *Click on the Play Forwards button to preview the animation.*

34. The final step that needs to be done is to add light objects to the scene to mimic the lighting in the video footage. Click on the **Light** icon to add a light source to your 3D scene.

35. In the Objects Manager, rename the light to **Side Light**. Click and drag the object into the **Track Null 1** object.

36. With the **Side Light** object selected in the Objects Manager, go to the Attributes Manager and click on the **General** tab.
 ▸ Change the **RGB Color** values to R = **166**, G = **218**, B = **255**.
 ▸ Increase the **Intensity** value to **110%**
 ▸ Set the **Shadows** property to **Shadow Maps (Soft)**.

37. In the Attributes Manager, click on the **Details** tab.
 ▸ Set the **Falloff** property to **Inverse Square (Physically Accurate)**. This will simulate realistic falloff of the light over the extruded text.
 ▸ Change the **Radius/Decay** of the falloff to **386 cm**.

38. In the Attributes Manager, click on the **Coord.** tab.
 ▸ Set the **X-Position** to **-350 cm**.
 ▸ Set the **Y-Position** to **140 cm**.
 ▸ Set the **Z-Position** to **20 cm**.

39. In the Attributes Manager, click on the **Shadows** tab.
 ▸ Decrease the **Density** value to **90%** to simulate more realistic shadows.
 ▸ Change the **RGB Color** values to R = **40**, G = **70**, B = **120**.

40. Click on the **Light** icon to add a second light source to your 3D scene. In the Objects Manager, rename the light to **Rim Light**. Click and drag the object into the **Track Null 1** object.

41. Go to the Attributes Manager and click on the **General** tab and set the **Shadows** property to **Shadow Maps (Soft)**.

42. In the Attributes Manager, click on the **Coord.** tab.
 ▸ Set the **X-Position** to **180 cm**.
 ▸ Set the **Y-Position** to **-90 cm**.
 ▸ Set the **Z-Position** to **-165 cm**.

43. In the Attributes Manager, click on the **Shadows** tab.

- ▶ Decrease the **Density** value to **90%** to simulate more realistic shadows.
- ▶ Change the **RGB Color** values to R = **34**, G = **49**, B = **81** (Figure 3.60).

Figure 3.60: *Change the light's color and shadow properties in the Attributes Manager.*

Before you render the composition in After Effects, make sure the render settings are set correctly in the CINEMA 4D file.

44. Even though the Background object does not render in CINEWARE, it can produce a white fringe around the extruded text due to the anti-aliasing. To prevent this, go to the Objects Manager and double-click on the bottom gray circle next to **Background** to change its color to red (Figure 3.61).

45. Locate the three clapboard icons in the top center of the user interface. Click on the icon to the right that has the sprocket (Figure 3.62).

Figure 3.61: *Turn off the Background object's render view button in the Objects Manager.*

Figure 3.62: *Open the Render Settings in CINEMA 4D Lite.*

46. Click on Anti-Aliasing to modify its render settings on the right side of the dialog box. Change the **Filter** setting from **Cubic (Still Image)** to **Gauss (Animation)**. This will reduce possible edge aliasing (flicker) in the animation.

47. Save your CINEMA 4D Lite file. Select **File > Save**. Jump back to After Effects.

48. Click and drag the **AE_3DCameraTracker.c4d** file from the Projects panel to the Timeline. Position it at the top of the layers in the Timeline.

49. Turn off the visibility for the **3D Tracker Camera** and **Track Null 1** layers in the Timeline. Those objects and keyframes are now stored inside the CINEMA 4D layer (Figure 3.63).

Figure 3.63: *Position the CINEMA 4D layer at the top of the Timeline. Turn off the visibility for the 3D Tracker Camera and the Null layer.*

50. Make sure the CINEWARE **Renderer** is set to **Standard (Final)** in the Effect Controls panel.

51. Select **Composition > Add to Render Queue**. This opens the Render Queue. It is a new tab that sits on top of the Timeline panel.

52. In the Output To dialog box select the **Chapter_03** folder on your hard drive as the final destination for the rendered movie. If this dialog box does not appear, click on **Garage.mov** next to Output To.

53. Click on **Lossless** next to Output Module. Set the format to **QuickTime** movie. Under Format Options, set the compression setting to **H.264** or **MPEG-4 Video**.

54. Set the Audio sampling at **44.100 kHz** using the drop-down menu.

55. Click **OK** to close the Output Module Settings dialog box.

56. Click the **Render** button.

57. When the render is done, go to the **Chapter_03** folder on your hard drive. Launch the QuickTime movie (Figure 3.64).

Figure 3.64: *The final rendered QuickTime movie.*

Summary

In this chapter, you learned how to use the 3D camera tracking effect in After Effects. This provides a relatively easy workflow to composite 3D objects from CINEMA 4D Lite onto 2D video footage in After Effects. The CINEWARE render and project settings make working between the two applications extremely flexible. Not only can you import and composite CINEMA 4D files into tracked video footage, but you can also export your composition from After Effects as a CINEMA 4D file.

Casting Shadows Using Layers with CINEWARE

Using CINEMA 4D layers offers greater compositing control with CINEWARE. This chapter explores how to use a layer-based workflow to composite realistic shadows created from lighting in CINEMA 4D Lite onto live footage in After Effects.

Lights and Shadows in CINEMA 4D

Light is what illuminates our world. Lighting in CINEMA 4D mimics the properties of light by simulating depth through shading, casting shadows, and interacting with surface materials to produce highlights and reflections. The previous chapters exposed you to adding light objects to a scene, and even a three-point lighting system. Understanding lighting is crucial in producing professional 3D models and animation.

In CINEMA 4D Lite there are four main light types (omni, spot, infinite, and area) and three basic shadow types (shadow maps, raytraced, and area). Each is designed to be used in different lighting situations to simulate a desired real world effect. This chapter focuses on the basics of 3D lighting and shadows.

As you learned, when you add a light object to a CINEMA 4D scene, it appears in the viewport as a starburst icon that has lines pointing in all directions. The icon represents the default light, an **omni light**. This light acts like an exposed light bulb that shines equally in all directions. When rendered, the omni light illuminates in a spherical area, all around the 3D objects. There is also a falloff region of light where it transitions from bright to dark (Figure 4.1).

Figure 4.1: *An omni light appears as a starburst icon and shines equally in all directions.*

The omni light can be changed to a directional, or **spot light**, in the Attributes Manager. This type of light spreads out in a cone shape similar to an actual spot light used in theater and movie productions. A spot light appears as a cone of light in the viewport with nothing outside of the cone illuminated (Figure 4.2). The spread and shape of the light can be controlled using its interactive orange handles in the viewport or modifying its properties in the Attributes Manager.

Figure 4.2: *A spot light is a directional light and appears as a cone of light.*

The third type of light is an **infinite light**. This simulates sunlight that illuminates a 3D model in one direction from an infinite distance with no falloff. An infinite light appears as a point with a single line in the viewport (Figure 4.3). When rendered, it produces a parallel wall of light that shines in all directions.

The last type of light is called an **area light**. This light is basically a rectangle of light, similar to a window in a room (Figure 4.3). The default shape can be changed to whatever you want. Area lights take the longest to render but produce the most realistic lighting on a model in CINEMA 4D.

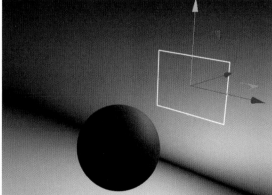

Figure 4.3: *An infinite light (left) simulates sunlight and an area light (right) produces a rectangular area of light similar to a window.*

Shadows help define depth and detail in your 3D scene. By default, lights in CINEMA 4D do not cast any shadows, but you can turn on shadows for light objects in the Attributes Manager. CINEMA 4D has three different types of shadows, and each impact the overall rendering time. These shadow options are located under the **General** tab for a light object (Figure 4.4).

▶ **Shadow Maps (Soft)** produces a nice soft edge around the shadow.

▶ **Raytraced (Hard)** is the simplest type of cast shadow to render producing a rather harsh shadow.

▶ **Area** shadows produce the most realistic shadow but takes a considerably longer time to render.

Figure 4.4: *There are three types of shadows: Shadow Maps (left image), Raytraced (middle image), and Area (right image).*

All shadow options can be modified using the **Shadow** channel in the Attributes Manager. Notice that the Area shadow is a little pixilated. To fix the graininess, increase the **Minimum Samples** value. Keep in mind that each time you increase this number, it costs you in terms of rendering time. You can also adjust the density, which is how dark the shadow is. Notice that the default density value is 100% producing a pitch black shadow. Decreasing this value to around 90% can help your projects look a little bit more realistic (Figure 4.5). Just keep in mind that any of these options impact the rendering time.

Figure 4.5: *The Shadow channel in the Attributes Manager allows you to control the shadow's density, color, and accuracy in the final rendered image.*

Chapter 4: Casting Shadows Using Layers with CINEWARE

Creating a Shadow Catcher in After Effects

In the previous chapter, you used the 3D Camera Tracker effect to accurately composite 3D objects from CINEMA 4D Lite over 2D video footage. The only element that was missing was a cast shadow. The following exercise builds on the previous two exercises from Chapter 3. You will use the 3D Camera Tracker to create a **Shadow Catcher** object. This object is created specifically for accepting and compositing shadows with video footage.

*Download (www.focalpress.com/9781138777934) the **Chapter_04.zip** file to your hard drive. It contains all the files needed to complete the exercises.*

Locate and play the **Checkerboard.mov** file in the **Completed** folder inside **Chapter_04** (Figure 4.6). The following exercise provides an introduction to creating a Shadow Catcher object using the 3D Camera Tracker effect. This will enable you to composite realistic shadows created from lights in a CINEMA 4D file onto video footage in After Effects using CINEWARE. Let's get started.

Figure 4.6: *The 3D model of the pawn casts a shadow using the Shadow Catcher object.*

Exercise 1: Exporting a Shadow Catcher from After Effects

The first step is to track the camera motion in the video directly in After Effects and then export the tracked data to CINEMA 4D Lite.

1. Launch **Adobe After Effects**. It opens an empty project by default. Save the project as **Checkerboard.aep** inside the downloaded **Chapter_04** folder.

2. Double-click in the Project panel to open the Import File dialog box. Locate the **Checkerboard.mov** QuickTime movie in the **Footage** folder inside **Chapter_04**. Click **Open** to import the footage into the Project panel (Figure 4.7).

3. Click and drag the imported file to the **Create a new Composition** icon at the bottom of the Project panel (Figure 4.8). A new composition is created.

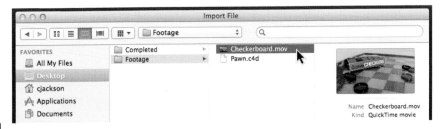

Figure 4.7: *Import the QuickTime movie into After Effects.*

Figure 4.8: *Create a new Composition in the Project panel using the imported QuickTime movie.*

4. To track the motion, make sure the video layer is selected in the Timeline.

5. Select **Animation > Track Camera**. The 3D Camera Tracker effect is applied to the layer and it automatically begins analyzing each frame of the video. Once the automatic analysis is complete, tiny cross track points appear on top of the video.

6. To position the bullseye target, you need to select at least three track points. For this exercise, hold down the Shift key and Shift-select the track points around the middle dark square on the checkerboard (Figure 4.9).

Figure 4.9: *Select the track points to position the bullseye target.*

7. To move the target, position the mouse cursor over the center of the bullseye. Click and drag the target to center it better on the checkerboard (Figure 4.10).

Figure 4.10: *Position the bullseye target within the dark square on the checkerboard.*

8. The center of the bullseye target will become the origin point for the 3D Camera Tracker. With the target positioned, right-click (Windows) or Control-click (Mac OS) on the bullseye target and choose **Set Ground Plane and Origin** (Figure 4.11).

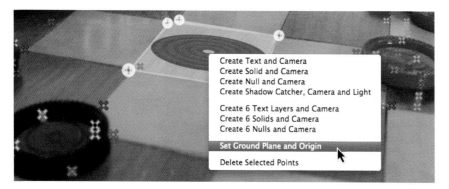

Figure 4.11: *Record a ground plane and origin point for the 3D Camera Tracker effect.*

9. Right-click (Windows) or Control-click (Mac OS) on the bullseye target again. This time select **Create Shadow Catcher, Camera, and Light** (Figure 4.12).

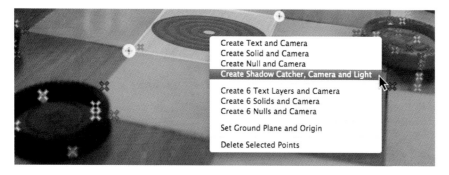

Figure 4.12: *Create a Shadow Catcher, Camera, and Light layer in the Timeline.*

After Effects creates a 3D camera and light layer in the Timeline. The light is positioned at a location similar to the light source used to shoot the video. A Shadow Catcher layer is also added to the Timeline. This is a solid layer that will be used to accept the cast shadows (Figure 4.13).

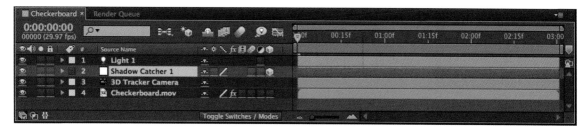

Figure 4.13: *Create a Shadow Catcher layer using the 3D Camera Tracker effect.*

Creating a Shadow Catcher in After Effects

111

10. As you learned in Chapter 3, not only can you import CINEMA 4D files into tracked video footage, but you can also export your composition from After Effects as a CINEMA 4D file. To do this, select **File > Export > MAXON CINEMA 4D Exporter**.

11. Save the project as **AE_ShadowCatcher.c4d** in the **Footage** folder inside the **Chapter_04** folder. Click **Save** (Figure 4.14).

Figure 4.14: *Export the After Effects project as a CINEMA 4D file.*

12. In order to match the lighting and shadows in the video, let's export the current frame from After Effects. Select **Composition > Save Frame As > Photoshop Layers** (Figure 4.15). In the Save dialog box, save the file in the **Footage** folder. Click **Save**.

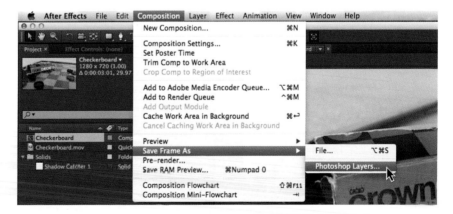

Figure 4.15: *Save the current frame of the composition as a Photoshop file.*

13. Save your After Effects project file.

14. Double-click in the Project panel to open the Import File dialog box.

15. Locate the **AE_ShadowCatcher.c4d** exported file in the **Footage** folder inside **Chapter_04**. Click **Open** to import the footage into the Project panel.

16. To open this file in CINEMA 4D Lite, single-click on the footage to highlight it in the Project panel. Select **Edit > Edit Original** (Figure 4.16).

Figure 4.16: *Open the exported CINEMA 4D file.*

Adding Shadows in CINEMA 4D

Let's jump over to CINEMA 4D Lite and take a look at the exported file from After Effects. In the Objects Manager there is a null object with the same name as the After Effects composition. Inside the null object is a **3D Tracker Camera**, **Shadow Catcher 1**, and **Light 1** object (Figure 4.17). The viewport is automatically set to display what the exported camera object is seeing. The Shadow Catcher appears as a 2D plane set at the recorded origin point.

Exercise 2: Lights and Shadows

1. Let's add the 3D model of the pawn chess piece to the scene. This model has already been created in a separate CINEMA 4D file.

 ▶ In the Objects Manager, select **File > Merge Objects**.

 ▶ Locate and select the **Pawn.c4d** file inside the **Footage** folder in **Chapter_04**.

 ▶ Click **Open** (Figure 4.18).

Figure 4.17: *The exported data is displayed in the Objects Manager.*

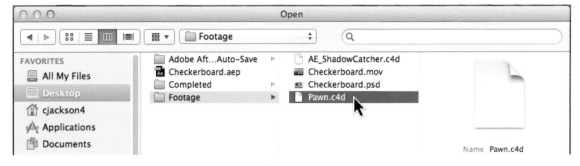

Figure 4.18: *Merge the 3D chess piece into the exported CINEMA 4D file.*

The object is added to the Objects Manager and appears at the origin point in the viewport (Figure 4.19). The pawn is a lathed object. As you learned in Chapter 2, a Lathe NURB is created by rotating a spline around an axis to produce a solid, symmetrical object.

Figure 4.19: *The merged Lathe NURB appears at the origin point in the viewport.*

2. The scale of the pawn chess piece is a little small for the scene. Go to the Attributes Manager and click on the **Coord.** tab. Increase the scale of the object to **2** for X, Y, and Z (Figure 4.20).

Figure 4.20: *Increase the scale of the 3D object in the Attributes Manager.*

3. Go to the Objects Manager and click and drag the **Lathe NURBS** into the **Checkerboard** Null object.

4. Go to the Materials Manager. A material for the Shadow Catcher was created when the file was exported from After Effects. Select **Create > New Material** to add a new material to the manager's panel. This will be the background reference image used to match the cast shadows in the video footage.

5. Double-click on the **Mat** icon to open the Material Editor dialog box.

6. In the **Color** channel, make the following changes (Figure 4.21):

 ▸ Click on the **Texture** arrow and select **Load Image** from the pop-up menu.

 ▸ Locate the **Checkerboard.psd** file in the **Footage** folder in **Chapter_04**. Click **Open**.

 ▸ Rename the texture to **Background** and press **Return**.

 ▸ When you are done, close the Material Editor dialog box.

Figure 4.21: *Load an image as a material using the texture parameter.*

7. Locate the Floor icon above the viewport window and left-click on the **Background** icon to add the object to the Objects Manager (Figure 4.22).

Figure 4.22: *Add a Background object to the Objects Manager.*

8. Click and drag the **Background** material from the Materials Manager and drop it onto the **Background name** in the Objects Manager.

9. Click on the **Render View** icon above the viewport to render the scene in the viewport window. This is a quick preview of what the render will look like in CINEWARE (Figure 4.23). Notice that the exported light is automatically set to cast a shadow onto the Shadow Catcher surface.

Figure 4.23: *Render a preview of the scene in the viewport.*

The shading on the pawn is calculated based on the angle of its surface. The exported light from After Effects provides a simple lighting setup with a key light illuminating one side of the object. While this creates the strong shading and definition of volume for the object, the contrast is too great. The dark side of the pawn is completely black since no light is hitting it.

In reality this side of the pawn would still be illuminated, just not as much as the brightly lit side, because of light bouncing around the room and hitting the dark side of the object. Bounce light is not calculated in CINEMA 4D, so you have to create it yourself. To do this, you need to add additional light objects pointing in the opposite direction to illuminate the shadow areas.

10. Click on the **Light** icon to add a light source to your 3D scene. In the Objects Manager, rename the light to **Side Light**. Click and drag the object into the **Checkerboard** Null object.

11. With the **Side Light** object selected in the Objects Manager, go to the Attributes Manager and click on the **General** tab.
 ‣ Change the **RGB Color** values to R = **255**, G = **230**, B = **205**.
 ‣ Decrease the **Intensity** value to **90%**.

12. In the Attributes Manager, click on the **Coord.** tab.
 ‣ Set the **X-Position** to **-1000 cm**.
 ‣ Set the **Y-Position** to **1000 cm**.
 ‣ Set the **Z-Position** to **-1500 cm**.

13. Click on the **Light** icon to add a third light source to your 3D scene. In the Objects Manager, rename the light to **Rim Light**. Click and drag the object into the **Checkerboard** Null object.

14. With the **Rim Light** object selected in the Objects Manager, go to the Attributes Manager and click on the **General** tab.

 ▸ Increase the **Intensity** value to **110%**.

 ▸ Set the **Shadows** property to **Shadow Maps (Soft)**.

15. In the Attributes Manager, click on the **Coord.** tab.

 ▸ Set the **X-Position** to **400 cm**.

 ▸ Set the **Y-Position** to **2000 cm**.

 ▸ Set the **Z-Position** to **1100 cm**.

16. Click on the **Render View** icon again to render the scene (Figure 4.24). The shading on the pawn's surface now simulates how light bouncing around the room would affect it. The cast shadow under the pawn will be used to mimic the reflection of the checkers seen in the video footage.

Figure 4.24: *Add more light objects to simulate bounce light in the scene.*

17. Go to the Materials Manager. Select **Create > New Material**. A preview of the new material appears in the manager's panel.

18. Double-click on the **Mat** icon to open the Material Editor dialog box.

19. In the **Color** channel, make the following changes:

 ▸ Change the **RGB Color** values to R = **247**, G = **219**, B = **173**.

 ▸ Rename the texture to **Pawn** and press **Return**.

You will also need to adjust the specular highlights. **Specular light** refers to the highlights on reflective objects, such as billiard balls. They appear as bright spots on a surface, at a point where the light source hits it directly.

20. In the **Specular** channel make the following changes (Figure 4.25):

 ▶ Decrease the **Width** value to **30%**.

 ▶ Increase the **Height** value to **40%**.

 ▶ Increase the **Inner Width** value to **10%**.

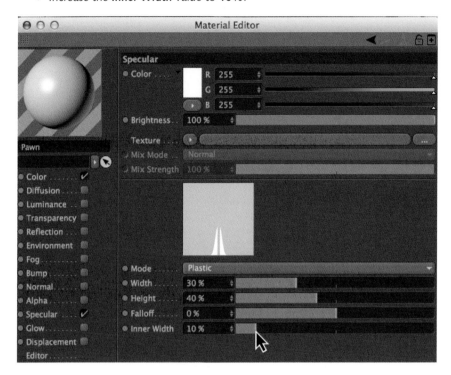

Figure 4.25: *Adjust the specular highlight settings in the Material Editor.*

21. When you are done, close the Material Editor panel.

22. Click and drag the **Pawn** material from the Materials Manager and drop it onto the **Lathe NURBS name** in the Objects Manager (Figure 4.26).

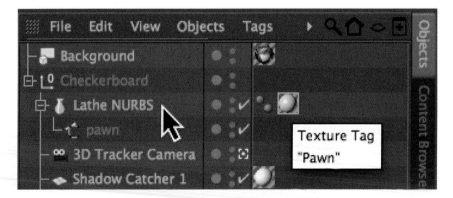

Figure 4.26: *Apply the texture to the Lathe NURBS object in the Objects Manager.*

23. Click on the **Render View** icon again to render the scene (Figure 4.27). When compared to the specular highlights on the checkers, there are too many highlights on the 3D model. Each highlight comes from a placed light object. Fortunately, you can turn off the specular highlights for a light object.

Figure 4.27: *Render the image to view the new material added to the pawn model.*

24. Go to the Objects Manager and select the **Rim Light** object.

25. In the Attributes Manager, go to the **General** tab. Uncheck the checkbox for **Specular** to deactivate the highlight created by this light object (Figure 4.28).

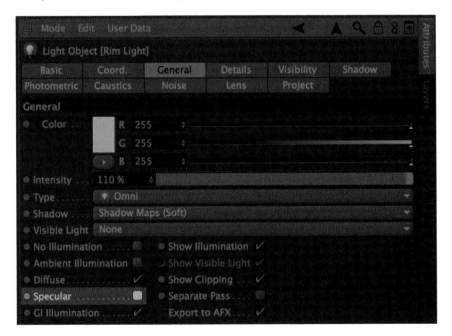

Figure 4.28: *Turn off the specular highlights for the Rim Light object.*

26. Go to the Objects Manager and select the **Side Light** object.

27. In the Attributes Manager, go to the **General** tab. Uncheck the checkbox for **Specular** to deactivate the highlight created by this light object.

28. Click on the **Render View** icon again to render the scene (Figure 4.29).

Figure 4.29: *Render the scene in the viewport.*

29. With the specular highlight set correctly, let's also smooth out the wireframe mesh of the pawn chess piece a little. Go to the Objects Manager and select the **Lathe NURBS** object.

30. Hold down the Option key and select the **HyperNURBS** from the NURBS object palette above the viewport (Figure 4.30). Holding down the Option key automatically makes the Lathe NURBS a child of the HyperNURBS.

Figure 4.30: *Add a HyperNURBS object to the scene.*

31. Locate the three clapboard icons in the top center of the user interface. Click on the icon to the right that has the sprocket to open the Render Settings.

32. Click on Anti-Aliasing to modify its render settings on the right side of the dialog box. Change the **Anti-Aliasing** setting from **Geometry** to **Best**.

33. Even though the Background object does not render in CINEWARE, it can produce a white fringe around the 3D model due to the anti-aliasing. To prevent this, go to the Objects Manager and double-click on the bottom gray circle next to **Background** to change its color to red (Figure 4.31).

34. Save your CINEMA 4D Lite file. Select **File > Save**.

35. Jump back to After Effects.

36. Click and drag the **AE_ShadowCatcher.c4d** file from the Projects panel to the Timeline. Position it at the top of the layers in the Timeline.

37. Turn off the visibility for the **Light 1**, **Shadow Catcher 1**, and the **3D Tracker Camera** layers in the Timeline. Those objects and keyframes are now stored inside the CINEMA 4D layer (Figure 4.32).

Figure 4.31: *Turn off the Background object's render view button in the Objects Manager.*

Figure 4.32: *Position the CINEMA 4D layer at the top of the Timeline. Turn off the visibility for the Light 1, Shadow Catcher 1, and 3D Tracker Camera layers.*

38. Change the CINEWARE **Renderer** to **Standard (Final)** in the Effect Controls panel (Figure 4.33). The next exercise focuses on adding layers in CINEMA 4D.

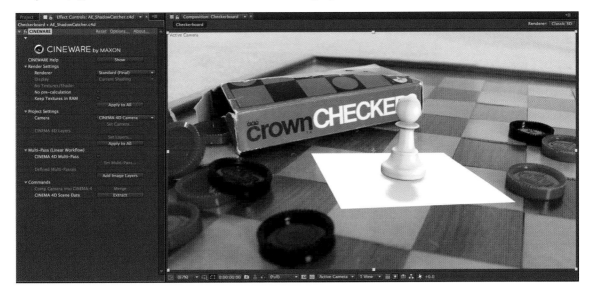

Figure 4.33: *Change the render settings in the CINEWARE Effect Controls panel.*

Adding Shadows in CINEMA 4D

Setting Up Layers and Compositing Tags

Your project is almost done. The only problem is the Shadow Catcher renders as a white solid in the Composition panel. To solve this, you need to create layers to separate the Shadow Catcher from the actual 3D model of the pawn. CINEMA 4D provides a layer system that is both very powerful and easy to use. When combined with CINEWARE, layers offer even more flexibility in compositing and adding effects to your motion graphics.

Exercise 3: Creating New Layers

1. Save your After Effects project. Jump back to CINEMA 4D Lite.

2. Click on the **Layers** tab directly under Attributes on the right side of the interface. This opens the Layers Manager on top of the Attributes Manager (Figure 4.34).

Figure 4.34: *Open the Layers Manager in CINEMA 4D.*

3. In the Layers Manager select **File > New Layer**. Rename the new layer **Pawn**.

4. Select **File > New Layer** again. Rename the new layer **Shadow** (Figure 4.35).

Figure 4.35: *Create two new layers: one for the 3D object and one for the Shadow Catcher object in the Layers Manager.*

5. Go to the Objects Manager. Select the **Shadow Catcher 1** object to highlight it.

6. In the Objects Manager, select **Edit > Add to Layer > Shadow** (Figure 4.36).

Figure 4.36: *Add the Shadow Catcher object to the Shadow layer.*

7. Select the **HyperNURBS** object to highlight it. When assigning layers, it is important to include all children. In the Objects Manager, select **Edit > Select Children** to select the HyperNURBS children.

8. In the Objects Manager, select **Edit > Add to Layer > Pawn**. Each layer is color coded and the assigned layer appears to the right of each object's name in the Objects Manager (Figure 4.37).

Now that you have successfully separated the 3D object from the Shadow Catcher using layers in CINEMA 4D, there is still a problem that needs to be solved when using CINEWARE. In order for CINEWARE to render the cast shadows on the Shadow Catcher, it needs the shadow-casting object (pawn) to exist on the same layer. So how do you solve this since you just placed the pawn model on a separate layer?

9. Select the **HyperNURBS** object in the Objects Manager to highlight it.

10. Click and hold the array icon above the viewport to reveal the pop-up palette of modeling objects. While this palette is open, left-click on the **Instance** icon to add a copy of the pawn 3D model to the Objects Manager (Figure 4.38).

Figure 4.37: *Add the HyperNURBS object and all of its children to the Pawn layer.*

Figure 4.38: *Create a copy of the 3D object using the Instance generator.*

11. Click and drag the **HyperNURBS Instance** object into the **Checkerboard** null object. Position it above the **Shadow Catcher 1** object.

12. In the Objects Manager, select **Edit > Add to Layer > Shadow** (Figure 4.39). We don't want the Instance to render in the After Effects composition, only the shadow it casts. To fix this, you need to add a **Compositing Tag** to the object in the Objects Manager. Compositing tags provide additional settings that allow you to control how an object is rendered in the final image.

13. Make sure the **HyperNURBS Instance** is still selected in the Objects Manager.

14. Select **Tags > CINEMA 4D Tags > Compositing** (Figure 4.40).

Figure 4.39: *Add the instance object to the Shadow layer.*

Figure 4.40: *Add a Compositing Tag to the instance object.*

15. Make sure the **Compositing Tag** is selected in the Objects Manager.

16. Click on the **Attributes** tab directly above Layers to open the Attributes Manager on top of the Layers Manager.

17. In the Attributes Manager, uncheck the checkbox for **Seen by Camera** to remove the object from the final render, but keep its cast shadow (Figure 4.41).

Figure 4.41: *Change the compositing settings for the instance object.*

18. Before you jump back to After Effects, select the **HyperNURBS Instance** again in the Objects Manager.

19. Go to the Attributes Manager and click on the checkbox for **Render Instance**. This will assist in speeding up the rendering time by rendering the instance rather than keeping it in RAM (Figure 4.42).

Figure 4.42: *Render instance to save on RAM.*

20. Save your CINEMA 4D Lite file. Select **File > Save**.

With the CINEMA 4D layers and compositing tags in place, the last stage in this workflow is to use CINEWARE to effectively blend the shadows with the video footage. CINEWARE offers the ability to isolate each layer in the CINEMA 4D file within the After Effects composition.

Compositing Layers with CINEWARE

In After Effects you will use CINEWARE and Blending Modes to effectively composite the cast shadow with the video background.

Exercise 4: Separating Layers Using CINEWARE

1. Jump back to After Effects. Go to the Timeline and select the **AE_ShadowCatcher.c4d** layer.

2. In CINEWARE, click on the checkbox for **CINEMA 4D Layers** under the Project Settings. Click on the **Set Layers** button.

3. Uncheck the checkbox for the **Pawn** layer (Figure 4.43). Click **OK**. The pawn 3D model disappears in the Composition panel leaving only the Shadow Catcher shape layer and the cast shadow visible.

Figure 4.43: *Turn off the Pawn layer in CINEWARE.*

4. In the Timeline, click on the **Toggle Switches/Modes** button to display the Mode options. Change the layer's mode from **Normal** to **Multiply** (Figure 4.44). The white shape vanishes leaving only the cast shadow blended on top of the video.

Figure 4.44: *Change the layer's blending mode to Multiply.*

5. Click and drag another copy of the **AE_ShadowCatcher.c4d** file from the Projects panel to the Timeline. Position it at the top of the layers in the Timeline.

6. In CINEWARE, click on the checkbox for **CINEMA 4D Layers** under the Project Settings. Click on the **Set Layers** button.

7. Uncheck the checkbox for the **Shadow** layer. Click **OK**.

8. Change the CINEWARE **Renderer** to **Standard (Final)** (Figure 4.45).

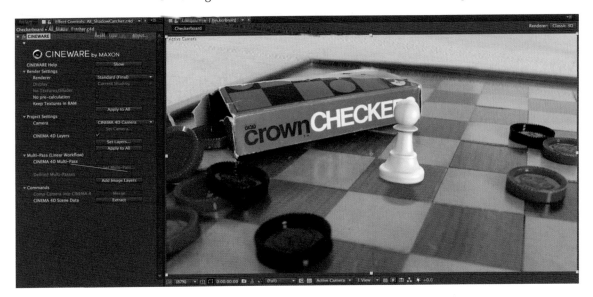

Figure 4.45: *Composite a copy of the Pawn layer on top of the Shadow layer.*

9. The 3D object is a little too crisp and clean for the composite. Select **Effect > Blur & Sharpen > Gaussian Blur** to add a small blur to the edges.

10. Increase the **Blurriness** value a small increment to **0.5** (Figure 4.46).

Figure 4.46: *Add a small blur to the edges of the 3D object.*

Chapter 4: Casting Shadows Using Layers with CINEWARE

11. Let's do the same for the layer that holds the cast shadow. Select the CINEMA 4D layer in the Timeline.

12. Select **Effect > Blur & Sharpen > Gaussian Blur** to add a blur to the edges.

13. Increase the **Blurriness** value to **2.0** (Figure 4.47).

Figure 4.47: *Add a blur to the cast shadow layer in the Timeline.*

Since the CINEMA 4D file becomes a 2D layer in a composition, effects can be applied to it just like any other layer. Experiment with other effects to visually change the pawn's and cast shadow's composite. Experiment using the Hue/Saturation effect to completely change the colors. Use the Curves or Levels effect to adjust each layer's contrast. When you are done, render the project.

14. Make sure the Timeline or Composition panel is highlighted.

15. Select **Composition > Add to Render Queue**. This opens the Render Queue. It is a new tab that sits on top of the Timeline panel.

16. In the Output To dialog box select the **Chapter_04** folder on your hard drive as the final destination for the rendered movie. If this dialog box does not appear, click on **Checkerboard.mov** next to Output To.

17. Click on **Lossless** next to Output Module.

18. Set the format to **QuickTime** movie.

19. Under Format Options, set the compression setting to **H.264** or **MPEG-4 Video**.

20. Set the Audio setting to **Audio Output Off** using the drop-down menu.

21. Click **OK** to close the Output Module Settings dialog box.

22. Click the **Render** button.

23. When the render is done, go to the **Chapter_04** folder on your hard drive. Launch the QuickTime movie (Figure 4.48).

Figure 4.48: *The final rendered QuickTime movie.*

Summary

This chapter explored how to use a layer-based approach in compositing CINEMA 4D files inside of After Effects. You used the 3D camera tracking effect in After Effects to create a Shadow Catcher object. The benefit of using this feature is the ease which you can composite realistic shadows onto video footage. What makes this work is the use of layers in CINEMA 4D. Layers are very powerful and quite useful in compositing 3D models into your After Effects projects. CINEWARE allows you to isolate each layer within a CINEMA 4D file opening up endless possibilities for applying effects.

CHAPTER 5

Lighting Effects

CINEMA 4D Lite's powerful lighting system lets you adjust color, brightness, and falloff. Light objects can also be set to visible or volumetric for dramatic backlighting. This chapter explores these lighting techniques and how they can be incorporated into motion graphics projects.

Seeing the Light

The lighting system in CINEMA 4D is designed to simulate light found in the real world. In the previous chapters, light objects were used simply to make a 3D model visible or to composite with video footage in a realistic manner. Lights can also be used for visual effects, such as a beam of light shining from a lighthouse. Color can be changed to create a particular mood. This chapter expands on previous CINEMA 4D techniques to create dramatic lighting effects for different types of motion graphics projects.

In motion graphics, a common visual effect is to cast visible rays of light emitting from a logo or title credits. Third-party plug-ins for After Effects, such as Trapcode from Red Giant, allow you to produce this effect fairly easily. In CINEMA 4D, light objects can be set to visible or volumetric to create the same effect. Both options create different visual results.

Each light object in CINEMA 4D has four visible parameters: None (default), Visible, Volumetric, and Inverse Volumetric. **Visible light** appears as a cloud of light that is brighter in the center and less intense at the edges. This is due to **falloff**. As the light spreads away from the center, its intensity diminishes. This can be controlled using the Inner and Outer Distance parameters in the Attributes Manager. Visible lights are the most basic and do not follow the rules of real, physical lights in that the visible light passes directly through a solid model rather than being blocked by it (Figure 5.1).

Figure 5.1: *Visible light passes through all objects.*

In reality, visible light contains small particles of dust or water. When lit by the light they create a foggy environment. Think about when you are in a theater watching a movie. Note the visible light coming from the projector. Light objects in CINEMA 4D simulate this effect by simply enabling the visible light

option. **Volumetric lighting** behaves more like real light in that it can be blocked by solid objects. Volumetric lighting can also be reversed where the shadow areas appear to be radiating light from their surface. This is called **inverse volumetric lighting** and can make a logo emit light from itself (Figure 5.2).

Figure 5.2: *Volumetric lights show the visible light and shadows but do not pass through solid objects in a scene (top image). Inverse volumetric lights perform the opposite where the shadow, or blocked light, areas emit light (bottom image).*

Noise can also be added to visible lights to create realistic fog. It produces random dark and bright areas and can be applied to the visible light itself, the illuminated objects in the scene, or both. There are also four types of noise that can produce different visual effects. They are: Noise, Soft, Hard, and Wavy Turbulence (Figure 5.3).

Figure 5.3: *Noise can create some dramatic lighting effects in a scene.*

The goal of the first exercise in this chapter is to become familiar with visible and volumetric lighting in CINEMA 4D. This visual effect looks impressive and is actually very easy to produce. Let's get started.

Adding Volumetric Lighting

Previous chapters covered the basics of lights in CINEMA 4D, but volumetric lights raise the design bar to understanding how lighting can have a dramatic impact on the final rendered scene. In this exercise you are going to learn how to add and modify volumetric lighting to achieve a desired visual effect. All you need are the files to get started.

*Download (www.focalpress.com/9781138777934) the **Chapter_05.zip** file to your hard drive. It contains all the files needed to complete the exercises.*

Locate and play the **FilmNoir.mov** file in the **Completed** folder inside **Chapter_05** (Figure 5.4). The following exercises provide an introduction to creating volumetric lighting. It is broken up into several steps to reinforce modeling and lighting techniques in CINEMA 4D Lite. Let's get started.

Figure 5.4: *The finished project is a fictional TV ident for broadcast.*

Exercise 1: Lighting the Lamp Post

The first light that needs to be added is for the 3D model of the lamp post.

1. Launch **Adobe After Effects** and open the **01_Volumetric.aep** project inside the downloaded **Chapter_05** folder.

 The file contains a composition with a CINEMA 4D layer, another composition with the side panel animation, and an audio track. The CINEWARE renderer is set to **Standard (FINAL)**. The default lighting in CINEMA 4D produces a rather flat rendered scene. Since the film noir film genre is known for its strong use of light and shadow, the first step is to add a new visible light object.

2. Select the **FilmNoir.c4d** layer in the Timeline to highlight it.

3. To open this file in CINEMA 4D Lite select **Edit > Edit Original**.

Let's deconstruct how the model of the lamp post was built. The model is a combination of primitive shapes, splines, and NURB generators. The spline shapes were created in Adobe Illustrator. To export artwork from Illustrator to CINEMA 4D Lite, here is a quick step-by-step guide (Figure 5.5):

- ▸ Turn on the Rulers (**View > Rulers > Show Rulers**). Change the rulers to Global Rulers (**View > Rulers > Change to Global Rulers**).
- ▸ Click and drag the **Ruler Origin** to the bottom or center of your paths.
- ▸ Save your file (or a copy) in **Illustrator 8** format.
- ▸ Open or Merge the saved Illustrator (.ai) file in CINEMA 4D Lite.
- ▸ Add it as a child of a NURB generator to create the final 3D model.

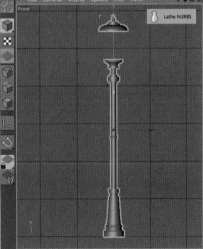

Figure 5.5: *Exporting Abobe Illustrator files for CINEMA 4D.*

The lamp box was created using a cube that was tapered at the bottom. CINEMA 4D Lite provides a small assortment of **Deformer** objects. The **Taper Object** narrows or widens objects at one end. This is done by dragging the orange handle on the deformer's surface (Figure 5.6). Note that the deformer is a child of the primitive cube in the Objects Manager. A deformer affects its parent object. A Boole model was also used to subtract two additional cubes from the main primitive object to create the lamp's windows on all four sides.

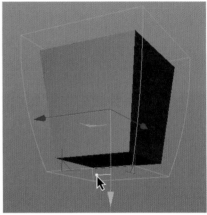

Figure 5.6: *A Taper Object deforms its parent object using its interactive handles.*

4. Click on the **Light** icon to add a light source to your 3D scene. The default light is turned off. In the Objects Manager, rename the light to **Lamp Light**.

5. Go to the Coordinates Manager and raise the light object on the Y-axis to **515 cm**. This will place the light object inside the lamp box (Figure 5.7).

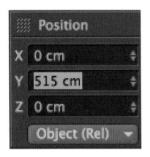

Figure 5.7: *Raise the light object along its Y-axis to position it inside the lamp box.*

6. Make sure the **Lamp Light** object is still selected in the Objects Manager. Go to the Attributes Manager. Change the Visible Light parameter from **None** to **Visible** using the drop-down menu (Figure 5.8).

Figure 5.8: *Turn on the visible light parameter.*

7. In the Attributes Manager, click on the **Details** tab (Figure 5.9).

▸ Set the **Falloff** property to **Inverse Square (Physically Accurate)**. This will simulate realistic falloff of the light over the scene.

▸ Change the **Radius/Decay** of the falloff to **600 cm**.

Figure 5.9: *Adjust the light object's parameters to simulate realistic falloff of light.*

8. Click on the **Render View** icon above the viewport to render the viewport window (Figure 5.10). This is a quick preview of what the final render will look like in CINEWARE. The light object appears as a cloud of light coming from the lamp post. As the light spreads away from the center, its intensity diminishes.

Figure 5.10: *Render a quick preview of the viewport window.*

Figure 5.11: *Visible light creates a visual effect of clouds, smoke, or fog.*

While the lighting effect is impressive, the light looks more like fog rather than an actual light source coming from the lamp post. The visible light passes through all solid shapes (Figure 5.11). In order to mimic a light source emitted from the lamp post, the light object must be changed to a volumetric light.

9. Click on the **General** tab for the light object in the Attributes Manager. Change the Visible Light parameter from **Visible** to **Volumetric** using the drop-down menu. Leave the falloff settings the same as before (Figure 5.12).

● Visible Light Volumetric

Figure 5.12: *Change the visible light's parameters in the Attributes Manager.*

10. Click on the **Render View** icon. Volumetric lighting does not penetrate solid objects and creates shadows within the visible light beam (Figure 5.13).

Figure 5.13: *Volumetric lighting creates a different visual effect.*

11. Click on the **Noise** tab in the Attributes Manager. Adding noise will create irregularities in brightness within the visible light beam. This gives it a more realistic appearance. Make the following changes (Figure 5.14):

 ▸ Set the **Noise** parameter to **Visibility**. This will add noise to the light source, not the illuminated surfaces of the 3D objects.

 ▸ Change the **Type** to **Hard Turbulence**.

Figure 5.14: *Add noise to the light object for a more realistic appearance.*

12. Click on the **Render View** icon to see a quick preview in the viewport (Figure 5.15). Experiment with the Noise parameters. The **Octaves** value determines the graininess of the noise. The higher the value, the more grain. The noise automatically animates to simulate dust particles flying around in the light source. To control the speed of the irregularities, change the **Velocity** value.

Figure 5.15: *Adjust the Noise parameters to change the visible light's appearance.*

Exercise 2: Illuminate the Text

With the lamp post lit, the extruded text falls too much into the shadow areas. This next exercise focuses on lighting the text to make it more readable and to pull out specular highlights on its beveled edges. All you need is more lights.

1. Click on the **Light** icon to add another light source to your 3D scene. In the Objects Manager, rename the light to **Type Main Light**.

2. With the Light object selected in the Objects Manager, go to the Attributes Manager and click on the **Coord.** tab.
 - Set the **X-Position** to **300 cm**.
 - Set the **Y-Position** to **400 cm**.
 - Set the **Z-Position** to **-1000 cm**.

3. Click on the **General** tab and decrease the **Intensity** value to **80%**. Turn on the light's shadows by selecting **Shadows Maps (Soft)** from the **Shadow** drop-down menu.

4. In the Attributes Manager, click on the **Details** tab (Figure 5.16).
 - Set the **Falloff** property to **Inverse Square (Physically Accurate)**. This will simulate realistic falloff of the light over the scene.
 - Leave the **Radius/Decay** of the falloff at **500 cm**.

5. Click on the **Render View** icon to preview the light in the viewport (Figure 5.16). This new light illuminates the extruded text evenly in the front. Next you will add two more lights to pull out the specular highlights in the text's material.

Figure 5.16: *Add a main light for the extruded text.*

6. Click on the **Light** icon again to add another light source to your 3D scene. In the Objects Manager, rename the light to **Type Side Light**.

7. With the Light object selected in the Objects Manager, go to the Attributes Manager and click on the **Coord.** tab.
 ▸ Set the **X-Position** to **130 cm**.
 ▸ Set the **Y-Position** to **400 cm**.
 ▸ Set the **Z-Position** to **25 cm**.

8. Click on the **General** tab and decrease the **Intensity** value to **70%**. Turn on the light's shadows by selecting **Shadows Maps (Soft)** from the **Shadow** drop-down menu.

9. In the Attributes Manager, click on the **Details** tab at set the falloff.
 ▸ Set the **Falloff** property to **Inverse Square (Physically Accurate)**.
 ▸ Leave the **Radius/Decay** of the falloff at **500 cm**.

10. Click on the **Project** tab. CINEMA 4D allows you to choose which objects will be affected by this light object. To illuminate only the text:
 ▸ Change the **Mode** to **Include**.
 ▸ Drag and drop the **FILM NOIR** extruded NURBS from the Objects Manager into the **Objects** box (Figure 5.17).

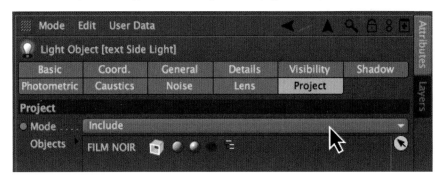

Figure 5.17: *Set the light object to only affect the extruded text in the scene.*

11. Click on the **Light** icon to add another light source to your 3D scene. In the Objects Manager, rename the light to **Type Top Light**.

12. With the Light object selected in the Objects Manager, go to the Attributes Manager and click on the **Coord.** tab.
 ▸ Set the **X-Position** to **0 cm**.
 ▸ Set the **Y-Position** to **600 cm**.
 ▸ Set the **Z-Position** to **-500 cm**.

13. Click on the **General** tab and decrease the **Intensity** value to **70%**. Turn on the light's shadows by selecting **Shadows Maps (Soft)** .

14. Click on the **Details** tab and set the **Falloff** property to **Inverse Square (Physically Accurate)**.

15. Click on the **Project** tab. To illuminate only the text:

- ▸ Change the **Mode** to **Include**.
- ▸ Drag and drop the **FILM NOIR** extruded NURBS from the Objects Manager into the **Objects** box.

16. Click on the **Render View** icon to preview the light in the viewport (Figure 5.18).

Figure 5.18: *Preview the lighting for the extruded text.*

17. The brick wall needs to recede into the shadows more to add more contrast to the extruded text. Select the **Lamp Light** object in the Objects Manager.

18. Go to the Attributes Manager and click on the **Details** tab. Decrease the **Radius/Decay** of the falloff to **300 cm**.

19. Click on the **Render View** icon to preview the light in the viewport (Figure 5.19).

Figure 5.19: *Final lighting for the extruded text.*

Chapter 5: Lighting Effects

Exercise 3: Setting Keyframes

Let's bring some life to the scene with animation. CINEMA 4D Lite provides animation capabilities through the use of keyframes. Similar to After Effects, CINEMA 4D does all the hard work for you. It will figure out the difference between two keyframes using interpolation. In this exercise you will animate the text, the intensity for the light objects, and finally the placed camera.

Currently, the extruded text is positioned correctly for the last keyframe of the animation. It may seem odd, but you are going to work backwards to create the final animation of the text moving into the scene. Let's go to the Timeline.

1. The Animation Palette is located under the viewport. It contains a Current Time Indicator similar to After Effects. Click and drag the green square to **frame 80** in the Timeline Ruler (Figure 5.20).

Figure 5.20: *Move the Current Time Indicator (green square) to frame 80.*

2. Select the **FILM NOIR** (Extrude NURBS) in the Objects Manager (Figure 5.21). It is always important to make sure that you have the correct object selected before recording any keyframes.

3. Click on the **Record Active Objects** icon to record keyframes for the extruded object's position on frame 80 in the Timeline Ruler (Figure 5.22).

Figure 5.21: *Select the extruded text.*

Figure 5.22: *Record keyframes for the extruded object on frame 80.*

4. Click and drag the Current Time Indicator (green square) back to **frame 0** in the Timeline Ruler. Note the blue square that appears at frame 80. This is the keyframe you recorded in the previous step (Figure 5.23).

An alternative way to dragging the Current Time Indicator to frame 0 would be to use the Timeline Controls which act similar to the Preview controls in After Effects (Figure 5.24). Click on the **Go To Start** button.

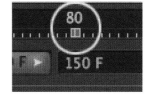

Figure 5.23: *Keyframes are displayed as blue squares in the Timeline Ruler.*

Go To Start Previous Frame Next Frame Go To End

Figure 5.24: *Timeline controls are similar to the Preview controls in After Effects.*

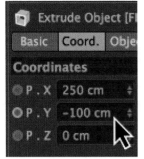

Figure 5.25: *Change the extruded object's coordinates to lower the text in the scene.*

5. Make sure the **FILM NOIR** (Extrude NURBS) is selected in the Objects Manager. Go to the Attributes Manager and click on the **Coord. tab**:

 ▸ Set the **Y-Position** to **-100 cm**. This lowers the text vertically in the scene.

 ▸ Note the **red circle** to the left of the **Y-Position** changes from a red stroke to an orange stroke. This is a visual indicator that keyframed properties have been changed since the initial recording (Figure 5.25).

6. Click on the **Record Active Objects** icon to record keyframes for the extruded object's position on frame 0 in the Timeline Ruler. Note that the red circles in the Attributes Manager fill in solid red indicating that keyframes were recorded for the properties.

If you see a round circle 🔘 *to the right of any property in the Attributes Manager, that means a keyframe can be set for the property. The keyboard shortcut to record a keyframe is to hold down the Control key and click on the circle. The circle will fill solid red* 🔴 *indicating a recorded keyframe. This is similar to the stopwatch icon used to record keyframes for properties in After Effects.*

7. Click the **Play Forwards** button to see the animated text travel up into the scene (Figure 5.26).

Go To Previous Key **Play Forwards** **Go To Next Key**

Figure 5.26: *Click on the Play Forwards button to preview the animation.*

Note the motion path that is created between the two keyframes (Figure 5.27). This is similar to the motion path used for spatial interpolation in After Effects.

Figure 5.27: *CINEMA 4D displays a motion path similar to After Effects.*

8. Go to the Timeline Ruler and click and drag the Current Time Indicator (green square) back to **frame 80** in the Timeline Ruler.

9. Select the **Text Main Light** (Light Object) in the Objects Manager (Figure 5.28).

Figure 5.28: *Select a text light object in the Objects Manager.*

10. Go to the Attributes Manager and click on the **General** tab. Hold down the Control key and click on the round circle in front of the **Intensity** parameter. The circle will fill solid red indicating that a keyframe was recorded (Figure 5.29).

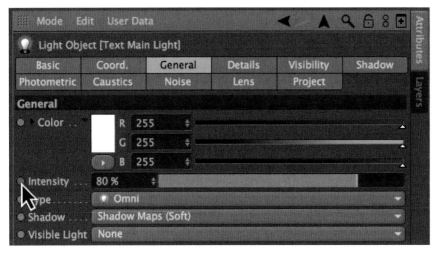

Figure 5.29: *Record a keyframe for the light object's intensity on frame 80.*

11. Click and drag the Current Time Indicator (green square) back to **frame 0** in the Timeline Ruler.

12. Go to the Attributes Manager. Decrease the light's **Intensity** value to **0%**.

13. Hold down the Control key and click on the orange round circle in front of the **Intensity** parameter. The circle will fill solid red indicating that a keyframe was recorded at frame 0 (Figure 5.30).

Figure 5.30: *Record a keyframe for the light object's intensity on frame 0.*

14. Repeat the previous steps to animate the intensity value for the **Text Side Light** and the **Text Top Light** objects.

 Select each light object in the Objects Manager. Use the Attributes Manager to set keyframes to raise the light's intensity from 0% on frame 0 to 70% on frame 80. Hold down the Control and click on the round circle to record keyframes for the **Intensity** property for each light.

15. Click the **Play Forwards** button to preview the animation. The last object to animate is the camera.

Adding Volumetric Lighting

Since you cannot animate the default camera in the viewport, a **Camera** object has been added to the Objects Manager.

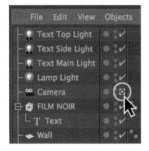

16. To view what the camera object is looking at in the viewport, go to the Objects Manager. Click on the **target** to the right of the **Camera name**. The target will turn white. The viewport will animate to display what the camera is looking at. This is the final position for the camera (Figure 5.31).

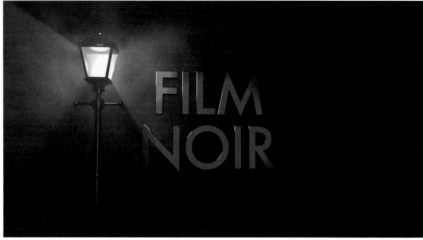

Figure 5.31: *Change the viewport default camera to the placed camera object's view.*

17. Go to the Timeline Ruler. Click and drag the Current Time Indicator (green square) to **frame 80** in the Timeline Ruler (Figure 5.32).

Figure 5.32: *Move the Current Time Indicator (green square) to frame 80.*

18. Make sure the **Camera** is selected in the Objects Manager. Click on the **Record Active Objects** icon to record keyframes for the camera's position on frame 80 in the Timeline Ruler (Figure 5.33).

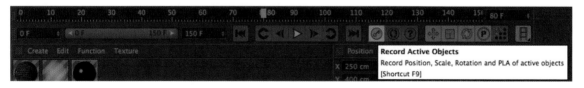

Figure 5.33: *Record keyframes for the extruded object on frame 80.*

19. Click and drag the Current Time Indicator (green square) back to **frame 0** in the Timeline Ruler. For the first frame of the animation, we want the camera to be zoomed in on the lamp post.

20. Go to the viewport. Use the navigation icons ⊹ ↕ ⊘ to change the placed camera's view (Figure 5.34). Frame the lamp box in the center of the viewport and zoom in close to it for the opening scene.

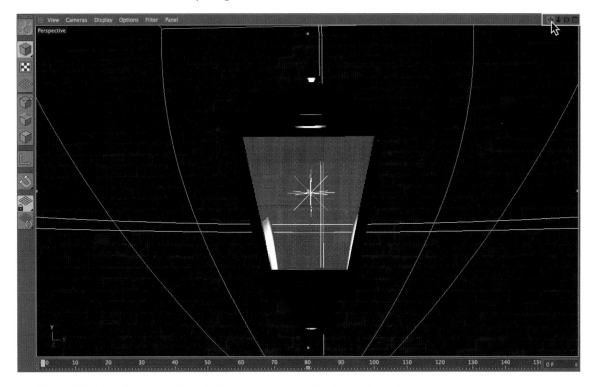

Figure 5.34: *Use the viewport's navigation icons to change the view on frame 0.*

21. Click on the **Record Active Objects** icon to record keyframes for the camera's position on frame 0 in the Timeline Ruler.

22. Save your CINEMA 4D file. Select **File > Save**. Jump back to After Effects. The CINEWARE effect automatically updates the Composition panel to reflect the saved changes made in CINEMA 4D.

23. Click on the **RAM Preview** to see the final 3D animation (Figure 5.35).

Figure 5.35: *Preview the 3D animation in After Effects using the CINEWARE plug-in.*

The After Effects project is a TV ident, which is a small motion graphics video that plays a few seconds before a television program starts, informing the viewer of which channel they're watching. For this promotional sequence the upcoming movie schedule is animated on the right. Feel free to experiment with the side panel composition to change the final animation. When you are done, render the final composition using CINEWARE and After Effects.

24. Select **Composition > Add to Render Queue**. This opens the Render Queue. It is a new tab that sits on top of the Timeline panel.

25. In the Output To dialog box select the **Chapter_05** folder on your hard drive as the final destination for the rendered movie. If this dialog box does not appear, click on **FilmNoir.mov** next to Output To.

26. Click on **Lossless** next to Output Module.

27. Set the format to **QuickTime** movie. Under Format Options, set the compression setting to **H.264** or **MPEG-4 Video**.

28. Set the Audio sampling at **44.100 kHz** using the drop-down menu.

29. Click **OK** to close the Output Module Settings dialog box.

30. Click the **Render** button.

31. When the render is done, go to the **Chapter_05** folder on your hard drive. Launch the QuickTime movie (Figure 5.36).

Figure 5.36: *The final rendered QuickTime movie.*

This completes the exercise. As you can see, manipulating lighting can have a dramatic impact on a scene. Areas of light and dark help define the overall composition and guide the viewers attention to objects of importance in the 3D scene. The next exercise adds color to the mix.

Mixing Color with Lights

The previous exercise demonstrated how visible lights can affect the overall composition. Adding color can also affect the mood within the 3D environment. CINEMA 4D Lite allows you to cast colored light on your 3D scene, similar to adding gels in a photography studio. Gels are a special type of colored plastic placed over a light source. They tint the light to a different color.

Physical lights, by themselves, offer a wide variety of shades of white light, ranging from a yellowish to a bluish white light. Light color is measured on a temperature scale referred to as Kelvin (K). Lower Kelvin numbers mean the light appears more yellow; higher Kelvin numbers mean the light is whiter or bluer. Color gels are used to create lighting accents and unnatural, artistic effects on stage or in film.

Locate and play the **DawnOfMan.mov** file in the **Completed** folder inside **Chapter_05** (Figure 5.37). The following exercises demonstrate how to mix color and light to customize the mood of a 3D scene. Let's get started.

Figure 5.37: *The finished project is a motion graphics opening title.*

Exercise 4: Creating the 3D Environment

The first part of this exercise builds the 3D environment of a cave wall.

1. Create a new project in **Adobe After Effects**. Save the project as **02_Color.aep** inside the downloaded **Chapter_05** folder.

2. Select **File > New > MAXON CINEMA 4D File.**

3. Save the project as **DawnOfMan.c4d** inside the **Footage** folder in the **Chapter_05** folder (Figure 5.38).

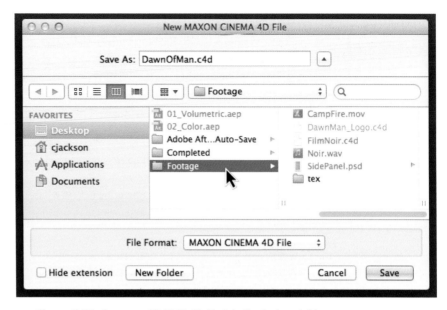

Figure 5.38: *Save your CINEMA 4D file into the footage folder.*

4. After saving the file, CINEMA 4D Lite automatically launches and opens the new file. Locate the three clapboard icons in the top center of the user interface. Click on the icon to the right that has the sprocket. This will open the Render Settings dialog box.

5. Click on the arrow icon under **Output**. From the preset pop-up menu, select **Film/Video> HDV/HDTV 720 29.97** (Figure 5.39). The resolution is changed and the frame rate is reset to 29.97 frames-per-second. When you are done, close the Render Settings dialog box.

Figure 5.39: *Reset the output to a higher resolution for the After Effects project.*

6. Go to the Timeline Ruler under the viewport window editor. The default duration for an animation in CINEMA 4D Lite is 90 frames. Type in **150** in the text entry dialog box. To see all frames in the Timeline Ruler, click on the right arrow icon next to **150 F** and drag to the right (Figure 5.40).

Figure 5.40: *Change the duration of the Timeline Ruler to 150 frames.*

7. Locate the cube icon above the viewport window. Click and hold the icon to reveal the pop-up palette of primitive shapes. While this palette is open, left-click on the **Landscape** icon to add the shape to the scene (Figure 5.41).

Figure 5.41: *Add a landscape object to the 3D scene.*

A landscape appears in the viewport on the XZ-plane. It is generated using fractals. Properties in the Attributes Manager can modify its appearance from a rough mountain range to gentle slopes and valleys. For this project, the Landscape object will be used to create the cave wall.

8. Make sure the **Landscape** object is selected in the Objects Manager.

9. Go to the Attributes Manager and make the following changes:

 ▸ Increase the **Size** to **6000 cm**, **100 cm**, and **4000 cm**.
 ▸ Set the **Width Segments** value to **300**.
 ▸ Set the **Depth Segments** value to **300**.
 ▸ Set the **Rough Furrows** value to **20%**.
 ▸ Set the **Fine Furrows** value to **100%**.
 ▸ Increase the **Scale** value to **5**.
 ▸ Change the **Orientation** to **-Z**. This rotates the object vertically, making it a wall instead of a floor.

Figure 5.42: *Reposition the Landscape object along the Z-axis using the Coordinates Manager.*

10. While the Landscape is still selected, go to the Coordinates Manager. Set the **Z** Position value to **400 cm** (Figure 5.42). Click **Apply**.

11. Go to the viewport. Use the navigation icons ⊕ ⬇ ⊘ to change the default camera view to frame your scene better (Figure 5.43).

Figure 5.43: *Reposition the default camera to frame the Landscape object.*

Keyboard Shortcuts

1 to **Pan** the Camera

2 to **Dolly** the Camera

3 to **Orbit** the Camera

Cmd + Shift + Z to undo a camera move

12. Go to the Materials Manager. Select **Create > New Material**. A preview of the new material appears in the manager's panel.

13. Double-click on the **Mat** icon to open the Material Editor dialog box. While the **Color** channel is selected, make the following changes:

 ▶ Click on the **Texture** arrow and select **Load Image** from the pop-up menu.

 ▶ Locate the **CaveArt.jpg** file in the **tex** folder in **Chapter_05**.

 ▶ Click **Open**.

14. Click on the checkbox for the **Bump** channel. To give the cave wall a more tactile look, you will import a grayscale bitmap (Figure 5.44).

 ▶ Click on the **Texture** arrow and select **Load Image** from the pop-up menu.

 ▶ Open the **CaveBumpMap.jpg** file in the **tex** folder in **Chapter_05**.

 ▶ Uncheck the checkbox for the **Specular** channel.

 ▶ Rename the texture to **Cave** and press **Return**.

Figure 5.44: *Create a new material or the cave wall.*

15. Click and drag the **Cave** material from the Materials Manager and drop it onto the **Landscape name** in the Objects Manager. A Texture Tag appears to the right of the object in the Objects Manager (Figure 5.45).

Figure 5.45: *Apply the material to the Landscape object in the Objects Manager.*

16. Click on the **Render View** icon to preview the light in the viewport (Figure 5.46).

Figure 5.46: *Preview the cave wall by rendering the viewport window.*

Exercise 5: Coloring the Light

In CINEMA 4D, the default color for a light is white. In the previous exercises you changed the intensity and shadows for light objects. In this exercise, you will adjust the colors of placed lights in order to create a more dramatic image.

1. Click on the **Light** icon to add a light source to your 3D scene. In the Objects Manager, rename the light to **Orange Light**. This will be positioned on the upper left side of the cave wall.

2. Go to the Attributes Manager and click on the **Coord.** tab to reposition the object in the viewport. You can also use the Move tool to position the light.

3. Change the location of the light object:
 ▸ Set the **X-Position** to **-1000 cm**.
 ▸ Set the **Y-Position** to **1000 cm**.
 ▸ Set the **Z-Position** to **-500 cm**.

4. Click on the **General** tab and decrease the **Intensity** value to **80%**. Turn on the light's shadows by selecting **Shadows Maps (Soft)** from the **Shadow** drop-down menu.

5. Change the **RGB Color** values to R = **255**, G = **190**, B = **150**.

6. In the Attributes Manager, click on the **Details** tab.
 ▸ Set the **Falloff** property to **Inverse Square (Physically Accurate)**. This will simulate realistic falloff of the light over the scene.
 ▸ Increase the **Radius/Decay** of the falloff to **1000 cm**.

7. Click on the **Render View** icon to preview the light (Figure 5.47). This new light illuminates the upper left corner of the cave wall.

Figure 5.47: *Preview the lighting by rendering the viewport window.*

8. Click on the **Light** icon again to add another light source to your 3D scene. In the Objects Manager, rename the light to **Red Light**.

9. Go to the Attributes Manager and click on the **Coord.** tab:
 ▸ Set the **X-Position** to **-2000 cm**.
 ▸ Set the **Y-Position** to **-500 cm**.
 ▸ Set the **Z-Position** to **-1000 cm**.

10. Click on the **General** tab and decrease the **Intensity** value to **50%**. Turn on the light's shadows by selecting **Shadows Maps (Soft)** from the **Shadow** drop-down menu.

11. Change the **RGB Color** values to R = 220, G = 20, B = 20.

12. In the Attributes Manager, click on the **Details** tab.

- ▸ Set the **Falloff** property to **Inverse Square (Physically Accurate)**.
- ▸ Increase the **Radius/Decay** of the falloff to **2000 cm**.

13. Click on the **Render View** icon to preview the light (Figure 5.48). Note that the wireframe sphere around the light object matches the color of the light. This represents the falloff for the light in the scene. The orange handles allow you to interactively adjust the falloff radius in the viewport.

Figure 5.48: *Preview the lighting by rendering the viewport window.*

14. Click on the **Light** icon again to add another light source to your 3D scene. In the Objects Manager, rename the light to **Blue Light**. This light will simulate the moonlight coming in from the cave opening on the right.

15. Go to the Attributes Manager and click on the **Coord.** tab:

- ▸ Set the **X-Position** to **2000 cm**.
- ▸ Set the **Y-Position** to **500 cm**.
- ▸ Set the **Z-Position** to **-1000 cm**.

16. Click on the **General** tab and decrease the **Intensity** value to **50%**. Select **Shadows Maps (Soft)** from the **Shadow** drop-down menu.

17. Change the **RGB Color** values to R = **50**, G = **150**, B = **250**.

18. In the Attributes Manager, click on the **Details** tab.

- ▸ Set the **Falloff** property to **Inverse Square (Physically Accurate)**.
- ▸ Increase the **Radius/Decay** of the falloff to **2000 cm**.

19. Click on the **Render View** icon to preview the lighting (Figure 5.49). The last light to add will simulate the light coming from the campfire.

Figure 5.49: *Preview the lighting by rendering the viewport window.*

20. Click on the **Light** icon again to add the final light source to your 3D scene. In the Objects Manager, rename the light to **Fire**.

21. Go to the Attributes Manager and click on the **Coord.** tab:

- ▸ Set the **X-Position** to **-2000 cm**.
- ▸ Set the **Y-Position** to **-1000 cm**.
- ▸ Set the **Z-Position** to **-2000 cm**.

22. Click on the **General** tab and decrease the **Intensity** value to **80%**. Select **Shadows Maps (Soft)** from the **Shadow** drop-down menu.

23. Change the **RGB Color** values to R = **255**, G = **130**, B = **0**.

24. In the Attributes Manager, click on the **Details** tab.

- ▸ Set the **Falloff** property to **Inverse Square (Physically Accurate)**.
- ▸ Increase the **Radius/Decay** of the falloff to **2000 cm**.

25. In the Attributes Manager, click on the **Shadow** tab (Figure 5.50).

▸ Set the **Density** property to **80%**.

▸ Change the **RGB Color** values to R = **90**, G = **10**, B = **10**.

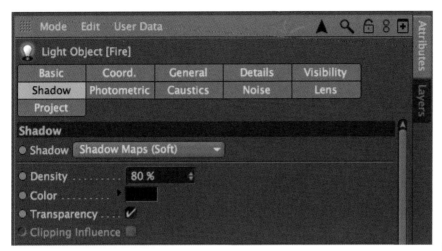

Figure 5.50: *Change the shadow properties for the light in the Attributes Manager.*

26. Let's animate the light object to give the illusion of light flickering from the campfire on the cave wall. Go to the Objects Manager. While the **Fire** light object is highlighted, select **Tags > CINEMA 4D Tags > Vibrate** (Figure 5.51).

The **Vibrate Expression** randomly animates an object's size, position, and rotation over time. The Vibrate tag can be applied to cameras as well to simulate turbulence or a bumpy ride. For this project, we only need to animate the light object's Z-position to create the flickering effect.

27. Go to the Objects Manager and click on the **Vibrate** tag. Go to the Attributes Manager and click on the checkbox for **Enable Position** (Figure 5.52).

▸ Set the **Amplitude** to **0 cm**, **0 cm**, and **500 cm**.

▸ Increase the **Frequency** to **4**.

Figure 5.51: *Add a Vibrate tag to the Light object in the Objects Manager.*

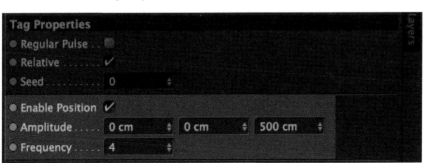

Figure 5.52: *Change the Vibrate tag's properties in the Attributes Manager.*

28. Click the **Play Forwards** button to see the light object randomly move along its Z-axis creating the flickering effect on the cave wall (Figure 5.53).

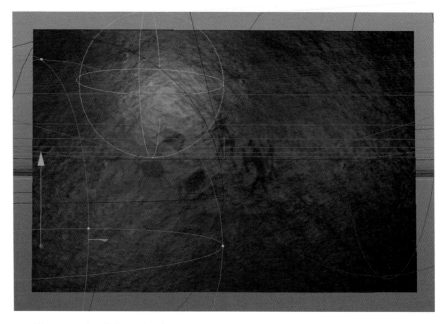

Figure 5.53: *Click on the Play Forwards button to preview the light object animation.*

Exercise 6: Add the Logotype

Now that the lighting is done, the last stage is to add an extruded logo, light it with its own lights, and frame the final composition.

1. Let's add the 3D logotype to the scene. This model has already been created in a separate CINEMA 4D file.

- ▶ In the Objects Manager, select **File > Merge Objects**.
- ▶ Locate and select the **DawnMan_Logo.c4d** file inside the **Footage** folder in **Chapter_05**.
- ▶ Click **Open** (Figure 5.54).

Figure 5.54: *Merge the 3D logotype into the CINEMA 4D file.*

The object is added to the Objects Manager and appears at the origin point in the viewport. The logo is an extruded object. Its material is added to the Materials Manager.

2. The scale of the 3D logotype is a little small for the scene. Go to the Attributes Manager and click on the **Coord.** tab (Figure 5.55).

 ‣ Increase the scale of the object to **6** for X, Y, and Z.
 ‣ Set the **X-Position** to **-175 cm**.
 ‣ Set the **Y-Position** to **-500 cm**.
 ‣ Set the **Z-Position** to **-600 cm**.
 ‣ Set the Heading Rotation (**R.H**) to **-60** degrees.

Figure 5.55: *Increase the scale of the 3D object in the Attributes Manager.*

3. Go to the viewport. Use the navigation icons to change the default camera view to frame your scene better. Zoom in on the logotype and rotate the camera to create an interesting composition (Figure 5.56).

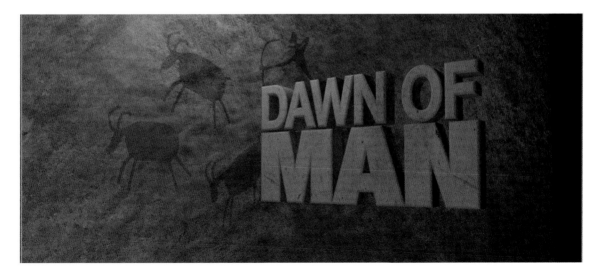

Figure 5.56: *Reposition the default camera to frame the scene better.*

Mixing Color with Lights

The extruded logo does not have enough contrast in the scene to stand out. Let's add some more lights to make it more readable and to pull out highlights on its extruded surfaces.

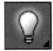

4. Click on the **Light** icon to add another light source to your 3D scene. In the Objects Manager, rename the light to **Text Main Light**.

5. With the Light object selected in the Objects Manager, go to the Attributes Manager and click on the **Coord.** tab.

 ▶ Set the **X-Position** to **-500 cm**.
 ▶ Set the **Y-Position** to **-500 cm**.
 ▶ Set the **Z-Position** to **-1000 cm**.

6. Click on the **General** tab and decrease the **Intensity** value to **70%**. Turn on the light's shadows by selecting **Shadows Maps (Soft)** from the **Shadow** drop-down menu.

7. Change the **RGB Color** values to R = **255**, G = **123**, B = **52**.

8. In the Attributes Manager, click on the **Details** tab.

 ▶ Set the **Falloff** property to **Inverse Square (Physically Accurate)**. This will simulate realistic falloff of the light over the scene.
 ▶ Increase the **Radius/Decay** of the falloff to **1000 cm**.

9. Click on the **Project** tab. To illuminate only the text:

 ▶ Change the **Mode** to **Include**.
 ▶ Drag and drop the **Extruded NURBS** from the Objects Manager into the **Objects** box (Figure 5.57).

Figure 5.57: *Set the light object to only affect the extruded logotype in the scene.*

10. Click on the **Render View** icon to preview the light (Figure 5.58). This new light illuminates the extruded logo evenly in the front and provides the contrast it needs to stand out against the background. One final rim light is needed to pull out the highlights on the extruded caps and define the edges.

Figure 5.58: *Preview the lighting for the extruded logotype.*

11. Click on the **Light** icon to add another light source to your 3D scene. In the Objects Manager, rename the light to **Text Rim Light**.

12. With the Light object selected in the Objects Manager, go to the Attributes Manager and click on the **Coord.** tab.

 ▶ Set the **X-Position** to **1000 cm**.

 ▶ Set the **Y-Position** to **1000 cm**.

 ▶ Set the **Z-Position** to **-1500 cm**.

13. Click on the **General** tab and decrease the **Intensity** value to **90%**. Turn on the light's shadows by selecting **Shadows Maps (Soft)** from the **Shadow** drop-down menu.

14. Change the **RGB Color** values to R = **154**, G = **203**, B = **255**.

15. In the Attributes Manager, click on the **Details** tab.

 ▶ Set the **Falloff** property to **Inverse Square (Physically Accurate)**.

 ▶ Increase the **Radius/Decay** of the falloff to **1000 cm**.

16. Click on the **Project** tab. To illuminate only the text:

 ▶ Change the **Mode** to **Include**.

 ▶ Drag and drop the **Extruded NURBS** from the Objects Manager into the **Objects** box.

17. Click on the **Render View** icon to preview the light (Figure 5.59). This new rim light illuminates the back edges of the extruded logotype. Backlighting helps to provide separation between the 3D object and the cave background. It also enhances the three-dimensional appearance of the extruded NURB, when the front lighting alone gives it a more two-dimensional look.

Figure 5.59: *Preview the final lighting for the extruded logotype.*

18. The project is now complete. Before you jump back to After Effects, let's set up the render settings that CINEWARE will use. Locate the three clapboard icons in the top center of the user interface. Click on the icon to the right that has the sprocket (Figure 5.60).

Figure 5.60: *Open the Render Settings in CINEMA 4D Lite.*

19. Click on **Anti-Aliasing** to modify its render settings on the right side of the dialog box. Change the **Filter** setting from **Cubic (Still Image)** to **Gauss (Animation)** (Figure 5.61) to reduce possible edge aliasing in the animation.

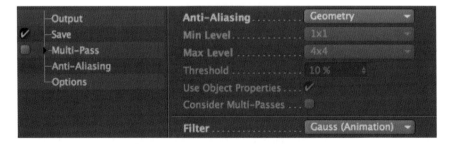

Figure 5.61: *Change the Anti-Aliasing render settings for CINEWARE.*

20. When you are done, close the Render Settings dialog box.

21. Save your CINEMA 4D Lite file. Select **File > Save**.

22. Jump back to After Effects to finish the project and render it.

Combining 2D and 3D Effects

As you learned in Chapter 1, a 3D scene built in CINEMA 4D Lite becomes a flat 2D layer inside an After Effects project. Since the CINEMA 4D file is a layer in a composition, you can composite it with other 2D layers. In this exercise you will add the finishing touches to your 3D scene in After Effects.

Exercise 7: Compositing 2D Layers

1. In After Effects, click and drag the **DawnOfMan.c4d** footage file to the **Create a new Composition** icon at the bottom of the Project panel (Figure 5.62).

Figure 5.62: *Create a new composition using the CINEMA 4D footage file.*

A new composition is created displaying your 3D scene using the CINEWARE effect. The CINEMA 4D file is displayed with the wireframes visible (Figure 5.63).

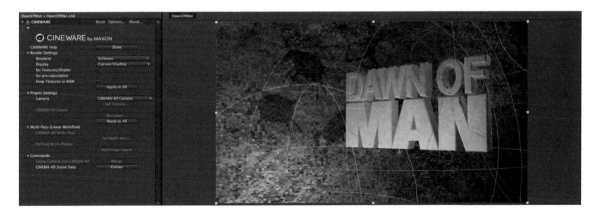

Figure 5.63: *The default renderer in CINEWARE is called Software.*

2. Double-click in the Project panel to open the Import File dialog box.

3. Locate the **CampFire.mov** QuickTime movie in the **Footage** folder inside **Chapter_05**. Click **Open** to import the footage into the Project panel.

4. Click and drag the **CampFire.mov** file from the Project Panel to the Timeline. Position it at the top of the layers in the Timeline. The QuickTime movie was saved with an alpha channel to make compositing easier.

5. Type **S** on the keyboard to show only the layer's Scale property. Scrub through the numeric value and set it to **166%** (Figure 5.64).

Figure 5.64: *Scale the QuickTime movie in the Timeline.*

6. Go to the Composition panel. Click and drag the layer off the left edge of the composition. Leave only a small portion of the camp fire visible (Figure 5.65).

Figure 5.65: *Reposition the QuickTime movie in the Composition panel.*

7. Let's blur the QuickTime movie to simulate depth of field and to hide any pixelization. Select **Effect > Blur & Sharpen > Gaussian Blur** to add a blur.

8. Increase the **Blurriness** value a small increment to **4** (Figure 5.66).

Figure 5.66: *Add a small blur to the QuickTime movie.*

9. Double-click in the Project panel to open the Import File dialog box.

10. Locate the **amber.psd** file inside the **tex** folder in the **Footage** folder.

11. Choose **Import As > Composition - Retain Layer Sizes**. Click **Open** to import the footage into the Project panel.

12. Click and drag the **amber** composition from the Project Panel to the Timeline. Position it at the bottom of the layers in the Timeline (Figure 5.67). This layer will be used as a texture for the Foam effect you will add next.

Figure 5.67: *Add the imported composition to the Timeline.*

Exercise 8: Compositing Visual Effects

As you know, effects are used to enhance a project in After Effects. In this exercise you will apply Foam, a particle generator. This effect will add animating ambers coming from the camp fire.

1. Make sure the Timeline panel is highlighted. Select **Layer** > **New** > **Solid**. The Solid Settings dialog box appears. A **solid** layer is just that, an area of color.

 ▸ Enter **Fire Ambers** for the solid name (Figure 5.68).

 ▸ Click on the **Make Comp Size** button.

 ▸ Click **OK**. The color of the solid layer doesn't matter.

 All solid layers are stored in a Solids folder in the Project panel. This folder is automatically generated when you create your first solid layer. Any new layers you create will also be stored in the Solids folder.

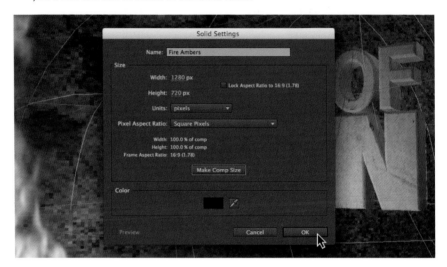

Figure 5.68: *Solid Settings dialog box.*

2. Reposition the solid layer underneath the **CampFire.mov** layer in the Timeline. Go to the Effects & Presets panel. Enter **Foam** into the Contains field. The item in the effects list that matches is displayed.

3. To apply the Foam effect to the solid layer, click and drag the effect to either the layer in the Comp panel or the Timeline panel. A red box with an X highlights the layer that will receive the effect. Release the mouse.

4. The effect is applied automatically. Notice that the solid color disappears and is replaced with a red circle in the center of the Comp panel. Let's experiment with the Foam properties.

5. Click on the twirler to the left of **Producer**. This controls where the bubbles originate from. Make the following change:

 ▸ Producer Point: **60, 685**. This lowers the vertical position of the producer point to the bottom of the camp fire in the Composition panel.

 ▸ Decrease the **Production Rate** value to **0.500**.

6. Click on the twirler to the left of **Bubbles**. This controls the size and lifespan of the bubbles.

7. Make the following change to the Bubbles:
 - Decrease the **Size** value to **0.400**.
 - Decrease the **Size Variance** value to **0.400**.

8. Click on the twirler to the left of **Physics**. This controls how fast the bubbles move and how close they stick together. Make the following changes:
 - Initial Direction: **0x + 40 degrees**
 - Wind Speed: **4.000**
 - Wind Direction: **0x + 50 degrees**
 - Turbulence: **0.980**
 - Wobble Amount: **0.007**
 - Pop Velocity: **5.000**
 - Viscosity: **0.600**
 - Stickiness: **0.750**

9. Click on the twirler to the left of **Rendering**. This controls the visual look of the bubbles. Make the following change:
 - Bubble Texture: Change from **Default Bubble** to **User Defined**.
 - Bubble Layer Texture: **amber**.
 - Bubble Orientation: **Physical Orientation**.

10. To see the finished results, select **Rendered** from the View pop-up menu at the top of the Effect Controls panel.

11. Click on the **RAM Preview** button to see the final Foam effect (Figure 5.69).

Figure 5.69: *Create a RAM preview to see the Foam effect.*

12. Click on the CINEMA 4D layer in the Timeline. Change the CINEWARE **Renderer** to **Standard (Final)** in the Effect Controls panel.

13. Select **Composition > Add to Render Queue**. This opens the Render Queue. It is a new tab that sits on top of the Timeline panel.

14. In the Output To dialog box select the **Chapter_05** folder on your hard drive as the final destination for the rendered movie. If this dialog box does not appear, click on **DawnOfMan.mov** next to Output To.

15. Click on **Lossless** next to Output Module.

16. Set the format to **QuickTime** movie. Under Format Options, set the compression setting to **H.264** or **MPEG-4 Video**.

17. Click **OK** to close the Output Module Settings dialog box.

18. Click the **Render** button.

19. When the render is done, go to the **Chapter_05** folder on your hard drive. Launch the QuickTime movie (Figure 5.70).

Figure 5.70: *The final rendered QuickTime movie.*

Summary

This chapter explored how lights can be used for visual effects, such as beams of light shining from a lamp post. Light objects in CINEMA 4D can simulate this effect by simply enabling the visible light option. Visible lights are the most basic and do not follow the rules of real, physical lights in that the visible light passes directly through a solid model rather than being blocked by it. Volumetric lighting behaves more like real light in that it can be blocked by solid objects. Color can also be changed to create a particular mood. The next chapter expands on previous CINEMA 4D techniques to create animated materials for a motion graphics project.

CHAPTER 6

..

Materials and
Shaders in Motion

Materials in CINEMA 4D Lite can be created using bitmaps or generated mathematically using shaders. Materials can even save on modeling time through the use of the bump and displacement maps. This chapter explores using materials in more detail.

What are Shaders?

A material affects the surface of an object through a combination of different parameters. These parameters are categorized into channels that include color, transparency, reflection, etc. The Material Editor in CINEMA 4D allows you to access and edit these channels to change the material's appearance. The following table outlines how each channel affects the surface of an object.

Table 6.1: *Material Channels*

Channel	Effect
Color	It determines the color of the surface. Bitmap images can be imported and used to replace the solid color.
Diffusion	It applies a grayscale map to scatter the light falling on the surface to soften the object.
Luminance	It emits light from the surface independently of any other placed light objects in the scene. This is often used as a light source for Global Illumination (discussed in Chapter 9).
Transparency	It allows you to see through the surface. This channel also includes a refraction parameter to control how the light bends as it hits and passes through the surface.
Reflection	It reflects other objects on the surface. A Brightness value of 100 is equivalent to a mirror.
Environment	It works with the Reflection channel to add a false reflection on the surface of an object. Bitmap images can be imported into this channel and will be reflected on the surface.
Fog	It is used to simulate fog or mist.
Bump	It creates a tactile look and feel for a surface. Bump maps use a grayscale bitmap to generate the bumps and divots. This channel only affects the texture's appearance not the object's geometry.
Normal	It is similar to a bump map in that it makes a low-polygon object appear more detailed and structured. Used in 3D game design, normal maps generate bumps and divots on a surface through the RGB channel information of a bitmap image.
Alpha	This channel masks a texture using a grayscale bitmap.
Specular	It creates the highlights on the surface and can be changed to simulate plastic or metal.
Glow	It creates a halo-like glow around the surface.
Displacement	It is similar to a bump map but actually distorts the object's geometry. The detail of the displacement is controlled by the number of polygon subdivisions in the object. The higher the number, the nicer the effect but with longer rendering times.

So, what are **shaders**? Shaders are procedural textures that are generated mathematically. Similar to primitive shapes, shaders are parametric where their parameters can be manipulated. Shaders are seamless and resolution independent providing an advantage over using bitmap images. In fact, you already used a shader in Chapter 2 when you created the marble texture for the bowling ball.

There are two types — 2D and 3D shaders. **2D shaders** are used in material channels just like bitmap images. These shaders offer a wide range of geometric patterns. They consist of standard surfaces such as checkerboard, marble, tiles, water, and even fire and flames (Figure 6.1).

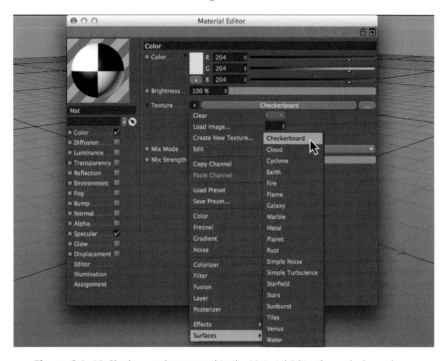

Figure 6.1: *2D Shaders can be accessed in the Material Editor for each channel.*

3D shaders are also called **volumetric shaders** and use the UVW projection on a surface. It looks at the object's volume when applied and calculates its placement based on the U, V, and W coordinates to "stick" to the surface. 3D shaders can be found in the Materials Manager by selecting **Create > Shader** (Figure 6.2).

Figure 6.2: *Volumetric Shaders are located in the Materials Manager.*

CINEMA 4D Lite provides a number of pre-built volumetric shaders for you to use. Each shader's parameters are different depending on the appearance they emulate. Here is a list of the volumetric shaders and a brief description of what the texture can be used for (Figure 6.3):

- **Banji:** emulates a simple glass texture
- **Banzi:** emulates a rough wood texture
- **Cheen:** emulates cellular, organic material
- **Danel:** emulates shiny metal
- **Fog:** emulates a fog bank
- **Mabel:** emulates a marble texture
- **Nukei:** emulates weathered material such as rust
- **Terrain:** emulates a landscape material

Figure 6.3: *The volumetric shaders provided in CINEMA 4D Lite.*

Using Volumetric Shaders

The first exercise demonstrates how to apply a 3D volumetric shader to create an opening title sequence for a motion graphics project. The 3D shader names may seem a bit strange, but the visual effects you can achieve through using them are amazing. Download the files for this chapter and let's get started.

 Download (www.focalpress.com/9781138777934) the **Chapter_06.zip** *file to your hard drive. It contains all the files needed to complete the exercises.*

Locate and play the **Microbes.mov** file in the **Completed** folder inside **Chapter_06** (Figure 6.4). The following exercises provide an introduction to applying a volumetric shader, specifically the Cheen shader. This shader is great for simulating microscopic organisms such as microbes and germs.

The project is broken up into several steps to reinforce modeling, texturing, and lighting techniques in CINEMA 4D Lite. The first step is to create the 3D model of the organism. This will be done using a primitive object.

Exercise 1: Model a Microbe with a Parametric Primitive

1. Launch **Adobe After Effects**. Save the new project as **01_Shader.aep** inside the downloaded **Chapter_06** folder.

Figure 6.4: *The finished project is an opening title animation.*

2. Select **File > New > MAXON CINEMA 4D File...** (Figure 6.5).

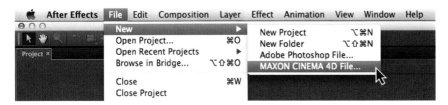

Figure 6.5: *Open a new CINEMA 4D file from After Effects.*

3. The first thing that you will see is a dialog box asking you to save your new MAXON CINEMA 4D file. Save the project as **Microbes.c4d** inside the **Footage** folder in the **Chapter_06** folder (Figure 6.6). Click **Save**.

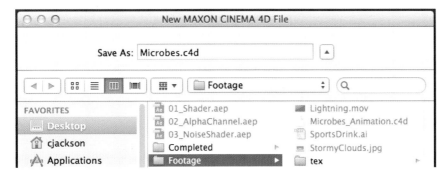

Figure 6.6: *Save your CINEMA 4D file into the Footage folder.*

4. Click on the **Render Settings** icon to open its dialog box. Click on the arrow icon under **Output**. From the preset pop-up menu, select **Film/Video> HDV/HDTV 720 29.97**. When you are done, close the Render Settings dialog box.

5. Go to the Timeline Ruler under the viewport window editor. Type in **150** in the text entry dialog box. To see all frames in the Timeline Ruler, click on the right arrow icon next to **150 F** and drag to the right (Figure 6.7).

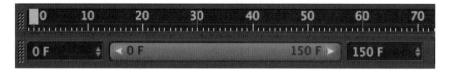

Figure 6.7: *Change the duration of the Timeline Ruler to 150 frames.*

6. Locate the cube icon above the viewport window. Click and hold the icon to reveal the pop-up palette of primitive shapes. While this palette is open, left-click on the **Capsule** icon to add the shape to the scene (Figure 6.8).

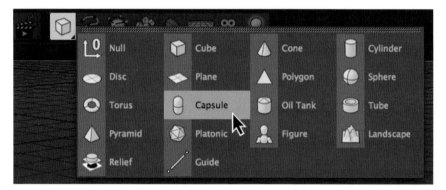

Figure 6.8: *Add a primitive capsule to the 3D scene.*

7. Primitive shapes consist of an underlying wireframe structure. In the viewport, select **Display > Gouraud Shading (Lines)**. By changing the display setting in the viewport, you can now see the structure of the capsule (Figure 6.9).

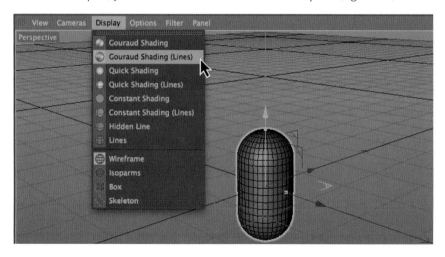

Figure 6.9: *Change the display setting in the viewport to see the wireframe structure.*

Chapter 6: Materials and Shaders in Motion

8. To make it easier to see the capsule's structure, go to the viewport and select **Cameras > Front** (Figure 6.10).

Figure 6.10: *Change the viewport camera view to Front.*

9. Go to the Attributes Manager and make the following changes to the capsule:

> ▸ Increase the value of the **Height** property to **400 cm**.

> ▸ Increase the **Height Segments** value to **24**. These additional segments will create a smoother curve once the Bend deformer is applied.

10. Click and hold the Deformer icon above the viewport to reveal the pop-up palette. While this palette is open, left-click on the **Bend** icon to add the deformer to the scene (Figure 6.11).

Figure 6.11: *Add a Bend deformer to the 3D scene.*

Figure 6.12: *Make the Bend deformer a child of the Capsule object.*

11. A deformer affects its parent object. The Bend deformer must be a child of the primitive capsule in order for it to work. Go to the Objects Manager and click and drag the Bend deformer into the Capsule object (Figure 6.12).

12. Go to the viewport. A purple box appears over the capsule. Click and drag the orange handle at the top of the purple box to bend the capsule.

Figure 6.13: *Use the interactive orange handle or the Attributes Manager to increase the strength of the Bend deformer.*

13. Go to the Attributes Manager. Change the **Strength** value for the Bend deformer to **90 degrees**. To ensure a smooth deformation, always make sure to have enough segments or subdivisions in the object (Figure 6.13).

14. Now that you have the microorganism modeled, let's create a new polygon object from it. Go to the Objects Manager and select the **Capsule** object.

15. Select **Objects > Current State to Object** (Figure 6.14). This command creates a new polygon copy of the selected capsule with the Bend deformer merged into a single object. It does not destroy the original copy of the capsule.

Figure 6.14: *Create a new polygon copy of the capsule with the Bend deformer.*

16. Delete the original **Capsule** with the **Bend** deformer from the Objects Manager.

17. Copy (Command + C) and paste (Command + V) the new polygon object nine times to create a total of ten polygon models in the Objects Manager.

18. Select all of the objects in the Objects Manager. Select **Edit > Select All**.

19. From the main menu at the top, select **Tools > Arrange Objects > Randomize** (Figure 6.15). This function allows you to randomly position, rotate, and scale a number of objects saving you time from manually doing it.

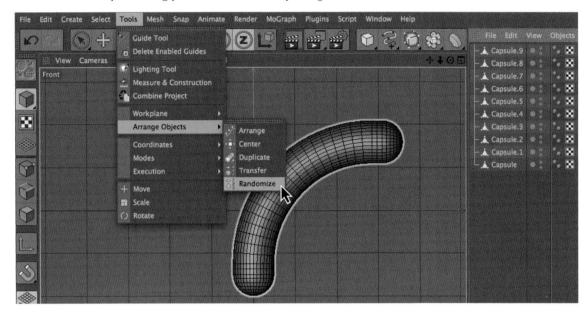

Figure 6.15: *Select the Randomize function from the Tools menu.*

20. In the Attributes Manager the Randomize options appear. Make the following changes (Figure 6.16).

- ▸ Increase the **Move** values to **1000 cm** for the X, Y, and Z positions.
- ▸ Change the **Rotation** values to **90**, **180**, and **60 degrees**.
- ▸ Click **Apply**. The polygon objects scatter randomly in the viewport.

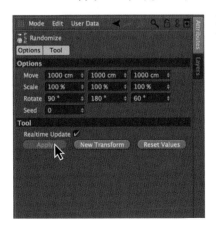

Figure 6.16: *Randomize the position and rotation of the copies in the viewport.*

21. Go to the viewport and select **Cameras > Perspective**. Use the Move and Rotate tool to fine tune the placement of the models (Figure 6.17) .

Figure 6.17: *Fine tune the placement and rotation of the objects.*

Exercise 2: Apply a 3D Volumetric Shader

This next exercise focuses on applying the volumetric shader to all of the objects. First, you need to group them together in a null object.

1. Select all of the objects in the Objects Manager. Select **Edit > Select All**.

2. Select **Objects > Group Objects** in the Object Manager. This will place all ten polygon objects inside a Null object. Rename the **Null** to **Microbes**.

3. Go to the Materials Manager. Select **Create > Shader > Cheen** (Figure 6.18).

Figure 6.18: *Add a Cheen shader in the Materials Manager.*

4. Click and drag the **Cheen** shader from the Materials Manager and drop it onto the **Microbes** (Null Object) **name** in the Objects Manager. This applies the 3D shader to all of the models nested inside the null object.

5. Click on the **Render View** icon to preview the shader texture (Figure 6.19). You now have floating microorganisms.

Figure 6.19: *Render a preview of the viewport window to see the 3D shader.*

6. Save your CINEMA 4D file. Select **File > Save**.

Exercise 3: Add Inverse Volumetric Lighting to the Scene

As you learned in the previous chapter, light objects can be set to visible or volumetric to create dramatic lighting effects. Volumetric lighting can also be reversed where the shadow areas appear to be radiating light from their surface. This is called inverse volumetric lighting. For this next exercise you can continue to add more microorganisms to your scene or open the provided CINEMA 4D project that is already animated in the **Chapter_06** folder.

1. In CINEMA 4D Lite, select **File > Open**. Locate the **Microbes_Animation.c4d** file in the **Footage** folder in **Chapter_06** (Figure 6.20). Click **Open**.

Figure 6.20: *Open the provided CINEMA 4D file in Footage folder.*

The file contains additional copies of the polygon objects and extruded text for the logo. A camera has been added along with the keyframes for the animation. Click the **Play Forwards** button in the Timeline controls to see the animation.

2. Click on the **Render View** icon to preview any frame in the Timeline. While the Cheen shader is great at creating a microscopic look, the default light provides a rather harsh, busy composition (Figure 6.21). Lighting is equally important, if not more, to enhancing the textures in the scene and for creating an atmosphere.

Figure 6.21: *Render a preview of the viewport window to see the 3D shader.*

3. Click on the **Light** icon to add a light source to your 3D scene. In the Objects Manager, rename the light to **Volumetric Light**.

4. With the Light object selected in the Objects Manager, go to the Attributes Manager and click on the **Coord.** tab to position the light object behind the logotype and floating microorganisms. The rotation will point the light looking up to create the shafts of light needed for the final render.

- ▸ Set the **Y-Position** to **-400 cm**.
- ▸ Set the **Z-Position** to **1500 cm**.
- ▸ Set the **Rotation Heading (R.H)** to **180 degrees**.
- ▸ Set the **Rotation Pitch (R.P)** to **20 degrees**.

5. Click on the **General** tab and increase the **Intensity** value to **250%**. Set the **Type** to a **Square Spot** light and turn on the light's shadows by selecting **Shadows Maps (Soft)** from the **Shadow** drop-down menu.

6. Change the **RGB Color** values to R = **80**, G = **90**, B = **150**. This creates a dark blue color that will also influence the brightness of the visible light.

7. Change the **Visible Light** parameter to **Inverse Volumetric**.

8. In the Attributes Manager, click on the **Visibility** tab. With large 3D scenes, you may need to increase the light cone shape to reach all of the objects.

- ▸ Increase the **Inner Distance** value to **2500 cm**.
- ▸ Increase the **Outer Distance** value to **5000 cm**.

9. Click on the **Render View** icon to preview the light in the viewport (Figure 6.22). The inverse volumetric lighting produces shafts of light coming from the floating organisms and helps reduce the stark color contrast against a black background. The only problem is that the logotype is now unreadable.

Figure 6.22: *Preview the inverse volumetric lighting in the scene.*

10. Click on the **Light** icon again to add another light source to your 3D scene. In the Objects Manager, rename the light to **Text Main Light**.

11. With the Light object selected in the Objects Manager, go to the Attributes Manager and click on the **Coord.** tab.
 ▸ Set the **Y-Position** to **-70 cm**.
 ▸ Set the **Z-Position** to **-800 cm**.

12. Click on the **General** tab and decrease the **Intensity** value to **90%**. Turn on the light's shadows by selecting **Shadows Maps (Soft)** from the **Shadow** drop-down menu.

13. Change the **RGB Color** values to R = **204**, G = **216**, B = **255**.

14. In the Attributes Manager, click on the **Details** tab.
 ▸ Set the **Falloff** property to **Inverse Square (Physically Accurate)**. This will simulate realistic falloff of the light over the text.
 ▸ Increase the **Radius/Decay** of the falloff to **1000 cm**.

15. Click on the **Project** tab. To illuminate only the text:
 ▸ Change the **Mode** to **Include**.
 ▸ Drag and drop the **MICROBES** extruded NURBS from the Objects Manager into the **Objects** box (Figure 6.23).

16. Click on the **Render View** icon to preview the light (Figure 6.24).

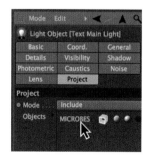

Figure 6.23: *Set the light object to only affect the logotype in the scene.*

Figure 6.24: *Preview the lighting for the logotype in the scene.*

17. Save your CINEMA 4D file. Select **File > Save**.

Exercise 4: Render the Animation using CINEWARE

If you used the provided CINEMA 4D file in the previous exercise, import that file (**Microbes_Animation.c4d**) into your After Effects project. If you built your own 3D scene, make sure to save the CINEMA 4D file in order for it to update in After Effects. For this exercise, you will add a background gradient layer and audio track. When you are done, you will render the final composition using CINEWARE and After Effects.

Figure 6.25: *Create a new composition using the CINEMA 4D footage file.*

1. In After Effects, click and drag your CINEMA 4D footage file to the **Create a new Composition** icon at the bottom of the Project panel (Figure 6.25).

2. A new composition is created displaying your 3D scene using the CINEWARE effect. The default Renderer setting is **Software**. In the CINEWARE panel, change the Renderer from **Software** to **Standard (Final)**.

3. Make sure the Timeline panel is highlighted. Select **Layer > New > Solid**. The Solid Settings dialog box appears. Make the following changes:

 ▸ Enter **Background** for the solid name.

 ▸ Click on the **Make Comp Size** button.

 ▸ Click **OK**. The color of the solid layer doesn't matter.

4. With the solid layer highlighted in the Timeline, select **Effect > Generate > Gradient Ramp**. A grayscale gradient appears in the Composition panel.

5. Go to the Effect Controls panel. Change the **Ramp Shape** to a **Radial Ramp**.

6. Click on the **Start Color** color swatch. Change the RGB values to R = **150**, G = **200**, B = **255**.

7. Click on the **End Color** color swatch. Change the RGB values to R = **30**, G = **30**, B = **50**. This will create a gradient to complement the colors in the 3D scene.

8. Change the stacking order of the layers in the Timeline. Click and drag the **Background** solid layer under the CINEMA 4D layer (Figure 6.26).

Figure 6.26: *Position the gradient background layer under the CINEMA 4D layer.*

9. Double-click in the Project panel to open the Import File dialog box. Locate the **underwater.mp3** audio file in the **Footage** folder inside **Chapter_06**. Click **Open** to import the footage into the Project panel.

10. Click and drag the **underwater.mp3** audio file to the Timeline. Position it at the top of the layers. This audio file will add some ambient background noise to the final render (Figure 6.27).

Figure 6.27: *Add the audio track to the Timeline.*

11. Select **Composition > Add to Render Queue**. This opens the Render Queue. It is a new tab that sits on top of the Timeline panel.

12. In the Output To dialog box select the **Chapter_06** folder on your hard drive as the final destination for the rendered movie.

13. Click on **Lossless** next to Output Module.

14. Set the format to **QuickTime** movie. Under Format Options, set the compression setting to **H.264** or **MPEG-4 Video**.

15. Set the Audio sampling at **44.100 kHz** using the drop-down menu.

16. Click **OK** to close the Output Module Settings dialog box.

17. Click the **Render** button.

18. When the render is done, go to the **Chapter_06** folder on your hard drive. Launch the QuickTime movie (Figure 6.28).

Figure 6.28: *The final rendered QuickTime movie.*

This completes the exercise. The 3D shaders provide quick and efficient textures for your models. Notice that the Cheen shader does not show any seams nor distort around the curved edges of the capsule. It calculates the placement of the texture based on the volume of the shape. The next exercise explores how to use the Alpha channel to assist in branding a logo in CINEMA 4D.

Product Placement with Alpha Channels

An RGB image contains three color channels — red, green, and blue. When combined, these channels produce the full color image. The alpha channel is a fourth channel that contains an 8-bit grayscale image. This image determines the transparency of each pixel. Black pixels become transparent, and white

pixels are opaque. Any value in between black and white has a certain degree of transparency. A 32-bit color image contains 24-bit color information with an 8-bit alpha channel.

Alpha channels are crucial when layering materials together in CINEMA 4D. Locate and play the **AlphaDrink.mov** file in the **Completed** folder inside **Chapter_06** (Figure 6.29). The following exercises demonstrate how to mix textures together using a material's alpha channel. Let's get started.

Figure 6.29: *The finished project is an animated advertisement.*

Exercise 5: Creating the 3D Model and Environment

The first part of this exercise builds the 3D bottle and studio environment.

1. In After Effects, open the **02_AlphaChannel.aep** project inside the downloaded **Chapter_06** folder. It contains animated text layers and an audio track.

2. Make sure the Timeline panel is highlighted. Select **Layer > New > MAXON CINEMA 4D File**. Save the project as **SportsDrink.c4d** inside the **Footage** folder in the **Chapter_06** folder. The saved CINEMA 4D file opens.

3. Click on the **Render Settings** icon to open its dialog box. Click on the arrow icon under **Output**. From the preset pop-up menu, select **Film/Video> HDV/HDTV 720 29.97**. When you are done, close the Render Settings dialog box.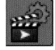

4. Go to the Timeline Ruler under the viewport window editor. Type in **150** in the text entry dialog box. To see all frames in the Timeline Ruler, click on the right arrow icon next to **150 F** and drag to the right.

5. In CINEMA 4D Lite, let's first build the sports drink bottle. The bottle will be generated using splines created in Adobe Illustrator. To import the splines, go to the Objects Manager.

- ▸ Select **File > Merge Objects**.
- ▸ Locate and select the **SportsDrink.ai** file inside the **Footage** folder.
- ▸ Click **Open**. The Adobe Illustrator Import dialog box appears.
- ▸ Click **OK**. The splines for the bottle appears in the center of the viewport.

6. To make it easier to see the spline and the effects of the lathe NURB, go to the viewport and select **Cameras > Front** (Figure 6.30).

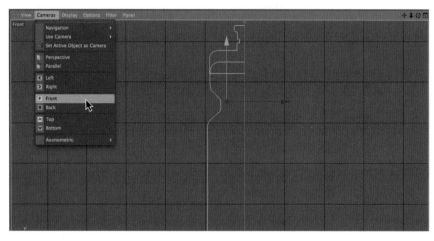

Figure 6.30: *Change the viewport camera view to Front.*

7. Go to the Objects Manager and select all of the imported splines. Select **Edit > Select All**. In the viewport the splines are highlighted and an axis point appears. In order for the lathe NURB to work correctly you will need to reposition the axis points from the center of the splines to the right edge. The lathe NURB uses the axis point to create the solid shape.

8. Click on the **Enable Axis** icon located on the left side of the viewport.

9. Go to the Coordinates Manager and enter **0** for the **X** Position. Click **Apply**. This will position all of splines' axis points to the right edge (Figure 6.31).

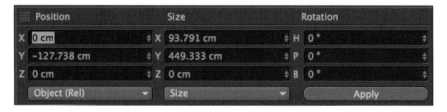

Position		Size		Rotation	
X	0 cm	X	93.791 cm	H	0 °
Y	–127.738 cm	Y	449.333 cm	P	0 °
Z	0 cm	Z	0 cm	B	0 °
Object (Rel)		Size		Apply	

Figure 6.31: *Position the X-axis point to the right edge of the splines.*

10. When you are done, click on the **Enable Axis** icon again to deactivate it. Always make sure you have the correct tool selected before you modify your 3D model(s) in the viewport.

11. Select the **Lathe NURBS** from the NURBS object palette above the viewport (Figure 6.32). In the Objects Manager, a Lathe NURBS object appears above the imported splines.

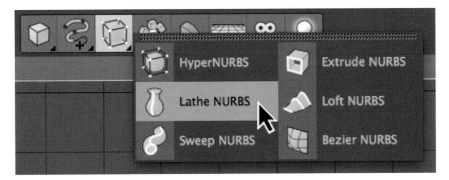

Figure 6.32: *Add a Lathe NURBS object to the scene.*

12. Go to the Objects Manager. Click and drag the **Path 1** spline into the Lathe NURBS. In the viewport, you should see what looks like the bottom part of the bottle (Figure 6.33). The NURB automatically rotates the spline around its Y-axis.

Figure 6.33: *Make the bottle spline a child of the Lathe NURBS to create a 3D object.*

13. Go to the Objects Manager and double-click on the **Lathe NURBS** name. Rename it **Bottle** and press **Return**. Let's also smooth out the wireframe mesh of the bottle a little. To do this, you need to add a HyperNURBS object. Make sure the lathe NURBS object is still selected in the Objects Manager.

Figure 6.34: *Add a HyperNURBS object to the scene.*

14. Hold down the Option key and select the **HyperNURBS** from the NURBS object palette above the viewport (Figure 6.34). Holding down the Option key automatically makes the **Bottle** Lathe NURBS a child of the HyperNURBS.

15. Select the **Lathe NURBS** from the NURBS object palette again. Go to the Objects Manager. Click and drag the **Path 2** spline into the second Lathe NURBS. In the viewport, you should see the cap of the bottle (Figure 6.35).

Figure 6.35: *Make the cap spline a child of another Lathe NURBS.*

16. Go to the Objects Manager and double-click on the **Lathe NURBS** name. Rename it **Cap** and press **Return**. Delete the Null object named **SportsDrink**.

17. With the model of the sports bottle complete, the next element to add to the scene is a studio backdrop. CINEMA 4D Lite ships with several pre-made models and materials for you to use in your projects. To access them:

 ► Click on the **Content Browser** vertical tab under the **Objects** tab. These tabs are located on the right edge of the Objects Manager.

 ► Double-click on **Presets**.

 ► Double-click on **Lite**.

- ▸ Double-click on **Lights and Studio Setups**.
- ▸ And finally, double-click on **Studio Backdrop** (Figure 6.36).

Figure 6.36: *Add a Studio Backdrop object from the Content Browser.*

18. Go to the viewport and select **Cameras > Perspective**. The seamless backdrop is a little small when compared to the size of the bottle. Click on the **Objects** tab to view the Objects Manager again.

19. With the **Studio Backdrop** object selected in the Objects Manager, go to the Attributes Manager and click on the **Coord.** tab (Figure 6.37).

- ▸ Increase the **X-Y-Z Scale** values to **2**.
- ▸ Set the **Y-Position** to **125 cm**.
- ▸ Set the **Z-Position** to **400 cm**.

Figure 6.37: *Scale and reposition the Studio Backdrop object.*

Figure 6.38: *Frame the final 3D scene in the viewport.*

Keyboard Shortcuts

1 to **Pan** the Camera

2 to **Dolly** the Camera

3 to **Orbit** the Camera

Cmd + Shift + Z to undo a camera move

20. Go to the viewport. Use the navigation icons to change the camera view to frame your scene better. Position the bottle on the left side of the composition to leave enough space for the text layers in After Effects (Figure 6.38).

21. Save your CINEMA 4D file. Select **File > Save**.

Exercise 6: Adding the Logo with an Alpha Channel

In this next exercise we will explore using the alpha channel used to add the logo bitmap image onto the bottle.

1. Go to the Materials Manager. Select **Create > New Material**. You can also double-click anywhere in the Materials Manager to create a new material.

2. Double-click on the **Mat** icon to open the Material Editor dialog box. We will keep the default color the same. Double-click on the **Mat** name. Rename it to **Bottle** and press **Return**.

3. Go to the Materials Manager. Select **Create > New Material** to add a second new material to the manager's panel. This material will be applied to the cap of the bottle.

4. Go to the Material Editor dialog box. While the **Color** channel is selected, change the **RGB Color** values to R = **18**, G = **40**, B = **111** in the right column. This will create a dark blue color for the cap.

5. In the **Specular** channel make the following changes (Figure 6.39):

 ▸ Decrease the **Width** value to **20%**.

 ▸ Increase the **Height** value to **40%**.

 ▸ Increase the **Inner Width** value to **20%**.

 ▸ Rename the texture to **Cap** and press **Return**.

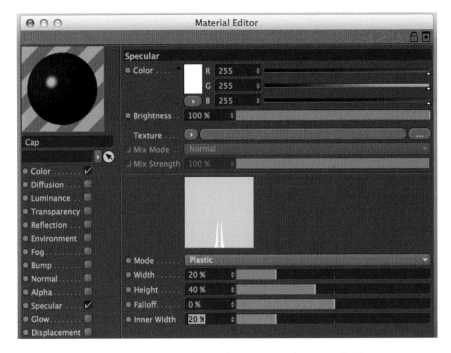

Figure 6.39: *Adjust the Specular channel properties in the Materials Editor.*

6. Go to the Materials Manager. Select **Create > New Material** to add a third new material to the manager's panel. This material will also be applied to the bottle. For this material, you will import the logo bitmap image.

7. Go to the Material Editor dialog box. While the **Color** channel is selected, make the following changes:

 ▸ Click on the **Texture** arrow and select **Load Image** from the pop-up menu.

 ▸ Locate the **GradeA_Logo.png** file in the **tex** folder in **Chapter_06**. Click **Open**.

 ▸ Double-click on the **Mat** name. Rename the texture to **Logo** and press **Return**.

8. Click on the checkbox next to the **Alpha** channel to activate it. Click on the **Texture** arrow and select **Bitmaps > GradeA_Logo.png** from the pop-up menu. CINEMA 4D uses the alpha channel in the PNG file. Areas of black are removed from the texture leaving only the white areas projected (Figure 6.40).

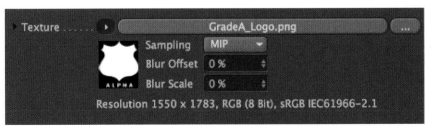

Figure 6.40: *Add the Alpha channel to the material.*

9. Click and drag the **Cap** material from the Materials Manager and drop it onto the **Cap** (Lathe NURBS Object) **name** in the Objects Manager.

10. Click and drag the **Bottle** material from the Materials Manager and drop it onto the **HyperNURBS** object **name** in the Objects Manager.

11. Click and drag the **Logo** material from the Materials Manager and drop it also onto the **HyperNURBS** object **name** in the Objects Manager.

12. Click on the **Logo Texture Tag** that appears to the right of the **HyperNURBS** object in the Objects Manager. Go to the Attributes Manager and change the **Projection** property from **UVW Mapping** to **Cylindrical** (Figure 6.41).

 ▸ Uncheck the checkbox for **Tile**. You only need one image of the logo.

 ▸ Change the **Offset U** value to **65%**, the **Offset V** value to **-80%**.

 ▸ Change the **Length U** value to **30%**, the **Length V** value to **90%**.

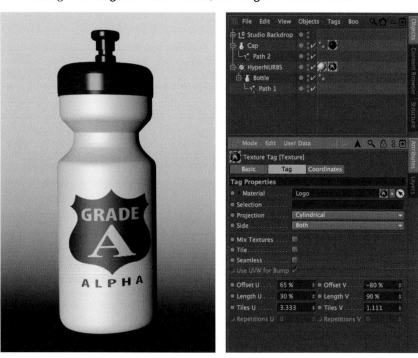

Figure 6.41: *Reposition the logo material on the bottle.*

Exercise 7: Lighting the Product

In this exercise, you will add lights in order to create a more dramatic image.

1. Click on the **Light** icon to add a light source to your 3D scene. In the Objects Manager, rename the light to **Left Light**. This will be positioned on the left side of the bottle.

2. Go to the Attributes Manager and click on the **Coord.** tab to reposition the object in the viewport. You can also use the Move tool to position the light Change the location of the light object:

 ▸ Set the **X-Position** to **-400 cm**.

 ▸ Set the **Y-Position** to **400 cm**.

3. Click on the **General** tab and turn on the light's shadows by selecting **Area** from the **Shadow** drop-down menu. Uncheck the checkbox for **Specular** to deactivate the highlight created by this light object.

4. Change the **RGB Color** values to R = **200**, G = **225**, B = **255**.

5. In the Attributes Manager, click on the **Details** tab.

 ▸ Set the **Falloff** property to **Inverse Square (Physically Accurate)**.

 ▸ Keep the **Radius/Decay** value at **500 cm**.

6. Click on the **Render View** icon to preview the light (Figure 6.42).

Figure 6.42: *Preview the lighting by rendering the viewport window.*

7. Click on the **Light** icon again to add another light source to your 3D scene. In the Objects Manager, rename the light to **Right Light**.

8. Go to the Attributes Manager and click on the **Coord.** tab:

 ▸ Set the **X-Position** to **300 cm**.

 ▸ Set the **Y-Position** to **600 cm**.

 ▸ Set the **Z-Position** to **-600 cm**.

9. Click on the **General** tab and decrease the **Intensity** value to **70%**.

10. Change the **RGB Color** values to R = **255**, G = **215**, B = **225**.

11. In the Attributes Manager, click on the **Details** tab.

> ▸ Set the **Falloff** property to **Inverse Square (Physically Accurate)**.

> ▸ Increase the **Radius/Decay** of the falloff to **1200 cm**.

12. Click on the **Render View** icon to preview the light (Figure 6.43).

Figure 6.43: *Preview the lighting by rendering the viewport window.*

13. Save your CINEMA 4D file. Select **File > Save**. Jump back to After Effects.

14. Change the stacking order of the layers in the Timeline. Click and drag the **SportsDrink.c4d** layer to the bottom of the stacked layers.

15. After you changed the frame duration in the CINEMA 4D file, a ghosted bar now extends to the end of the composition in the Timeline. Retrim its Out Point by clicking and dragging it to the end of the composition (Figure 6.44).

Figure 6.44: *Retrim the CINEMA 4D layer's Out Point to the end of the Timeline.*

16. Click on the CINEMA 4D layer in the Timeline. Change the CINEWARE **Renderer** to **Standard (Final)** in the Effect Controls panel.

17. Select **Composition > Add to Render Queue**. This opens the Render Queue. It is a new tab that sits on top of the Timeline panel.

18. In the Output To dialog box select the **Chapter_06** folder on your hard drive as the final destination for the rendered movie.

19. Click on **Lossless** next to Output Module.

20. Set the format to **QuickTime** movie. Under Format Options, set the compression setting to **H.264** or **MPEG-4 Video**.

21. Set the Audio sampling at **44.100 kHz** using the drop-down menu.

22. Click **OK**. Click the **Render** button. When the render is done, go to the **Chapter_06** folder. Launch the QuickTime movie (Figure 6.45).

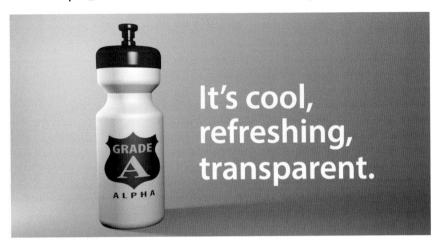

Figure 6.45: *The final rendered QuickTime movie.*

This completes the exercise. If you want to add condensation to the bottle, add several primitive spheres to the scene. Position the spheres so that they intersect with the bottle and studio backdrop. Use the **Banji** volumetric shader for the water texture. Animate the spheres sliding down the bottle (Figure 6.46).

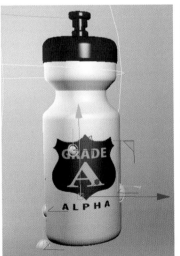
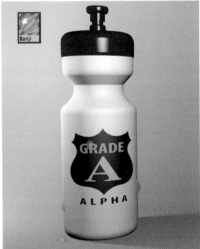

Figure 6.46: *Add condensation using spheres and the Banji volumetric shader.*

Animating Materials with Noise Shaders

As you have learned at the beginning of this chapter, materials contain channel shaders. One special channel shader is Noise. This shader can turn a flat, smooth surface into an turbulent ocean. Locate and play the **TritonPromo.mov** file in the **Completed** folder inside **Chapter_06** (Figure 6.47). In this last project, you will use the Noise shader in conjunction with the Bump and Displacement channels to create a teaser trailer for an upcoming fictitious television show.

Figure 6.47: *The finished project is an animated television promo.*

Exercise 8: Displacement Maps in After Effects

After Effects uses Noise to create a distortion effect. The effect you will use in this exercise is called a **Displacement Map**. This effect distorts a layer by displacing pixels horizontally and vertically based on the color values of pixels in another layer. Here is how it works:

1. In After Effects, open the **03_NoiseShader.aep** project inside the downloaded **Chapter_06** folder. It contains two compositions in the Project panel.

2. Go to the Project panel and double-click on the **Fractal Noise** composition. This opens its Timeline and Composition panel (Figure 6.48). Play it.

 A Displacement Map can use the grayscale information to distort pixels within a layer. Areas of light grays will displace pixels up and to the right. Darker grays do just the opposite. Since this grayscale information is constantly changing in this composition, the displacement will also animate over time.

3. Go to the Project panel and double-click on the **Stormy Clouds** composition. You will see that the **Fractal Noise** composition has been added as a layer at the bottom of the Timeline in order apply a Displacement Map.

Figure 6.48: *The Displacement Map will use the grayscale Fractal Noise information.*

4. With the Timeline panel still highlighted, select **Layer > New > Adjustment Layer**. An adjustment layer is added at the top of the Timeline. The footage item is also stored inside the Solids folder in the Projects panel.

5. Go to the Effects & Presets panel. Enter **Displacement** into the Contains field. Two matched items appear: Displacement Map and Time Displacement. You will use the Displacement Map.

6. To apply the Displacement Map effect to the adjustment layer, click and drag the effect to **Adjustment Layer 1** in the Timeline panel. Release the mouse.

7. In the Effect Controls panel change the Displacement Map Layer property to the **Fractal Noise** layer. Adjust the other properties to match Figure 6.49.

Figure 6.49: *Displacement Map settings.*

8. Click on the **RAM Preview** button to see the effect. Notice the clouds move and undulate to simulate actual storm clouds.

Animating Materials with Noise Shaders **195**

The Displacement Map gives the illusion of the clouds moving. It pushes and pulls pixels based on changes in luminosity (brightness and darkness) occurring in the **Fractal Noise** composition.

9. There is one small problem. The edges of the image layers are also distorting. As a result, the black color underneath is being revealed. To correct this, Shift-select both the **StormyClouds.jpg** and the **Lightning.mov** layers.

10. Type **S** on the keyboard to show only the Scale property. Scrub through the numeric value and set it to **105%**. Now the edge distortion occurs outside the Composition panel.

11. Rearrange the stacking order of the layers. Reposition the **Adjustment Layer 1** under the text layer (Figure 6.50). The text does not need to be displaced.

Figure 6.50: *Rearrange the stacking order so that the adjustment layer does not affect the text layer.*

12. Click on the **RAM Preview** button to see the final Displacement Map animation.

13. Save your After Effects project. The next step is to create a displacement map in CINEMA 4D Lite to create the ocean.

Exercise 9: Using Noise Shaders in CINEMA 4D

In this exercise you will create the ocean waves using a Noise shader.

1. Make sure the Timeline panel is highlighted. Select **Layer > New > MAXON CINEMA 4D File**. Save the project as **3D_Ocean.c4d** inside the **Footage** folder in the **Chapter_06** folder. The saved CINEMA 4D file opens.

2. Click on the **Render Settings** icon to open its dialog box. Click on the arrow icon under **Output**. From the preset pop-up menu, select **Film/Video> HDV/HDTV 720 29.97**. When you are done, close the Render Settings dialog box.

3. Go to the Timeline Ruler under the viewport window editor. Type in **150** in the text entry dialog box. To see all frames in the Timeline Ruler, click on the right arrow icon next to **150 F** and drag to the right.

4. Click and hold the cube icon above the viewport to reveal the pop-up palette of primitive shapes. While this palette is open, left-click on the **Plane** icon to add the shape (Figure 6.51).

Figure 6.51: *Add a Plane primitive object to the scene. This will become the ocean.*

5. With the Plane object still selected, go to the Attributes Manager. Make the following changes:

 ▸ Increase the **Width** and **Height** to **800 cm**.

 ▸ Increase the **Width Segments** and **Height Segments** to **100**.

6. In the viewport, select **Display > Gouraud Shading (Lines)**. By changing the display setting in the viewport, you can now see the structure of the plane. The additional segments will create a smoother displacement effect once the material is added (Figure 6.52). Unfortunately, the render time will increase.

Figure 6.52: *Change the display setting in the viewport to see the wireframe structure.*

7. Go to the Materials Manager. Select **Create > New Material**.

8. Double-click on the **Mat** icon to open the Material Editor dialog box. Double-click on the **Mat** name. Rename it **Ocean** and press **Return**.

9. While the **Color** channel is selected, click on the **Texture** arrow and select the Fresnel shader from the pop-up menu.

10. Click on the **Fresnel** button to change the 2D channel shader's gradient colors:

 ▸ Under the color gradient, double-click on the white (left) color pointer.

 ▸ In the Color Picker dialog box, change the **RGB Color** values to R = **60**, G = **130**, B = **190**.

 ▸ Click **OK** to close the Color Picker dialog box.

 ▸ Double-click on the black (right) color pointer.

 ▸ In the Color Picker dialog box, change the **RGB Color** values to R = **10**, G = **20**, B = **40** (Figure 6.53).

 ▸ Click **OK** to close the Color Picker dialog box.

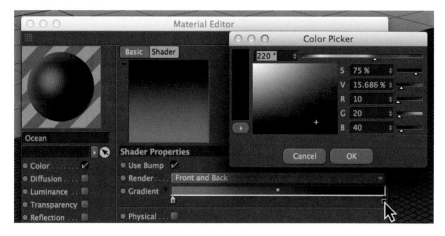

Figure 6.53: *Change the shader's gradient colors.*

11. Click on the checkbox for the **Reflection** channel. When you activate this channel, its default brightness value of 100% turns the material into a mirror.

 ▸ Decrease the **Brightness** value to **30%**.

 ▸ Click on the **Texture** arrow and select **Fresnel** from the pop-up menu.

 ▸ Decrease the **Mix Strength** value to **50%**.

 ▸ Increase the **Blurriness** to **1%**.

12. Click on the checkbox for the **Bump** channel. Here is where we will start to use the Noise shader to create our ocean effect.

 ▸ Click on the **Texture** arrow and select **Noise** from the pop-up menu.

 ▸ Click on the **Noise** button to change the 2D channel shader's parameters.

 ▸ Change the **Noise** type to **Blistered Turbulence**. There are 32 different types of noise to choose from.

 ▸ Increase the **Global Scale** to **200%**.

 ▸ To animate the Noise, increase the **Speed** to **1%** (Figure 6.54).

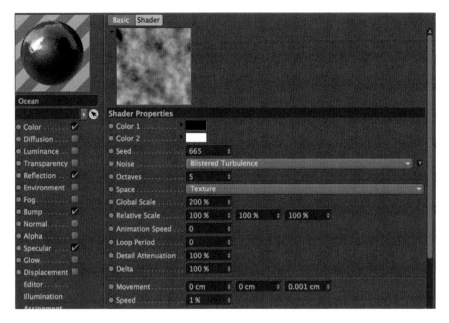

Figure 6.54: *Change the Noise shader's parameters for the Bump channel.*

13. Remember that the bump map only affects the appearance of the surface, a displacement map distorts the object's geometry. Click on the checkbox for the **Displacement** channel. Make the following changes:

> Click on the **Texture** arrow and select **Layer** from the pop-up menu. The Layer shader allows you to combine shaders and bitmaps together in the same material channel. Think of it as layers in Photoshop.

> Click on the **Layer** button to add multiple Noise shaders.

> Click on the **Shader** button and select **Noise** from the pop-up menu.

> Click on the thumbnail image 🔲 of the **Noise** to change its parameters.

> Increase the **Global Scale** to **400%**.

> Change the **Movement** to: **0.2 cm, 0.2 cm, 0.001 cm**.

> To animate the noise, increase the **Speed** to **1%**.

> Click on the **back arrow** ◀ at the top-right corner of the Material Editor to return to the **Layer** parameters. Let's add another layer.

> Click on the **Shader** button again and select **Noise** from the pop-up menu.

> Click on the thumbnail image 🔲 for the new **Noise** layer.

> Increase the **Global Scale** to **200%**.

> Change the **Movement** to: **0.1 cm, 0.2 cm, 0.001 cm**.

> To animate the noise, increase the **Speed** to **1%**.

> Click on the **back arrow** ◀ at the top-right corner of the Material Editor to return to the **Layer** parameters. Set the top Noise layer's mixing mode to **Multiply** (Figure 6.55).

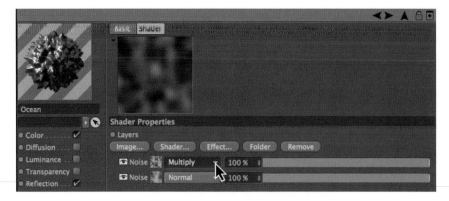

Figure 6.55: *Change the Noise's mixing mode in the Layer shader.*

14. Click on the **back arrow** at the top-right corner of the Material Editor to return to the **Displacement** parameters. Set the **Height** to **6 cm**. When you are done, close the Material Editor dialog box.

15. Go to the Objects Manager and select the **Plane** object. In order for the displacement map to affect this object, it first needs to be converted from a parametric primitive to an editable polygon object. To do this, click on the **Make Editable** button located on the top-left side of the viewport.

16. Hold down the Option key and select the **HyperNURBS** from the NURBS object palette. This will smooth out the plane's displacement.

17. Click and drag the **Ocean** material from the Materials Manager and drop it onto the **HyperNURBS** object **name** in the Objects Manager. Rename the HyperHURBS to **Ocean**. To see the displacement map, render the scene.

18. Click on the **Render View** icon to preview the ocean (Figure 6.56).

Figure 6.56: *Preview the displacement map by rendering the viewport window.*

Chapter 6: Materials and Shaders in Motion

Exercise 10: Lights, Camera, and Logo Animation

In this exercise you will add the finishing touches to the 3D animation.

1. Click on the **Light** icon to add a light source to your 3D scene.
 In the Objects Manager, rename the light to **Ocean Light**.

2. Go to the Attributes Manager and click on the **Coord.** tab:
 - ▸ Set the **Y-Position** to **150 cm**.
 - ▸ Set the **Z-Position** to **25 cm**.

3. Click on the **General** tab and decrease the **Intensity** value to **60%**.

4. Change the **RGB Color** values to R = **94**, G = **225**, B = **255**.

5. In the Attributes Manager, click on the **Details** tab.
 - ▸ Set the **Falloff** property to **Inverse Square (Physically Accurate)**.
 - ▸ Decrease the **Radius/Decay** value at **300 cm**.

6. Click on the **Render View** icon to preview the light (Figure 6.57).

Figure 6.57: *Preview the lighting by rendering the viewport window.*

7. Click on the **Camera** icon to add a placed camera to your 3D scene.

8. Go to the Attributes Manager and click on the **Coord.** tab (Figure 6.58):
 - ▸ Set the **X-Position** to **0 cm**.
 - ▸ Set the **Y-Position** to **5 cm**.
 - ▸ Set the **Z-Position** to **-400 cm**.
 - ▸ Set the **Rotation Heading (R.H)** to **0 degrees**.
 - ▸ Set the **Rotation Pitch (R.P)** to **3 degrees**.
 - ▸ Set the **Rotation Bank (R.B)** to **0 degrees**.

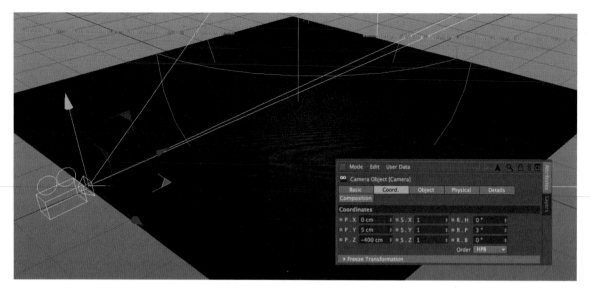

Figure 6.58: *Reposition the camera along the "water line" of the ocean model.*

9. Click and hold the Environment icon above the viewport to reveal the pop-up palette of objects. While this palette is open, left-click on the **Sky** icon to add the object (Figure 6.59). This object will be reflected in the water texture.

Figure 6.59: *Add a Sky object to the scene.*

The **Sky** object is an infinitely large sphere centered at the origin of the scene. Textures can be applied to this object. Let's see how that works.

10. Go to the Materials Manager. Select **Create > New Material**. This material will be applied to the Sky to reflect the cloud colors in the ocean material.

11. Go to the Material Editor dialog box. While the **Color** channel is selected, make the following changes:

 ▶ Click on the **Texture** arrow and select **Load Image** from the pop-up menu.

 ▶ Locate the **StormyClouds.psd** file in the **tex** folder in **Chapter_06**. Click **Open**.

 ▶ Double-click on the **Mat** name. Rename the texture to **Sky** and press **Return**.

12. Click and drag the **Sky** material from the Materials Manager and drop it also onto the **Sky** object **name** in the Objects Manager.

13. Click on the **Sky Texture Tag**. Go to the Attributes Manager. Notice that the **Projection** property is already set to **Spherical** for the Sky object.

14. Change the **Offset U** value to **-25%**, the **Offset V** value to **-15%**.

15. To view what the placed camera is looking at in the viewport, go to the Objects Manager. Click on the **target** to the right of the **Camera name**. The target will turn white (Figure 6.60).

16. Click on the **Render View** icon to preview the scene (Figure 6.61).

Figure 6.60: *Change the viewport camera to the new camera's view.*

Figure 6.61: *Preview the Sky by rendering the viewport window.*

17. Let's add the logo for the Triton television show. This is already created in a separate CINEMA 4D file. To import the logo, go to the Objects Manager.

 ▶ Select **File > Merge Objects**.

 ▶ Locate the **Triton_Extruded_Logo.c4d** file inside the **Footage** folder.

 ▶ Click **Open**. The CINEMA 4D object, materials, and lights are added to your scene (Figure 6.62).

The merged file contains an extruded spline with two lights applied to it. The Triton logo has two textures mapped onto it. One is a pre-made, brushed metal material that ships with CINEMA 4D Lite; the other material is a bright yellow solid applied to only the beveled edges of the extruded NURBS. A light object named **Lightning** is positioned above the scene and has a keyframed animation. The animation increases the light's intensity on certain frames in the Timeline to correspond to the lightning in the video footage in After Effects (Figure 6.63).

Figure 6.62: *Merge the provided CINEMA 4D file into your scene to add the logo and lighting effects.*

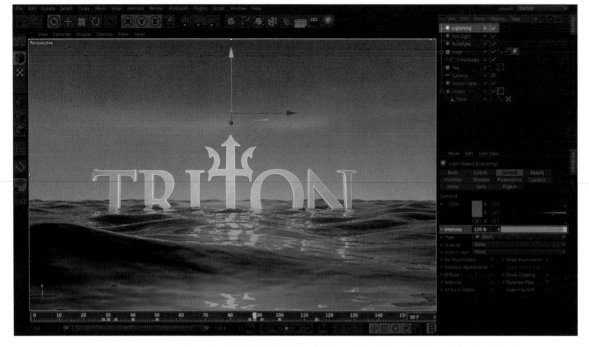

Figure 6.63: *The Light object's intensity has been keyframed to simulate the lightning that occurs in the video footage in After Effects.*

18. Even though the Sky object does not render in CINEWARE, it can produce an aliased fringe around the edge of the ocean. To prevent this, go to the Objects Manager and select the **Sky** object.

19. Select **Tags > CINEMA 4D Tags > Compositing** (Figure 6.64).

Figure 6.64: *Add a Compositing Tag to the Sky object.*

20. Make sure the **Compositing Tag** is selected in the Objects Manager.

21. In the Attributes Manager, uncheck the checkbox for **Seen by Camera** to remove the object from the final render, but keep its reflection in the ocean material (Figure 6.65).

22. Open the Render Settings dialog box in CINEMA 4D Lite.

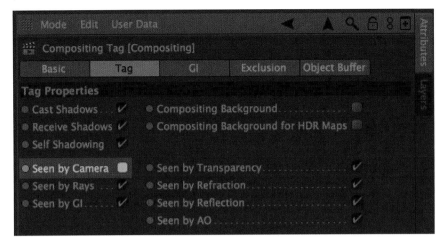

Figure 6.65: *To prevent a halo fringe around the edge of the ocean, use the Compositing Tag in CINEMA 4D to hide the Sky object from the placed camera.*

23. Click on **Anti-Aliasing** to modify its render settings on the right side of the dialog box. Change the **Anti-Aliasing** setting from **Geometry** to **Best**. Change the **Filter** setting from **Cubic (Still Image)** to **Gauss (Animation)** (Figure 6.66). CINEWARE will use these adjustments to render the final frames with a higher image quality for the ocean material's reflections in After Effects.

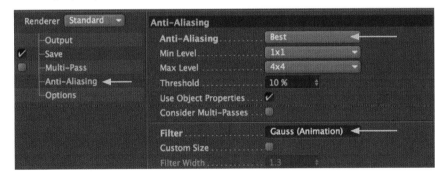

Figure 6.66: *Change the Anti-Aliasing render settings for the animation.*

24. When you are done, close the Render Settings dialog box.

Optimizing a CINEMA 4D Scene

With all of the lights, displacement animation, and reflections, the final render time will be affected. CINEWARE will slow down considerably in After Effects. There are steps you can take to help optimize your CINEMA 4D scene. Let's take a look at a few techniques.

1. Go to the Timeline Ruler and move the Current Time Indicator to the last frame.

2. Click on the **Render to Picture Viewer** icon about the viewport.

The Picture Viewer renders the last frame and records how long it took to render. For this example, it took 49 seconds to render one frame (Figure 6.67). Multiply that by the number of frames you have to get an estimate of how long the entire animation will take to render in CINEWARE – too long.

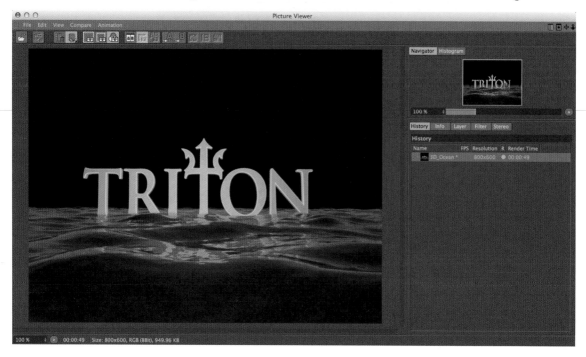

Figure 6.67: *The Picture Preview displays an estimate for render times.*

So, how can you speed up the render time without having to buy a faster computer? Anti-aliasing is the first thing to look at.

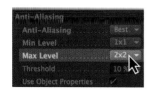

Figure 6.68: *Change the Anti-Aliasing settings to reduce the render time.*

3. Reopen the Render Settings dialog box and go to the **Anti-Aliasing** settings. When you set the anti-aliasing to **Best**, it enables the object smoothing and activates parameters that you can control. Reduce the **Max Level** setting to **2x2** using the drop-down menu (Figure 6.68). This affects the high-contrast areas and objects with transparencies.

4. Click on the **Render to Picture Viewer** icon again. In the **History** section, the render time was cut in half (Figure 6.69). Click on each name to toggle between the two rendered images to see any differences. The lower anti-aliasing setting did affect the reflections, but it will not be noticed by the viewer as it animates.

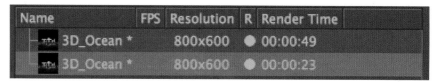

Name	FPS	Resolution	R	Render Time
3D_Ocean *		800x600	●	00:00:49
3D_Ocean *		800x600	●	00:00:23

Figure 6.69: *The Picture Preview displays a history of all the renders for comparison.*

5. Go to the Objects Manager and click on the **Ocean** HyperNURB. Go to the Attributes Manager, reduce the **Subdivision Renderer** setting to **2** (Figure 6.70). This will reduce the ocean's smoothness slightly but help with render times.

6. Click on the **Render to Picture Viewer** icon again. That change saved three seconds; every little bit helps when it comes to render times (Figure 6.71).

Figure 6.70: *Reduce the smoothness of the HyperNURBS object to help with the render time.*

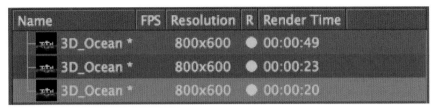

Figure 6.71: *Compare the changes made by clicking on each image.*

7. Go to the Materials Manager. Double-click on the **Ocean** material to open the Material Editor dialog box. Click on the **Reflection** channel. Decrease the **Blurriness** to **0% (Figure 6.72).** Blurry reflections can have a huge impact on the render time.

Figure 6.72: *Turn off the blurry reflections in the ocean material to help with the final render time.*

8. Click on the **Render to Picture Viewer** icon again. You should see a dramatic change in the render time (Figure 6.73).

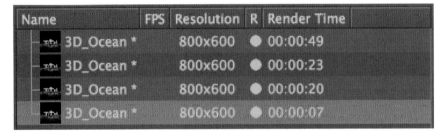

Figure 6.73: *Blurry reflections impact the render time significantly.*

When comparing the rendered frames in the Picture Viewer, there is a noticeable change in the reflection detail (Figure 6.74), but that is acceptable for this scene. When rendering an animation, the individual frames do not need to be as accurate as frames for a still image. The viewer will not miss anything.

Figure 6.74: *A comparison between the best render settings (left image) and the optimized render settings (right image).*

9. Save your CINEMA 4D Lite file. Select **File > Save**.

10. Jump back to After Effects. Since you changed the frame duration in the CINEMA 4D file, retrim the CINEMA 4D layer's Out Point by clicking and dragging it to the end of the composition (Figure 6.75).

Figure 6.75: *Retrim the Out Point to extend to the end of the composition.*

11. Change the CINEWARE **Renderer** to **Standard (Final)**.

12. Select **Composition > Add to Render Queue**.

13. In the Output To dialog box select the **Chapter_06** folder on your hard drive.

14. Click on **Lossless** next to Output Module. Set the format to **QuickTime** movie. Under Format Options, set the compression setting to **H.264** or **MPEG-4 Video**.

15. Set the Audio sampling at **44.100 kHz** using the drop-down menu. Click **OK**.

16. Click the **Render** button.

17. When the render is done, go to the **Chapter_06** folder on your hard drive. Launch the QuickTime movie (Figure 6.76).

Figure 6.76: *The final rendered QuickTime movie.*

Summary

This chapter explored using procedural shaders to enhance the surfaces of your 3D models. Shaders come in two styles, 3D volumetric and 2D channel shaders. They are created though a series of mathematical calculations which generate textures that simulate natural elements such as wood, glass, and marble. Similar to vector art, shaders do not pixelate when scaled or projected onto a surface.

Chapter 6: Materials and Shaders in Motion

CHAPTER 7

Working with Cameras in CINEMA 4D and CINEWARE

Cameras are regarded as objects in CINEMA 4D. They can be positioned and rotated in the same way as other 3D objects. In addition to the default camera, you can add any number of cameras to a scene and control which camera to look through using CINEWARE.

Cameras in CINEMA 4D and CINEWARE

Cameras are an essential component as they allow us to view our 3D scene. As you learned in previous chapters, CINEMA 4D provides a default camera that serves as a starting viewpoint. It generates a perspective view of the models and their 3D environment. The 4-Panel view contains four separate vantage points, each with their own cameras (Figure 7.1).

Figure 7.1: *The 4-Panel view allows you to see your scene from different viewpoints.*

Shading Modes can be accessed through the viewport's **Display** menu. This will allow you to view your model(s) as a shaded object, or as a polygon mesh, or a combination of both. Here is a list of the shading modes and a brief description of what each displays in the viewport:

- **Gouraud Shading:** displays shaded, smooth objects with lighting effects that come from placed light objects in the scene.
- **Gouraud Shading (Lines):** adds the wireframe structure to the shaded objects in order to see the polygon structure.
- **Quick Shading:** displays shaded, smooth objects without any lighting effects from placed light objects in the scene. It uses an auto light.
- **Quick Shading (Lines):** adds the wireframe structure to the quick shaded objects in order to see the polygon structure.
- **Constant Shading/Constant Shading (Lines):** displays flat color shading (no gradients) with or without the wireframe structure visible.
- **Hidden Line:** displays the wireframe structure of an object, but hides any wireframe lines not seen by the camera's view.
- **Line:** displays the complete polygon mesh structure for an object.

Since the default camera cannot be animated in CINEMA 4D Lite, you must add camera objects to your 3D scene. These cameras can be positioned and rotated over time to create creative cinematic effects. Cameras appear as a wireframe object (cube with two circle splines) in the viewport (Figure 7.2).

Figure 7.2: *Placed cameras appear as wireframe objects in the viewport.*

In addition to a basic camera, CINEMA 4D Lite provides two other types of camera objects. The **Target Camera** is essentially a camera that comes with a target object. This target object is what the camera points to and follows at all times. The **Stereo Camera** allows you to create stereoscopic renders to view using 3D anaglyph glasses (Figure 7.3).

Figure 7.3: *Camera objects in CINEMA 4D Lite.*

You can add as many cameras as you want to a CINEMA 4D file, each with different settings and animation. The CINEWARE Project Settings allow you select a CINEMA 4D camera or a 3D camera layer created in After Effects. The **Camera** parameter lets you choose which CINEMA 4D camera or an After Effects camera should be used to display the scene in the Composition panel (Figure 7.4). There are four camera options to choose from.

Figure 7.4: *CINEWARE lets you choose which camera to use in After Effects.*

The first option, **CINEMA 4D Camera,** uses the active CINEMA 4D camera. If you have multiple cameras in the file, use the **Select CINEMA 4D Camera** option to select one of the existing CINEMA 4D cameras in the scene. This provides you with great flexibility in editing different camera shots together using only one CINEMA 4D file.

The next two options are for 3D camera layers created inside a composition in After Effects. The main difference between both options is the 3D coordinate system used. In CINEMA 4D the origin point is at the center of the scene. In After Effects, the origin point is located in the top left corner of the composition.

The **Centered Comp Camera** option recalculates the CINEMA 4D coordinates to adapt to the After Effect coordinate system. Use this option if you want to center your model within the Composition panel using a camera layer created in After Effects. The **Comp Camera** option is best used for 3D camera layers created using the 3D Camera Tracker in After Effects. Let's see how it works.

Using Camera Layers in After Effects

The first exercise explores how to use the Centered Comp Camera option in CINEWARE to animate a CINEMA 4D scene using an After Effects camera. As you learned in Chapter 1, you cannot make any 3D adjustments to a 3D object directly inside After Effects. However, you can use an After Effects camera to move through the 3D space inside the CINEMA 4D file.

 Download (www.focalpress.com/9781138777934) the **Chapter_07.zip** *file to your hard drive. It contains all the files needed to complete the exercises.*

Locate and play the **Outerworlds.mov** file in the **Completed** folder inside **Chapter_07** (Figure 7.5). The finished project is an animated logo for a fictitious studio. The model was created with a low polygon count which gives the planet a unique look. The planet's animated ring was created using another NURB generator called a Sweep NURBS.

The project is broken up into several steps to reinforce modeling, texturing, and lighting techniques in CINEMA 4D Lite. The first step is to create the 3D logo. The planet is modeled using a primitive sphere object.

Figure 7.5: *The finished project is an animated logo for a fictitious company.*

Exercise 1: Low Polygon Modeling

1. In After Effects, open the **01_AE_Camera.aep** project inside the downloaded **Chapter_07** folder. It contains animated text layers and an audio track.

2. Make sure the Timeline pancl is highlighted. Select **Layer > New > MAXON CINEMA 4D File**. Save the project as **Planet.c4d** inside the **Footage** folder in the **Chapter_07** folder. The saved CINEMA 4D file opens.

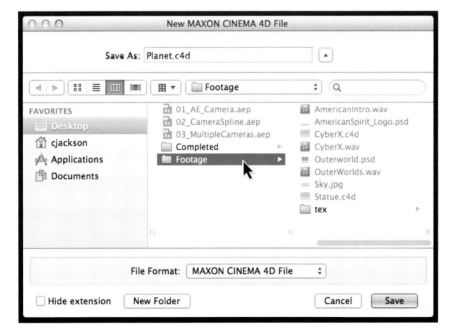

Figure 7.6: *Save your CINEMA 4D file into the Footage folder.*

3. Click on the **Render Settings** icon to open its dialog box. Click on the arrow icon under **Output**. From the preset pop-up menu, select **Film/Video> HDV/HDTV 720 29.97**. When you are done, close the Render Settings dialog box.

4. Go to the Timeline Ruler under the viewport window editor. Type in **300** in the text entry dialog box. To see all frames in the Timeline panel, click on the right arrow icon next to **300 F** and drag to the right (Figure 7.7).

Figure 7.7: *Change the duration of the Timeline Ruler to 300 frames.*

5. Locate the cube icon above the viewport window. Click and hold the icon to reveal the pop-up palette of primitive shapes. While this palette is open, left-click on the **Sphere** icon to add the shape to the scene (Figure 7.8).

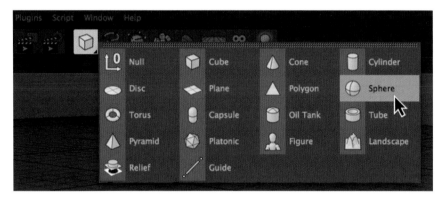

Figure 7.8: *Add a primitive sphere to the 3D scene.*

6. In the viewport, select **Display > Gouraud Shading (Lines)** (Figure 7.9).

Figure 7.9: *Change the display setting in the viewport to see the wireframe structure.*

7. Go to the Attributes Manager and make the following changes:

- ▸ Change the **Type** to **Icosahedron** using the drop-down menu.
- ▸ Uncheck the checkbox for **Render Perfect** (Figure 7.10).

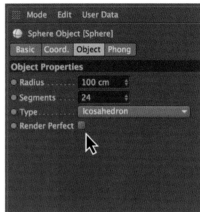

Figure 7.10: *Change the sphere's type in the Attributes Manager.*

8. Go to the Objects Manager and delete the **Phong Tag**. This tag gives an object its smooth appearance (Figure 7.11). Without it, you see the polygon structure of the object. Render the viewport to see the difference.

Figure 7.11: *Delete the Phong Tag in the Objects Manager.*

Exercise 2: Creating a Sweep NURBS

A **Sweep NURBS** uses two or more splines to generate a 3D object. One spline defines the cross section that is swept along the second spline, the path (Figure 7.12). This allows you to create 3D objects such as pipes, hoses, and rope.

Figure 7.12: *A Sweep NURBS uses two or more splines to create a 3D object.*

1. Select the **Circle** spline from the spline palette above the viewport window (Figure 7.13). The spline appears around the sphere.

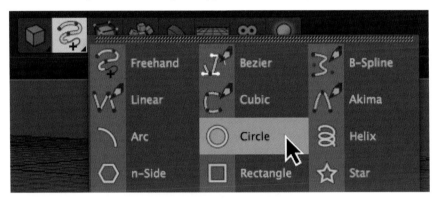

Figure 7.13: *Add a circle spline to the scene.*

2. Go to the Attributes Manager and change the circle's **Radius** to **150 cm**.

3. Add a **Rectangle** spline from the spline palette to the scene.

4. Go to the Attributes Manager and change the rectangle's **Width** to **20 cm** and its **Height** to **5 cm**. With the two splines created, the next step is to add a Sweep NURBS to generate the ring around the planet.

5. Select the **Sweep NURBS** from the NURBS object palette above the viewport. In order for the generator to work you need to place both splines inside the **Sweep NURBS** object in the Objects Manager. The order is important:

 ▸ Click and drag the **Circle** spline into the Sweep NURBS object.

 ▸ Click and drag the **Rectangle** into the Sweep NURBS object. In the viewport, you will see the ring appear around the sphere (Figure 7.14).

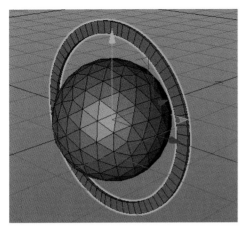

Figure 7.14: *Place the splines inside the Sweep NURBS to generate the ring.*

6. With the Sweep NURBS selected in the Objects Manager, go to the Attributes Manager and click on the **Coord.** tab to rotate the ring around the planet.

 ▸ Set the **Rotation Pitch (R.P)** to **-60 degrees**.
 ▸ Set the **Rotation Bank (R.B)** to **-90 degrees**.

7. In the Attributes Manager, click on the **Object** tab. The **Start** and **End Growth** parameters let you set how much of the circular path the rectangular spline is swept along. These parameters can be keyframed to animate growing objects.

8. The Animation Palette is located under the viewport. It contains a Timeline Ruler with a Current Time Indicator similar to After Effects. Click and drag the green square to **frame 30** in the Timeline Ruler (Figure 7.15).

Figure 7.15: *Move the Current Time Indicator (green square) to frame 30.*

9. Go to the Attributes Manager and change the **End Growth** value to **0%**.

10. Hold down the Control key and click on the gray round circle in front of the **End Growth** parameter. The circle will fill solid red indicating that a keyframe was recorded at frame 30 (Figure 7.16).

11. Go to the Animation Palette and click and drag the Current Time Indicator (green square) forward to **frame 210** in the Timeline Ruler.

12. Go to the Attributes Manager and change the **End Growth** value to **100%**.

13. Hold down the Control key and click on the orange round circle in front of the **End Growth** parameter. The circle will fill solid red indicating that a keyframe was recorded at frame 210.

14. Click the **Play Forwards** button to see the animated ring grow around the planet.

Figure 7.16: *Change the End Growth parameter on frame 30.*

Exercise 3: Add the Materials and Lights

In this next exercise we will add the materials and lighting to our logo.

1. Go to the Materials Manager. Select **Create > New Material**. You can also double-click anywhere in the Materials Manager to create a new material.

2. Double-click on the **Mat** icon to open the Material Editor dialog box.

3. While the **Color** channel is selected, change the **RGB Color** values to R = 255, G = 125, B = 50. This will create an orange color for the planet. Rename the material **Planet** (Figure 7.17).

Figure 7.17: *Create the orange material for the planet's surface.*

4. Go to the Materials Manager. Select **Create > New Material** to add a second new material to the manager's panel.

5. Go to the Material Editor dialog box. While the **Color** channel is selected, click on the **Texture** arrow to open the dropdown menu (Figure 2.54).

6. While the **Color** channel is selected, change the **RGB Color** values to R = 249, G = 255, B = 80. This will create a yellow color for the planet's ring. Rename the material **Ring** (Figure 7.18).

Figure 7.18: *Create the yellow material for the planet's ring.*

7. Click and drag the **Planet** material from the Materials Manager and drop it onto the **Sphere name** in the Objects Manager.

8. Click and drag the **Ring** material from the Materials Manager and drop it onto the **Sweep NURBS name** in the Objects Manager.

Chapter 7: Working with Cameras in CINEMA 4D and CINEWARE

9. Click on the **Render View** icon to preview the materials (Figure 7.19). The next step is to add some dramatic lighting to the logo.

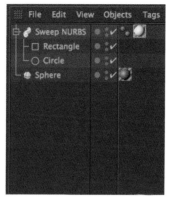

Figure 7.19: *Render a preview of the viewport window to see the materials.*

10. Click on the **Light** icon to add a light source to your 3D scene. In the Objects Manager, rename the light to **Top Light**.

11. Go to the Attributes Manager and click on the **General** tab.

 ▸ Change the **RGB Color** values to R = **255**, G = **137**, B = **12**.

 ▸ Decrease the **Intensity** value to **80%**.

12. In the Attributes Manager, click on the **Coord.** tab.

 ▸ Set the **X-Position** to **0 cm**.

 ▸ Set the **Y-Position** to **450 cm**.

 ▸ Set the **Z-Position** to **0 cm**.

13. Click on the **Light** icon to add another light source to your scene. In the Objects Manager, rename the light to **Right Light**.

14. Go to the Attributes Manager and click on the **General** tab.

 ▸ Change the **RGB Color** values to R = **80**, G = **60**, B = **250**.

 ▸ Increase the **Intensity** value to **200%**.

15. In the Attributes Manager, click on the **Coord.** tab.

 ▸ Set the **X-Position** to **300 cm**.

 ▸ Set the **Y-Position** to **150 cm**.

 ▸ Set the **Z-Position** to **-100 cm**.

16. Click on the **Light** icon to add a third light source to your scene. In the Objects Manager, rename the light to **Left Light**.

17. Go to the Attributes Manager and click on the **General** tab.

 ▸ Change the **RGB Color** values to R = **0**, G = **17**, B = **60**.

 ▸ Increase the **Intensity** value to **200%**.

18. In the Attributes Manager, click on the **Coord.** tab.
 ▸ Set the **X-Position** to **-200 cm**.
 ▸ Set the **Y-Position** to **-150 cm**.
 ▸ Set the **Z-Position** to **0 cm**.

19. In the Attributes Manager, click on the **Details** tab.
 ▸ Set the **Falloff** property to **Inverse Square (Physically Accurate)**.
 ▸ Set the **Radius/Decay** of the falloff to **500 cm**.

20. Click on the **Light** icon to add the final light source to your 3D scene. In the Objects Manager, rename the light to **Bottom Light**.

21. Go to the Attributes Manager and change the **RGB Color** values to R = **255**, G = **255**, B = **255**.

22. In the Attributes Manager, click on the **Coord.** tab.
 ▸ Set the **X-Position** to **0 cm**.
 ▸ Set the **Y-Position** to **150 cm**.
 ▸ Set the **Z-Position** to **-250 cm**.

23. Click on the **Render View** icon to preview the lighting (Figure 7.20).

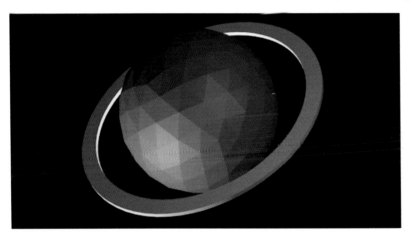
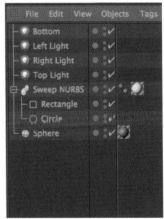

Figure 7.20: *Render a preview of the viewport window to see the lighting effect.*

Careful placement of the light objects, and the adjustment of their intensity and color, helps define the details of the planet's surface. Using lighting and color also allows the viewer's eye to focus on specific parts of the logo and accents the low polygon effect. The final rendered image mixes the material colors with the light sources that are colored to bring out more of an emotional impact.

24. Save your CINEMA 4D file. Instead of adding a camera to this scene, you will use an 3D camera layer in After Effects to animate around the logo.

Exercise 4: Changing the CINEWARE's Camera Settings

In this exercise you will use an camera layer created in After Effects
to move through the 3D space inside a CINEMA 4D file.

1. Jump back to After Effects. CINEWARE updates the CINEMA 4D file
 in the Composition panel.

2. Since you changed the frame duration in the CINEMA 4D file, retrim
 the CINEMA 4D layer's Out Point by clicking and dragging it to the end
 of the composition (Figure 7.21).

Figure 7.21: *Retrim the Out Point to extend to the end of the composition.*

3. Let's add a camera to the composition. Select **Layer > New > Camera**.
 The Camera Settings dialog box appears. Enter **AE Camera** for the name
 (Figure 7.22). Click **OK**.

Figure 7.22: *Add a 3D camera to the composition.*

4. Click on the **Panet.c4d** layer in the Timeline. In the CINEWARE panel, change
 the **Camera** to **Centered Comp Camera** under the Project Settings. The logo
 repositions to the center of the Composition panel (Figure 7.23).

Figure 7.23: *Change the CINEWARE Camera to Centered Comp Camera.*

5. Make sure the Current Time Indicator (CTI) is on the first frame in the Timeline.

6. Twirl open the **AE_Camera's** transform properties. Any changes you make to these settings will change the view in the CINEMA 4D layer (Figure 7.24).

 ▸ Set the **Z-Position** to **-800**. The planet will move closer to the camera.

 ▸ Click on the **stopwatch** icon next to the **Position** property.

 ▸ Click on the **stopwatch** icon next to the **X Rotation** property.

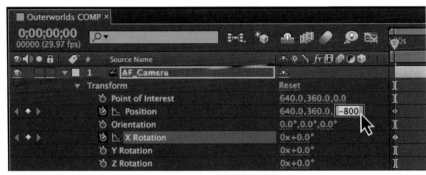

Figure 7.24: *Set keyframes for the 3D camera layer on the first frame in the Timeline.*

7. Move the CTI forward in the Timeline to position it after the 6-second mark.

8. Make the following changes to the **AE_Camera** layer's properties (Figure 7.25):

 ▸ Set the **X-Position** to **300**.

 ▸ Set the **Y-Position** to **1200**.

 ▸ Set the **Z-Position** to **-900**.

 ▸ Set the **X Rotation** to **0x-2.0 degrees**.

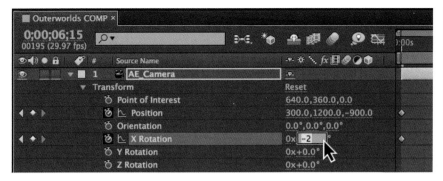

Figure 7.25: *Set keyframes for the 3D camera layer in the Timeline.*

9. Click on the **RAM Preview** button to see the camera animation as it moves through the 3D space within the CINEMA 4D file.

10. Change the CINEWARE **Renderer** to **Standard (Final)**.

11. Save your After Effects project. Select **Composition > Add to Render Queue**.

12. In the Output To dialog box select the **Chapter_07** folder on your hard drive.

13. Click on **Lossless** next to Output Module. Set the format to **QuickTime** movie. Under Format Options, set the compression setting to **H.264** or **MPEG-4 Video**.

14. Set the Audio sampling at **44.100 kHz** using the drop-down menu. Click **OK**.

15. Click the **Render** button.

16. When the render is done, go to the **Chapter_07** folder on your hard drive. Launch the QuickTime movie (Figure 7.26).

Figure 7.26: *The final rendered QuickTime movie.*

This completes the project. As you can see, CINEWARE is extremely versatile in allowing you to change cameras between CINEMA 4D and After Effects. The next project demonstrates how to attach a camera to a path in CINEMA 4D.

Attaching a Target Camera to a Spline

The goal of this lab is to become familiar with more camera techniques in CINEMA 4D Lite. A **target camera** differs from a normal camera in that it focuses on a specific object. This camera can be moved freely within a scene without "losing sight" of the targeted object.

You can also attach a camera to a particular spline and animate it along the path. This must be a spline object. Locate and play the **AmericanSpirit.mov** file in the **Completed** folder inside **Chapter_07** (Figure 7.27). The camera animation was created using a target camera attached to a circular spline that surrounds the statue. The following exercises demonstrate how to achieve this cinematic effect. Let's get started.

Figure 7.27: *The finished project is an animated title sequence.*

Exercise 5: Creating a Target Camera in CINEMA 4D

The first part of this exercise creates a target camera to "look" at the statue.

1. In After Effects, open the **02_CameraSpline.aep** project inside the downloaded **Chapter_07** folder. It contains all the elements needed to complete the project.

 The file contains a composition with a CINEMA 4D layer. The CINEWARE renderer is set to **Standard (FINAL)**. Click the **RAM Preview** button and you will see the statue remains in place, centered within the Composition panel.

2. Select the **Statue.c4d** layer in the Timeline panel to highlight it.

3. To open this file in CINEMA 4D Lite select **Edit > Edit Original**.

4. In CINEMA 4D Lite, click and hold the camera icon to reveal the pop-up palette of camera types. While this palette is open, left-click on the **Target Camera** icon to add the camera to the scene (Figure 7.28).

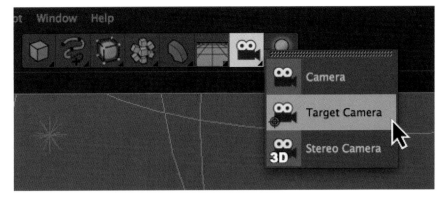

Figure 7.28: *Add a Target Camera to the scene.*

5. Go to the Objects Manager and rename the target camera to **Animated Camera**. A Target Camera also adds a Null object named **Camera.Target.1** to the scene. This is the object the camera looks at. Rename it **Look at Me** (Figure 7.29).

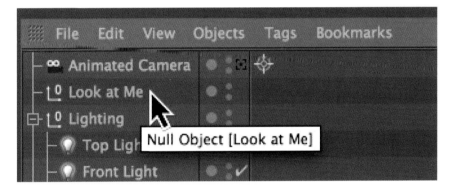

Figure 7.29: *Rename the Null object in the Objects Manager.*

6. Make sure the **Look at Me** Null object is still highlighted in the Objects Manager. Let's animate this object over time and the target camera will follow it.

7. In the Attributes Manager, click on the **Coord.** tab.
 ▸ Set the **X-Position** to **0 cm**.
 ▸ Set the **Y-Position** to **375 cm**.
 ▸ Set the **Z-Position** to **0 cm**.

8. This repositions the Null object to the head of the statue. Make sure the Current Time Indicator in the Timeline Ruler is at **frame 0**.

9. Click on the **Record Active Objects** icon to record keyframes for the Null object's position on frame 0 in the Timeline Ruler.

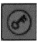

10. Go to the Animation Palette. Click and drag the Current Time Indicator (green square) to **frame 120** in the Timeline Ruler.

11. Set the **Y-Position** for the Null Object to **275 cm** This lowers the object to the center of the statue. Note the **red circle** to the left of the **Y Position** changes from a red stroke to an orange stroke. This is a visual indicator that keyframed properties have been changed since the initial recording (Figure 7.30).

12. Click on the **Record Active Objects** icon to record keyframes for the Null object's position on frame 120 in the Timeline Ruler. Note that the red circles in the Attributes Manager fill in solid red indicating that keyframes were recorded for the properties.

13. Go to the Animation Palette. Click and drag the Current Time Indicator (green square) to **frame 240** in the Timeline Ruler.

14. Set the **Y-Position** for the Null Object back to **375 cm**.

15. Click on the **Record Active Objects** icon to record keyframes for the Null object's position on frame 240 in the Timeline Ruler.

16. To view what the target camera is looking at in the viewport, go to the Objects Manager. Click on the **target** to the right of the **Animated Camera name**. The target will turn white (Figure 7.31).

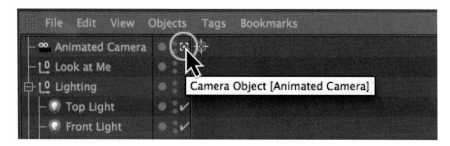

Figure 7.31: *Change the viewport camera to the target camera's view.*

17. Click the **Play Forwards** button to see the camera follow the animated Null object (Figure 7.32). If a target object is moved, the camera will follow. The next exercise uses a spline that acts as a path along which the target camera will be animated.

Figure 7.32: *Click on the Play Forwards button to preview the camera animation.*

Exercise 6: Align to Spline

The next part of this exercise attaches the target camera to a spline path.

1. Select the **Circle** spline from the Spline palette above the viewport window The spline appears around the base of the statue.

2. Go to the Attributes Manager and change the circle's **Radius** to **500 cm**. Set the **Plane** parameter to **XZ** using the dropdown menu.

3. In the Attributes Manager, click on the **Coord.** tab (Figure 7.33).

 ▸ Set the **X-Position** to **0 cm**.

 ▸ Set the **Y-Position** to **250 cm**.

 ▸ Set the **Z-Position** to **-205 cm**.

 ▸ Set the **Rotation Heading (R.H)** to **90 degrees**.

 ▸ Set the **Rotation Bank (R.B)** to **-15 degrees**.

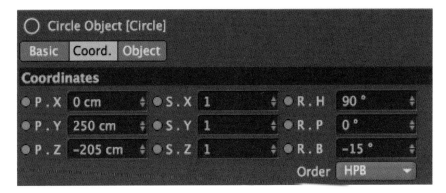

Figure 7.33: *Position and rotate the circle spline in the scene.*

4. Now we have a circle that surrounds the statue – a track for the camera. The camera needs to be attached to this spline. This is done using a CINEMA 4D Tag. Go to the Object Manager and select the **Animated Camera**.

5. Select **Tags > CINEMA 4D Tags > Align to Spline** (Figure 7.34).

Figure 7.34: *Add a CINEMA 4D tag to the target camera in the Objects Manager.*

6. A tag appears next to the target camera in the Objects Manager. Click and drag the **Circle** from the Objects Manager to the tag field named **Spline Path** in the Attributes Manager (Figure 7.35). The target camera's view changes to show the back of the statue's head. It is now attached to the spline.

7. Now that the target camera is positioned on the circular path. The next step is to animate it. Go to the Animation Palette. Click and drag the Current Time Indicator (green square) to **frame 0** in the Timeline Ruler.

Figure 7.35: *Set the Circle as the Spline Path.*

8. Hold down the Control key and click on the empty black circle next to the **Position** parameter for the Align to Spline Tag. This is a keyboard shortcut to record a keyframe for a parameter (Figure 7.36). The circle fills in solid red.

Figure 7.36: *Record a keyframe for the target camera's position on the spline.*

9. Go to the Animation Palette. Click and drag the Current Time Indicator (green square) to **frame 240** in the Timeline Ruler.

10. Change the Position parameter to **100%** for the Align to Spline Tag. The red circle changes from a red stroke to an orange stroke indicating the parameter's value has been changed since the initial recording. Control-click on the orange stroked circle to record a keyframe of frame 240 (Figure 7.37).

Figure 7.37: *Record a keyframe for the target camera's position on frame 240.*

11. Click the **Play Forwards** button to see the camera animate around the statue (Figure 7.38). The circle spline acts as a path along which the target camera moves. The animated Null object keeps the focus of the camera on the statue.

Figure 7.38: *Preview the target camera's animation in the viewport.*

12. Save your CINEMA 4D file. Select **File > Save**.

Exercise 7: Temporal Interpolation in CINEMA 4D

CINEMA 4D interpolates both space and time. You see the spatial interpolation as a motion path in the viewport. **Temporal** interpolation refers to the change in value between keyframes with regards to time. You can determine whether the value stays at a constant rate, accelerates or decelerates. CINEMA 4D bases its interpolation methods on the Bezier interpolation method using **F-Curves**. Directional handles allow you to control the transition between keyframes.

Easing provides more realistic movement to objects since nothing in real life moves at a constant speed. Similar to After Effects, CINEMA 4D provides several different types of easing including: Easy Ease, Ease In, and Ease Out. The default interpolation applies Easy Ease. This smooths both the keyframe's incoming and outgoing interpolation. Let's explore how to change this.

1. Locate the **Layout** pop-up menu in the upper right corner. Select **Animation** from the menu options (Figure 7.39). The user interface reconfigures its panels and a new Timeline panel opens to display the interpolation tools available to fine-tune the animation.

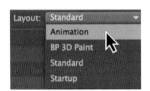

2. The new Timeline panel is similar to the Timeline panel in After Effects. To see all the recorded keyframes in the project, select **Frame > Frame All** (Figure 7.40). This panel allows you to move and change the keyframe interpolation.

Figure 7.39: *Change the layout to Animation.*

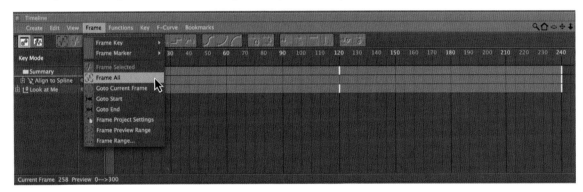

Figure 7.40: *Frame all of the keyframes in the Timeline panel.*

3. Any object that has recorded keyframes has its own horizontal track. Click on the "+" icon next to **Align to Spline** to open its animated parameter (Figure 7.41) This is similar to revealing a layer's Transform properties in After Effect.

Figure 7.41: *Open the animated parameter for the Align to Spline Tag.*

4. Single-click on the **Position** parameter to select all of its keyframes. The default Timeline mode is referred to as **Key Mode**. Recorded keyframes are visually represented by the solid blue rectangles in the Timeline.

5. While the keyframes are selected, click on the **Linear** icon (Figure 7.42). This removes the default easing applied at the beginning and at the end of the camera animation. Linear interpolation moves at a constant rate. The distance traveled by the target camera along the circular path is now the same for each frame. Click on the **Play Forwards** button to see the linear interpolation.

Figure 7.42: *Change the keyframed interpolation to Linear in the Timeline panel.*

6. To reapply easing to the camera's motion, click on any of the easing icons at the top of the Timeline panel (Figure 7.43).

Figure 7.43: *Reapply an ease to the camera motion using the Easing tools.*

7. Similar to the Graph Editor in After Effects, CINEMA 4D provides an **F-Curve Manager**. Click on the **F-Curve** icon in the top left corner of the Timeline panel (Figure 7.44). The horizontal tracks are replaced with a graph showing the change in position over time. Each keyframe contains **Tangency handles** which allow you to fine tune the temporal transition between keyframes.

 Pressing the spacebar toggles the Timeline panel between the Key Mode and the F-Curve Mode.

8. Experiment with the black Tangency handles for each keyframe. You can manipulate them by dragging them up and down in the Timeline panel.

9. When you are done with the F-Curve, change the CINEMA 4D layout back to **Standard** using the **Layout** menu options.

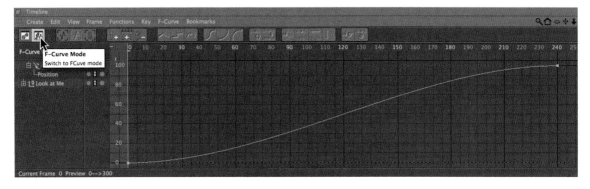

Figure 7.44: *The F-Curve manager allows you to manipulate the interpolation.*

10. Save your CINEMA 4D file. Select **File > Save**.

11. Jump back to After Effects. The CINEWARE plug-in updates the CINEMA 4D file in the Composition panel. Click the **RAM Preview** button and you will see the new camera animation that moves around the statue.

12. Save your After Effects project. Select **Composition > Add to Render Queue**.

13. In the Output To dialog box select the **Chapter_07** folder on your hard drive

14. Click on **Lossless** next to Output Module. Set the format to **QuickTime** movie. Under Format Options, set the compression setting to **H.264** or **MPEG-4 Video**.

15. Set the Audio sampling at **44.100 kHz** using the drop-down menu. Click **OK**.

16. Click the **Render** button.

17. When the render is done, go to the **Chapter_07** folder on your hard drive. Launch the QuickTime movie (Figure 7.45). This completes the project. The next exercise focuses on editing multiple cameras together using CINEWARE.

Figure 7.45: *The final rendered QuickTime movie.*

Controlling Multiple Cameras in CINEWARE

As you learned at the beginning of this chapter, you can add multiple cameras to a CINEMA 4D file. CINEWARE allows you to choose which camera view to display in the Composition panel in After Effects. Locate and play the **CyberX mov** file in the **Completed** folder inside **Chapter_07** (Figure 7.46). In this next project, you will CINEWARE to edit multiple camera views together using only one CINEMA 4D file.

Figure 7.46: *The finished project is an animated logo for a fictitious company.*

Exercise 8: Choosing a CINEMA 4D Camera in CINEWARE

This exercise demonstrates how to use the Project Settings in CINEWARE to select a camera inside a CINEMA 4D file.

1. In After Effects, open the **03_MultipleCameras.aep** project inside the downloaded **Chapter_07** folder. The project contains a composition with a CINEMA 4D layer and an audio track.

2. Select the **CyberX.c4d** layer in the Timeline panel to highlight it.

3. To open this file in CINEMA 4D Lite select **Edit > Edit Original**.

4. The CINEMA 4D file contains three placed cameras. Each camera is animated and focuses on different parts of the extruded logo (Figure 7.47).

 ▸ The **Top Camera** looks down on the extruded logo. The view gives the illusions of looking at the sides of buildings in a futuristic environment.

 ▸ The **X Camera** slowly trucks out to reveal the extruded X in the logo.

 ▸ The **Wide Camera** pans over the extruded logo from left to right. As it pans, the camera trucks back to reveal the final shot of the logotype.

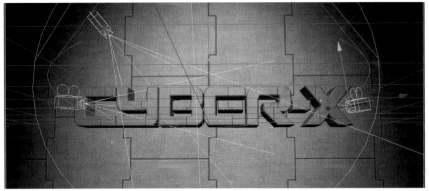

Figure 7.47: *Three separate cameras provide different animated views of the logotype.*

5. Jump back to After Effects. Make sure the **CyberX.c4d** layer is still selected.

6. Go to the Project Settings in CINEWARE and change the **Camera** setting to **Select CINEMA 4D Camera** (Figure 7.48).

Figure 7.48: *Change the Camera settings in CINEWARE.*

7. Click on the **Set Camera** button to open the CINEMA 4D camera dialog box.

8. Select **Top Camera** from the dropdown menu. Click **OK** (Figure 7.49).

Figure 7.49: *Change the CINEMA 4D camera to the Top Camera view.*

9. The Composition panel updates with the camera view from the CINEMA 4D file. Move the Current Time Indicator (CTI) to three seconds (03:00).

10. Go to the Project panel and drag another copy of the **CyberX.c4d** footage file to the Timeline. Position at the top of the stacked layers and align the left edge of its colored bar with the CTI (Figure 7.50).

Figure 7.50: *Add another copy of the CINEMA 4D footage file to the composition.*

11. Go to the Project Settings in CINEWARE and change the **Camera** setting to **Select CINEMA 4D Camera**.

12. Click on the **Set Camera** button to open the CINEMA 4D camera dialog box.

13. Select **X Camera** from the dropdown menu. Click **OK** (Figure 7.51).

Figure 7.51: *Change the CINEMA 4D camera to the X Camera view.*

14. Move the Current Time Indicator (CTI) to five seconds (05:00).

15. Go to the Project panel and drag another copy of the **CyberX.c4d** footage file to the Timeline. Position at the top of the stacked layers and align the left edge of its colored bar with the CTI (Figure 7.52).

Figure 7.52: *Add another copy of the CINEMA 4D footage file to the composition.*

16. Go to the Project Settings in CINEWARE and change the **Camera** setting to **Select CINEMA 4D Camera**.

17. Click on the **Set Camera** button to open the CINEMA 4D camera dialog box.

18. Select **Wide Camera** from the dropdown menu. Click **OK** (Figure 7.53).

Figure 7.53: *Change the CINEMA 4D camera to the Wide Camera view.*

19. Click on the **RAM Preview** button to see the different camera views edited together. Since the CINEMA 4D file becomes a 2D layer in After Effects, it contains the layer transform properties such as opacity.

20. Move the Current Time Indicator (CTI) to three seconds (03:00).

21. Select the middle **CyberX.c4d** layer and rename it **X Camera**. Type **T** on the keyboard to show only the Opacity property. Scrub through the numeric value to set it to **0%**.

22. Click on the **stopwatch** icon next to Opacity to activate keyframes.

23. Move the Current Time Indicator (CTI) to four seconds (04:00).

24. Scrub through the Opacity numeric value and set it back to **100%**. A keyframe is automatically generated (Figure 7.54).

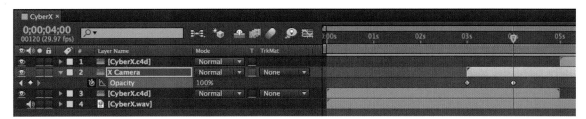

Figure 7.54: *Set keyframes to the Opacity property.*

25. Move the Current Time Indicator (CTI) to five seconds (05:00).

26. Select the top **CyberX.c4d** layer and rename it **Wide Camera**. Type **T** on the keyboard to show only the Opacity property. Scrub through the numeric value to set it to **0%**.

27. Move the Current Time Indicator (CTI) to six seconds (06:00).

28. Scrub through the Opacity numeric value and set it back to **100%**. A keyframe is automatically generated (Figure 7.55).

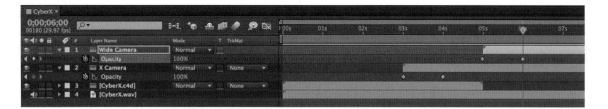

Figure 7.55: *Set keyframes to the Opacity property.*

29. Click on the **RAM Preview** button to see the keyframed animation. Fading in the CINEMA 4D layers helps the transition from one camera view to the next.

30. Trim the **X Camera** and **CyberX.c4d** layers back in the Timeline (Figure 7.56).

Figure 7.56: *Trim the layers in the Timeline.*

31. Change the CINEWARE **Renderer** to **Standard (Final)**.

32. Click on the **Apply to All** button to change the renderer for all CINEMA 4D layers in the composition (Figure 7.57).

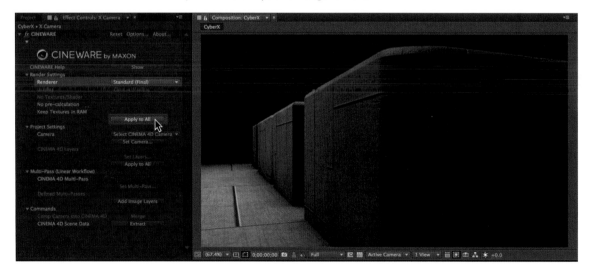

Figure 7.57: *Change the CINEWARE renderer for all the CINEMA 4D layers.*

33. Save your After Effects project. Select **Composition > Add to Render Queue**.

34. In the Output To dialog box select the **Chapter_07** folder on your hard drive.

35. Click on **Lossless** next to Output Module. Set the format to **QuickTime** movie. Under Format Options, set the compression setting to **H.264** or **MPEG-4 Video**.

36. Set the Audio sampling at **44.100 kHz** using the drop-down menu. Click **OK**.

37. Click the **Render** button.

38. When the render is done, go to the **Chapter_07** folder on your hard drive. Launch the QuickTime movie (Figure 7.58).

Figure 7.58: *The final rendered QuickTime movie.*

Adding a Stage Object to Change Cameras

The previous exercise demonstrated how CINEWARE lets you become a film editor in After Effects. The Project Settings allow you to select different cameras located inside a CINEMA 4D file. You can also use the **Stage** object in CINEMA 4D to do something similar. It acts like a movie director allowing you to change a camera, environment, or background image within an animation.

Exercise 9: Assigning Cameras to a Stage Object

In this exercise you will create a Stage object in CINEMA 4D to animated between different camera views within the same file.

1. Jump back to CINEMA 4D Lite. Make sure the **CyberX.c4d** file is still open.

2. Select **File > Save As**. Save the CINEMA 4D file as **CyberX_StageObject.c4d** into the **Footage** folder in **Chapter_07**.

3. Locate the Floor icon above the viewport window (Figure 7.59). Click and hold the icon to reveal the pop-up palette. While this palette is open, left-click on the **Stage** icon to add the object to the Objects Manager. You will use the Stage object to switch between the three camera views in the viewport.

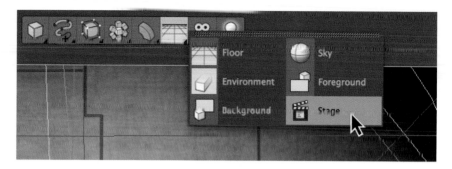

Figure 7.59: *Add a Stage object to the scene.*

4. Make sure the Current Time Indicator in the Time Ruler is at **frame 0**.

5. Click and drag the **Top Camera** from the Objects Manager into the Stage object's **Camera** box in the Attributes Manager (Figure 7.60). The viewport changes its view.

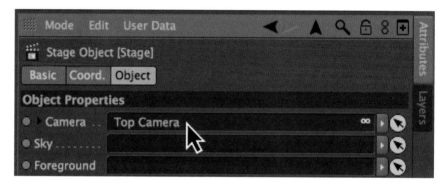

Figure 7.60: *Add a camera to the Stage object in the Attributes Manager.*

6. In the Attributes Manager, hold down the Control key and click on the gray round circle in front of the **Camera** parameter. The circle will fill solid red indicating that a keyframe was recorded at frame 0 (Figure 7.61).

Figure 7.61: *Record a keyframe for the Camera parameter on frame 0.*

7. With the first camera assigned at the start of the Timeline, let's add another camera. Go to the Animation Palette. Click and drag the Current Time Indicator (green square) to **frame 80** in the Timeline Ruler.

8. Click and drag the **Wide Camera** from the Objects Manager into the Stage object's **Camera** box in the Attributes Manager (Figure 7.62).

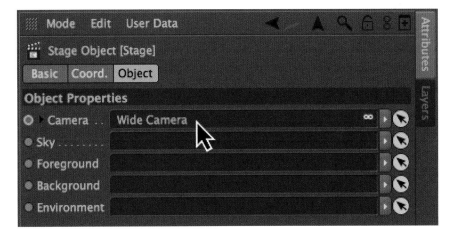

Figure 7.62: *Add another camera to the Stage object in the Attributes Manager.*

9. In the Attributes Manager, hold down the Control key and click on the orange stroked circle in front of the **Camera** parameter. The circle will fill solid red indicating that a keyframe was recorded at frame 80 (Figure 7.63).

Figure 7.63: *Record a keyframe for the Camera parameter on frame 80.*

10. Click the **Play Forwards** button (Figure 7.64). The animation starts with the first camera and then switches to the second camera at the second keyframe on frame 80.

Figure 7.64: *Click on the Play Forwards button to preview the camera animation.*

11. Save your CINEMA 4D file. Select **File > Save**.

12. Jump back to After Effects. Double-click in the Project panel to open the Import File dialog box. Locate the **CyberX_StageObject.c4d** file in the **Footage** folder inside **Chapter_07**. Click **Open** to import the footage into the Project panel.

13. Click and drag the imported file to the **Create a new Composition** icon at the bottom of the Project panel. A new composition is created.

14. Click on the **RAM Preview** button to see the Stage object switch cameras (Figure 7.65). Experiment by adding more cameras to the CINEMA 4D file and then edit them together using the Stage object.

Figure 7.65: *Preview the Stage object's camera animation in the Composition panel.*

15. Change the CINEWARE **Renderer** to **Standard (Final)**.

16. Save your After Effects project. Select **Composition > Add to Render Queue**.

17. In the Output To dialog box select the **Chapter_07** folder on your hard drive.

18. Click on **Lossless** next to Output Module. Set the format to **QuickTime** movie. Under Format Options, set the compression setting to **H.264** or **MPEG-4 Video**.

19. Click **OK**

20. Click the **Render** button.

21. When the render is done, go to the **Chapter_07** folder on your hard drive. Launch the QuickTime movie. This completes the project and this chapter.

Summary

This chapter explored using cameras in CINEMA 4D and CINEWARE. You can add as many cameras as you want to a CINEMA 4D file, each with different settings and animation. The CINEWARE Project Settings allow you to select a CINEMA 4D camera or a 3D camera layer created in After Effects. The Camera parameter lets you choose which camera should be used to display the scene in the Composition panel. The Stage object also lets you edit your cameras together directly within CINEMA 4D Lite.

CHAPTER 8

Multi-Pass Rendering with CINEWARE

Rendering is the final stage in a 3D modeling workflow. The render engine takes into account the 3D model's geometry, its surface materials, and illumination through lighting, to produce a final image. This chapter focuses on Multi-Pass rendering for post-production using CINEWARE.

Rendering in CINEMA 4D Lite

Rendering a CINEMA 4D Lite scene is accomplished through the CINEWARE plug-in in After Effects. CINEWARE produces a 2D Image In higher quality than what the viewport can display. Rendering times can vary greatly. Simple scenes will take a few seconds to calculate. Scenes that employ highly detailed models, surface materials with reflections, and area lights and shadows, may take hours depending on the hardware used. The quality and time it takes to render the final image is controlled through the Render Settings (Figure 8.1).

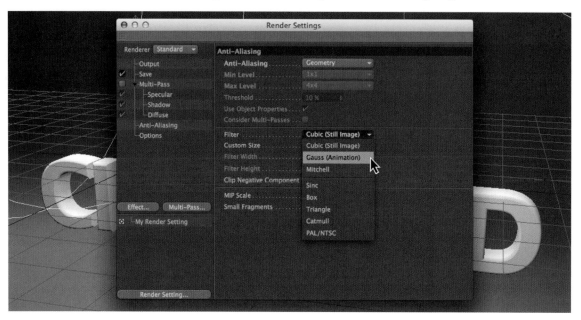

Figure 8.1: *CINEWARE uses the Render Settings in CINEMA 4D Lite.*

Anit-aliasing smooths out an object's edges and curves. Without it, the object would look jagged, with a stair-step appearance. There are two main types of anti-aliasing in CINEMA 4D. The default mode is **Geometry** which smooths all object edges. This setting works well for small format images or animation with fast movement. The second mode, **Best**, applies anti-aliasing not only to edges, but to shadows and objects behind transparencies. Think about which setting works best based on the type of CINEMA 4D project, and what the final render will be used for.

Since After Effects deals with motion at 72 pixels-per-inch, much of the higher quality detail is lost due to the reduced resolution, and that each image is seen only for a fraction of a second. For most CINEWARE projects, the Best setting would not make a large visual difference and would slow down the rendering process by using it. Consider using Best anti-aliasing for scenes with large amounts of transparencies and reflections. In addition, you can also choose a

filter to use with the anti-aliasing: **Still Image** gives a sharp edge for still images **Animation** softens the edges to reduces jittery motion in the animation.

Up to this point, you have been rendering a 2D flattened image of a 3D scene using CINEWARE. CINEMA 4D Lite also provides **Multi-Pass** rendering which renders certain parameters, channels, and effects onto different layers to refine later in a post-editing application such as After Effects. When combined together, the layers create the final rendered image (Figure 8.2). Separately, each Multi-Pass layer can be modified in After Effects to achieve a different render without having to go back to CINEMA 4D Lite.

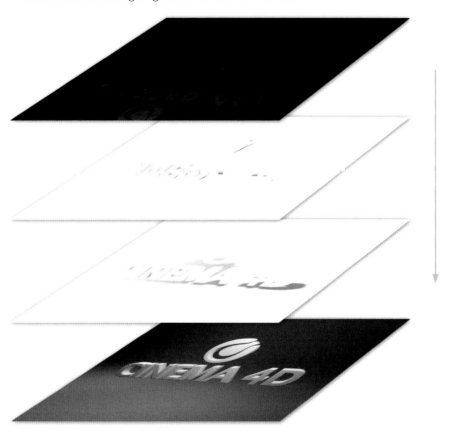

Figure 8.2: *The Multi-Pass render creates separate layers for channels and effects.*

Objects can also be isolated within a 3D scene using **object buffers**. An object buffer creates a matte that separates the image from the background. Each buffer is assigned a numeric ID when added to the Multi-Pass render. All of these render options provide and easier and faster workflow to adjust your 3D scene in After Effects without having to jump back to CINEMA 4D Lite. This chapter illustrates how to set up a scene for Multi-Pass rendering. Once this file is created and saved, you will use CINEWARE to adjust its final render.

Creating Shadows with Ambient Occlusion

Before you set up the Multi-Pass render in CINEMA 4D Lite, let's add ambient occlusion to a 3D scene. Ambient occlusion is a shading method. It simulates shadows without having to add extra lights that cast shadows. You can use ambient occlusion to emphasize geometry that contains a lot of detailed surfaces, or to add soft shadows to the entire scene. Let's see how it works.

 *Download (www.focalpress.com/9781138777934) the **Chapter_08.zip** file to your hard drive. It contains all the files needed to complete the exercises.*

Exercise 1: Adding the Ambient Occlusion Shader

This exercise demonstrates how to use ambient occlusion in a CINEMA 4D file.

1. In After Effects, open the **01_MultiPass.aep** project inside the downloaded **Chapter_08** folder. The project contains a composition with a CINEMA 4D layer.

2. Select the **MultiPass.c4d** layer in the Timeline panel to highlight it.

3. To open this file in CINEMA 4D Lite select **Edit > Edit Original**. The file contains two extruded objects, a studio backdrop object, three lights, and a placed camera (Figure 8.3).

Figure 8.3: *Open the CINEMA 4D file.*

4. Click on the **Render to Picture Viewer** icon about the viewport. The Picture Viewer renders the frame and records how long it took to render. As you can see, the lights are casting shadows onto the studio backdrop (Figure 8.4). The shadow detail in the extruded objects could be a little stronger.

Figure 8.4: *The Picture Preview displays the rendered scene.*

Most 3D applications have a difficult time creating shadows between objects that touch or lie within close proximity to one another. Rather than using a complex system of lights that cast shadows, there is an effect that will simulate shadow detail relatively fast and effectively. It is the Ambient Occlusion shader.

5. Open the Render Settings dialog box in CINEMA 4D Lite. Click on the render icon that has the sprocket.

6. Click on the **Effect** button and select **Ambient Occlusion** from the drop-down menu (Figure 8.5).

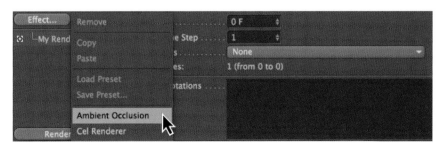

Figure 8.5: *Add the Ambient Occlusion effect in the Render Settings dialog box.*

7. Increase the **Contrast** value to **10%**. Close the Render Settings dialog box.

8. Click on the **Render to Picture Viewer** icon again. In the **History** section, click on each name to toggle between the two rendered images to see the subtle differences in the shadow detail within the 3D objects (Figure 8.6). The Ambient Occlusion shader calculates the distance between objects and simulates shadows to add more definition and detail to the extruded text.

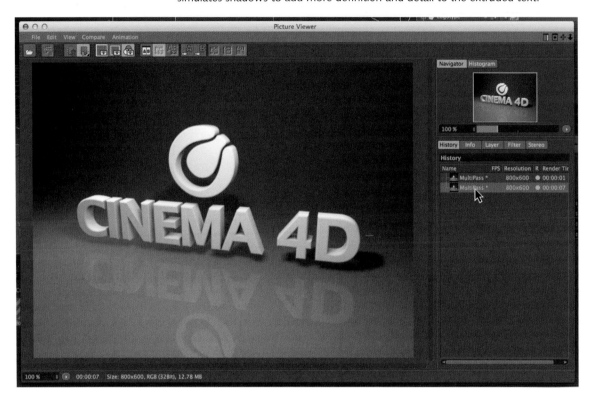

Figure 8.6: *Render the scene again to see the Ambient Occlusion effect.*

9. Notice that the render time increases to around seven seconds. To optimize this, you can experiment with the Ambient Occlusion's sampling parameters. Open the Render Settings dialog box in CINEMA 4D Lite.

10. Decrease the **Minimum Samples** value to **5** for the Ambient Occlusion. This controls the amount of noise in the shadow areas. The higher the number, the smoother the shadows, but with longer rendering times (Figure 8.7).

Figure 8.7: *Adjust the Ambient Occlusion settings to reduce the render time.*

11. Click on the **Render to Picture Viewer** icon again. In the **History** section, the render time was cut almost in half (Figure 8.8). Click on each name to toggle between the rendered images to see any differences. The sampling setting did not affect the overall final render too much. Always use the Picture Viewer to experiment with ways to reduce render times without sacrificing image quality.

Figure 8.8: *Render the scene again to see the Render Setting changes.*

12. When you are done, close the Picture Viewer dialog box.

13. Save your CINEMA 4D Lite file. Select **File > Save**. This completes this first exercise.

Setting Up Multi-Pass Rendering

All of the render settings, including Multi-Pass, are set and modified from within the Render Settings dialog box. The Multi-Pass option is where you can set up the various layers that you want to create during the rendering process.

Exercise 2: Adding Layers for Multi-Pass Rendering

1. Open the Render Settings dialog box in CINEMA 4D Lite.

2. Click on the checkbox for **Multi-Pass** to enable it (Figure 8.9).

Figure 8.9: *Enable the Multi-Pass option in the Render Settings dialog box.*

3. Click on the **Multi-Pass** button to see the different layers that can be rendered.

 ▶ Select **Shadow** from the drop-down menu to add it.

 ▶ Add **Reflection** from the drop-down menu.

 ▶ Add **Diffuse** from the drop-down menu.

 ▶ Finally, add **Ambient Occlusion** to the Multi-Pass render (Figure 8.10).

 ▶ When you are done, close the Render Settings dialog box.

Figure 8.10: *Add the channels that will render as separate layers.*

4. Use the Picture Viewer to see the separate image layer passes added to the render settings. Click on the **Render to Picture Viewer** icon about the viewport.

5. In the Picture Viewer, click on the **Layer** button and on the checkbox for **Multi-Pass** (Figure 8.11).

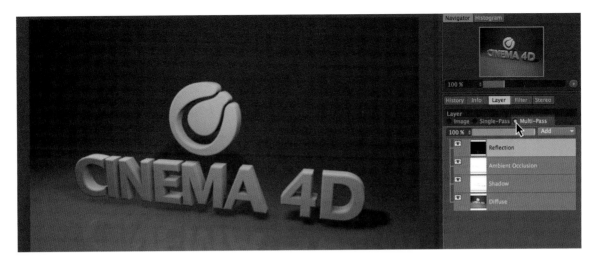

Figure 8.11: *View the individual Multi-Pass layers in the Picture Viewer.*

6. The rendered image only shows the four channels you enabled for the Multi-Pass render. Click on the eye icon to toggle each layer on and off to see what is actually rendered. Notice that the Ambient Occlusion layer contains only the simulated shadow detail (Figure 8.12).

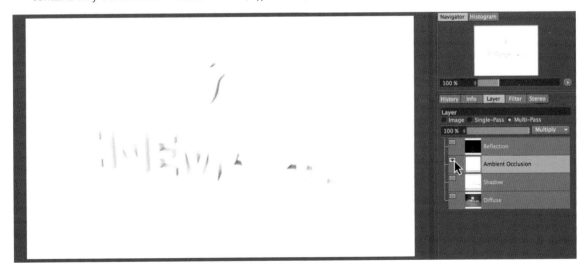

Figure 8.12: *Toggle each layer on and off to see what it will render.*

7. When you are done, turn on the visibility for all the Multi-Pass layers.

8. Close the Picture Viewer dialog box.

 This completes the exercise. With the Multi-Pass rendering set up to render individual image layers, the next exercise will explore how to create an object buffer in CINEMA 4D Lite to isolate the extruded logo symbol.

Adding an Object Buffer

An object buffer creates a mask layer for an object. This is ideal for isolating certain models in a 3D scene for post-production. A specific ID number is assigned to each object buffer. Let's create one for the extruded logo.

Exercise 3: Compositing with an Object Buffer

1. In CINEMA 4D Lite, go to the Objects Manager and select the **LOGO** Extruded NURBS object to highlight it. Object buffers are located in Compositing tags.

2. Select **Tags > CINEMA 4D Tags > Compositing** (Figure 8.13).

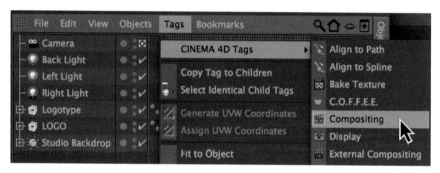

Figure 8.13: *Add a Compositing Tag to the extruded logo.*

3. Make sure the **Compositing Tag** is selected in the Objects Manager.

4. In the Attributes Manager, click on the **Object Buffer** tab. Click on the first **Enable** checkbox for the object buffer. Its numeric ID is set to **1** (Figure 8.14).

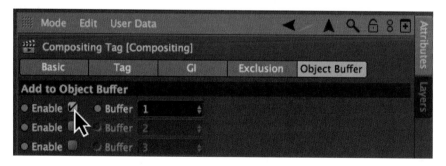

Figure 8.14: *Enable the Object Buffer for the extruded logo in the Attributes Manager.*

5. Open the Render Settings dialog box in CINEMA 4D Lite.

6. Click on the **Multi-Pass** button and add an **Object Buffer** from the drop-down menu. Make sure the Group ID is set to **1** (Figure 8.15). You can add multiple object buffers to the 3D scene using Compositing tags. Each tag will be assigned a different ID number to reference in the Multi-Pass settings.

7. Rename the **Object Buffer** to **Logo** in the Render Settings dialog box.

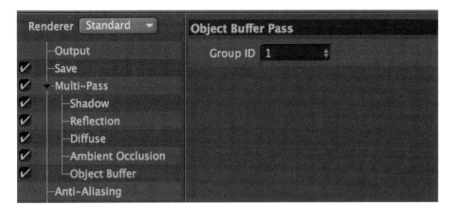

Figure 8.15: *Add the Object Buffer to the Multi-Pass render.*

8. When you are done, close the Render Settings dialog box.

9. Use the Picture Viewer to see the separate image layer passes added to the render settings. Click on the **Render to Picture Viewer** icon about the viewport.

10. Click on the **Layer** button and on the checkbox for **Multi-Pass**.

11. The rendered image only shows the five channels you enabled for the Multi-Pass render. Click on the icon for **Object Buffer 1** to see only the extruded logo matted from the background (Figure 8.16).

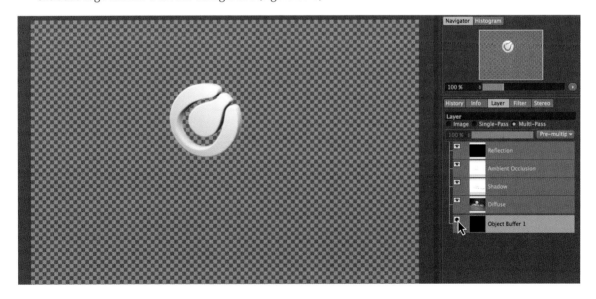

Figure 8.16: *View the Object Buffer in the Picture Viewer.*

12. When you are done, close the Picture Viewer dialog box.

13. Save your CINEMA 4D Lite file. Select **File > Save**. This completes this exercise. Let's see what CINEWARE can do with this in After Effects.

Adding an Object Buffer **251**

Compositing Multi-Pass Layers in CINEWARE

CINEWARE supports Multi-Pass rendering within a CINEMA 4D file. This allows for more control over the final rendered image during post-production work in After Effects. It is very easy to apply to a composition.

Exercise 4: Using CINEWARE's Multi-Pass Settings

1. Jump back to After Effects. The CINEWARE effect automatically updates the Composition panel.

2. Select the **MultiPass.c4d** layer in the Timeline panel to highlight it.

3. In the CINEWARE Project Settings, click on the checkbox for **Defined Multi-Passes**. Click on the **Add Image Layers** button (Figure 8.17).

Figure 8.17: *Add the image layers under the Project Settings in CINEWARE.*

4. Click **OK** to the dialog box that appears warning about post effects. Five new layers appear in the Timeline. Each layer represents an image layer from the Multi-Pass render saved in the CINEMA 4D file. Notice that the blending modes are already set (Figure 8.18).

Figure 8.18: *The Multi-Pass image layers are added to the Timeline panel.*

5. Now you can make any adjustments you want to the image layers to affect the final rendered image. Let's first add a blur the reflection. Select the **MultiPass.c4d Reflection** layer in the Timeline.

6. Select **Effect > Blur & Sharpen > Gaussian Blur**. Increase the **Blurriness** value to **10.0** (Figure 8.19).

Figure 8.19: *Add a blur to the reflection image layer.*

7. Type **T** on the keyboard to show only the Opacity property. Scrub through the numeric value to set it to **30%**.

8. Select the **MultiPass.c4d Ambient Occlusion** layer in the Timeline.

9. Select **Effect > Color Correction > Brightness & Contrast**. Decrease the **Brightness** value to **-25** to darken the shadows more (Figure 8.20).

Figure 8.20: *Darken the shadows created by the Ambient Occlusion shader.*

10. Select the **MultiPass.c4d Diffuse** layer in the Timeline.

11. Select **Edit > Duplicate** to create a copy of the layer in the Timeline.

12. Select the **MultiPass.c4d Object Buffer** layer in the Timeline. This layer will be used as a Track Matte in After Effects to mask the logo

13. Reposition the object buffer layer above the **MultiPass.c4d Diffuse 2** layer created in the previous steps (Figure 8.21).

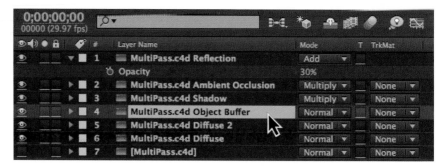

Figure 8.21: *Reposition the object buffer layer in the Timeline panel.*

14. The Composition panel displays the black and white matte created by the object buffer. Select the **MultiPass.c4d Diffuse 2** layer.

15. Click on the pop-up menu under **TrkMat** and select **Luma Matte** "**MultiPass.c4d Object Buffer**" to apply the track matte (Figure 8.22).

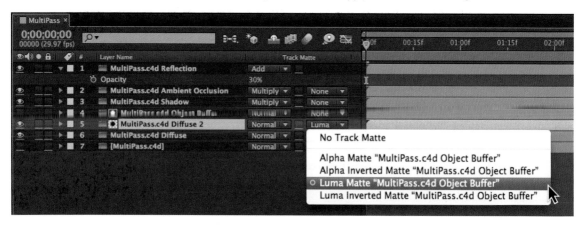

Figure 8.22: *Apply a track matte to the duplicated layer in the Timeline panel.*

16. Make sure the **MultiPass.c4d Diffuse 2** layer is still selected in the Timeline.

17. Select **Effect > Color Correction > Hue & Saturation**.

18. Change the **Master Hue** value to **215 degrees** to change the color of the logo to a teal color (Figure 8.23). Using the Object Buffer in CINEMA 4D Lite in conjunction with the Track Matte in After Effects allows you to edit your 3D objects quicker in post-production than jumping back to CINEMA 4D Lite and creating a new material for the extruded logo.

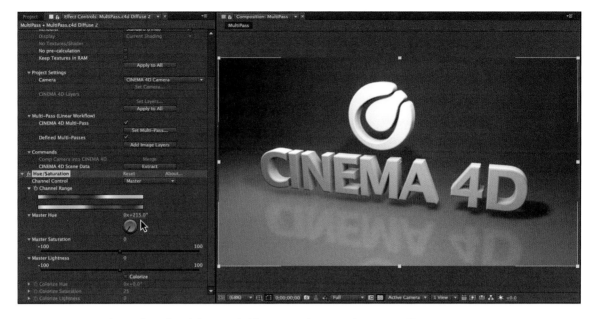

Figure 8.23: *Change the color of the extruded logo using the Hue & Saturation effect.*

19. Select the **MultiPass.c4d Shadow** layer in the Timeline panel.

20. Select **Edit > Duplicate** to create a copy of the layer in the Timeline. This new layer increases the intensity of the cast shadows as a result of the blending mode being set to **Multiply**.

21. Type **T** on the keyboard to show only the Opacity property. Scrub through the numeric value to set it to **50%** (Figure 8.24).

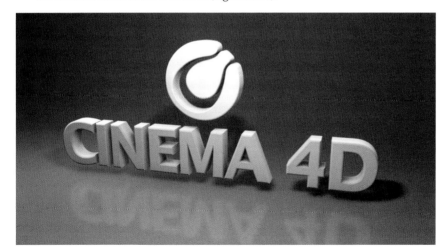

Figure 8.24: *The final layered composite using the Multi-Pass render in CINEWARE.*

22. Save your After Effects project. This completes the exercise and this chapter.

The final composition is now complete. Using the Multi-Pass render in CINEMA 4D and CINEWARE allows you to adjust several components in post-production with ease. The changes you made would traditionally require the whole image to be re-rendered to test each change. CINEWARE and the multi-pass method does all the hard work for you and saves a tremendous amount of time.

Summary

This chapter explored render settings using CINEWARE. CINEMA 4D Lite provides Multi-Pass rendering which renders certain parameters, channels, and effects onto different layers to refine later in After Effects. When combined together, the layers create the final rendered 2D image. Separately, each Multi-Pass image layer can be modified in After Effects to achieve a different render without having to go back to CINEMA 4D Lite.

Rendering is the last stage of the 3D workflow. The next, and final, chapter concludes your journey using After Effects and CINEMA 4D Lite. It focuses on upgrading CINEMA 4D Lite to include more MoGraph functionality to add to your motion graphics projects.

CHAPTER 9

Beyond CINEMA 4D Lite

CINEMA 4D Lite provides an extensive set of tools, features, and functions to create 3D content for After Effects. Upgrading to CINEMA 4D Broadcast or Studio unlocks even more 3D capabilities. This last chapter explores some of the added features you get if you go beyond CINEMA 4D Lite.

Upgrading from CINEMA 4D Lite

This book has focused on some creative possibilities you now have at your fingertips with CINEMA 4D Lite. Even though it is a scaled-down version of CINEMA 4D, the Lite version still provides a surprisingly extensive set of tools to build 3D content. If you want to go beyond CINEMA 4D Lite, think about upgrading to either CINEMA 4D Broadcast or Studio.

Figure 9.1: *Upgrade to CINEMA 4D Broadcast or Studio to get all of the MoGraph tools.*

Upgrading CINEMA 4D Lite will unlock even more features and functions to enhance your motion graphics projects. So what do you get? CINEMA 4D Broadcast offers the following new features to add to your 3D repertoire:

- ▶ MoGraph: All of the motion graphics tools are included (Figure 9.1). Currently, CINEMA 4D Lite only includes the Fracture object and two effectors, Plain and Random.
- ▶ Polygonal modeling tools allow you to mold your parametric primitives into new organic or hard-edged models.
- ▶ Physical Render uses real camera settings to view your scene with 3D depth of field, motion blur and more.
- ▶ Particle Systems allow you to use any object, including lights. Applying various physical effects such as gravity, turbulence, and wind can enhance your 3D animation.
- ▶ Stereoscopic Rendering allows you to create stereo 3D visuals.

- Dynamics with MoGraph allow your objects to include bounce, gravity, and friction parameters.
- The Camera Crane object allows you to create realistic cinematic camera shots with just a few clicks.

CINEMA 4D Studio includes all of the features of Broadcast plus:

- Physics simulation, such as Soft Body Dynamics and Cloth Dynamics, add more organic realism to your 3D project.
- Hair can be easily apply to a surface and animate over time.
- Sculpting tools turn your models into digital clay.
- Sketch and Toon rendering allows you to output cel-rendered animation for your motion graphics projects.

If you own a professional version of CINEMA 4D, you can use that with CINEWARE instead of the Lite version that comes with After Effects. Click on the **Options** hyperlink within the CINEWARE panel. This opens the CINEWARE Settings dialog box. Change both the render and executable path to the professional version of CINEMA 4D instead of the Lite version (Figure 9.2).

Figure 9.2: *Link to a professional version of CINEMA 4D through the CINEWARE options.*

There are some subtle user interface differences between the Lite version and the CINEMA 4D Broadcast or Studio versions. Some of the icons in the toolbar are designed differently. There are more menu options for new features (Figure 9.3).

Figure 9.3: *There are some subtle user interface differences between the Lite version (top image) and the professional versions (bottom image) of CINEMA 4D.*

Starting with the R15 professional versions of CINEMA 4D, the HyperNURBS object has been renamed to Subdivision Surface. Basically, the new name describes what the tool does better than using the term HyperNURBS. The icon looks exactly the same as it does in CINEMA 4D Lite. It also functions the same as HyperNURBS in the Lite version. If you click and hold on the **Subdivision Surface** icon and look at the other NURB objects in the pop-up palette, you can see that the word NURBS has been removed from all of them (Figure 9.4). The generators all behave exactly the same as they do in the Lite version, just the names have changed.

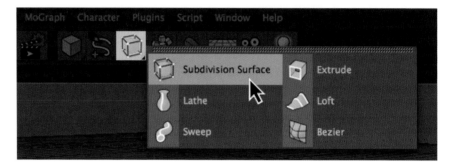

Figure 9.4: *The word NURBS has been removed from the generator objects in the professional versions of CINEMA 4D.*

The goal of this last chapter is to highlight some of the professional tools and functions not available in the Lite version. If you have a copy of CINEMA 4D Broadcast or Studio, you can follow along and build the exercises throughout this chapter. If you only have the Lite version, you can download a trial version of CINEMA 4D Studio from www.maxon.net. This will help you determine how upgrading CINEMA 4D Lite can enhance your 3D motion graphics.

Modeling with Points, Edges, and Polygons

As you read in Chapter 2, parametric primitives are used as the building blocks to create models in CINEMA 4D. If we break these parametric objects down to their underlying structure, you will see that they are made up of points, edges, and polygons. CINEMA 4D Lite does allow you to convert a parametric object into a polygonal object by clicking on the **Make Editable** button (Figure 9.5). Think of this action as the same as converting text to outlines in Adobe Illustrator or rasterizing a text layer in Adobe Photoshop.

Once a parametric object has been made editable in a scene, the Points, Edges, and Polygons modes become active. What do they affect? **Points** are the intersections where the structural lines cross each other. **Edges** are the actual lines themselves that define the shape of the object. **Polygons** are the surface shapes formed within a connected subdivision (Figure 9.5).

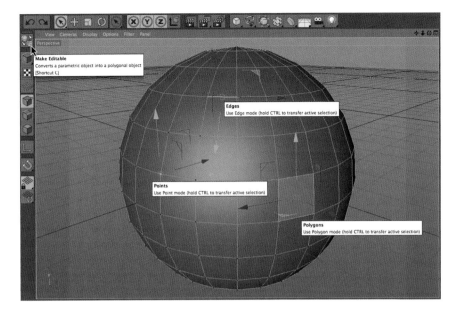

Figure 9.5: *You can break apart a parametric primitive to modify its points, edges, and polygons using the Make Editable button.*

Complex objects with very fine detail are typically achieved through polygonal modeling. Being able to manipulate at the polygon or point level gives you the most control over the final shape. CINEMA 4D Lite allows you to move and rotate points, edges, and polygons, but that is about it. To create a model with any complexity would take a long time. There are many polygon modeling tools available in CINEMA 4D Broadcast or Studio to help speed up the process.

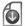 *Download (www.focalpress.com/9781138777934) the* **Chapter_09.zip** *file to your hard drive. It contains all the files needed to complete the exercises.*

Exercise 1: Using Polygon Modeling Tools

Polygon modeling tools are not included in the Lite version. In order to complete the following exercise you will need either the CINEMA 4D Broadcast or Studio professional version. This exercise demonstrates how to use some of the polygon modeling tools to create a 3D object.

1. Open CINEMA 4D Broadcast or Studio. One difference you should note is that the Lite version can only be opened through After Effects. The professional version of CINEMA 4D can be launched independently without After Effects even being opened.

2. Click and hold the cube icon above the viewport to reveal the pop-up palette of primitive shapes. While this palette is open, left-click on the **Cylinder** icon to add the shape to the center of the viewport (Figure 9.6).

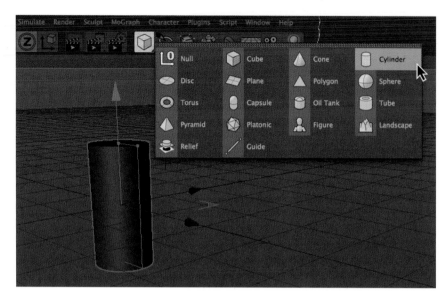

Figure 9.6: *Add a Cylinder object to the scene.*

3. Since we will be manipulating the object's underlying wireframe structure, select **Display > Gouraud Shading (Lines)** in the viewport (Figure 9.7).

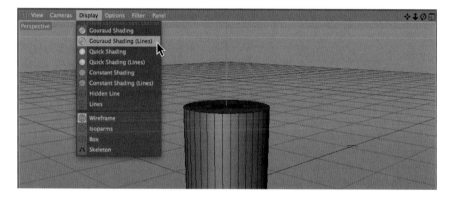

Figure 9.7: *Change the display setting in the viewport to see the wireframe structure.*

4. Go to the Attributes Manager and change the cylinder's Radius to **100 cm**. Decrease the **Rotation Segments'** value to **8**. Reducing the segments will help it render faster. Even though the shape of the cylinder is no longer smooth, adding it into a Subdivision Surface (HyperNURBS) object later in the exercise will change it back to a cylindrical object.

5. While the primitive is still selected in the viewport, click on the **Make Editable** button to convert the parametric primitive into a polygonal object (Figure 9.8). When you make a primitive editable, you can manipulate its points, edges, and polygons, but lose the ability to make any more parametric changes.

Chapter 9: Beyond CINEMA 4D Lite

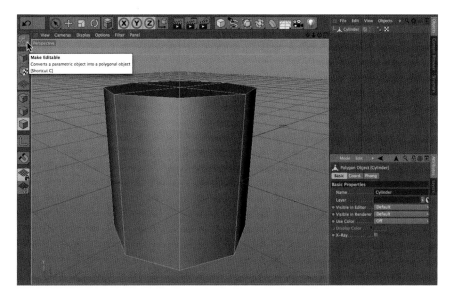

Figure 9.8: *Convert the parametric primitive into a polygon object.*

There is a reason for not making a primitive object editable to start with. You should always adjust its parametric values first, such as how many divisions it has or how smooth the edges should be. These changes cannot be made after the object is made editable. Let's take this polygon object and model an ice cream container out of it. The first thing you need to do is create the lid.

6. Use the navigation icons in the top right corner of the viewport to frame the top cap of the cylinder. This will allow you to select the polygon faces easier.

7. Make sure you have the **Live Section (Arrow)** 🔘 tool selected. Click on the **Polygons** icon on the left side of the viewport. The polygon tool allows you to select the different polygons on an object. Click on a polygon in the top cap of the cylinder to select it (Figure 9.9).

> **Keyboard Shortcuts**
> **1** to **Pan** the Camera
> **2** to **Dolly** the Camera
> **3** to **Orbit** the Camera
> **Cmd + Shift + Z** to undo a camera move

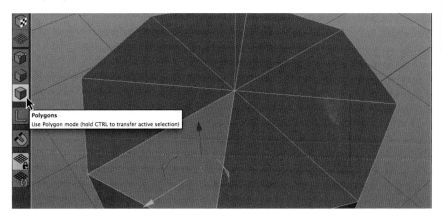

Figure 9.9: *Select a polygon face in the top cap of the cylinder.*

8. With a polygon face highlighted, go to **Select > Select Connected**. This command is a quick way to select all the polygon faces in the top cap.

When modeling a polygonal object, you are manipulating its underlying structure. This structure is often referred to as the **mesh**. CINEMA 4D offers a variety of tools to adjust a mesh's points, edges and polygons. The tools that you will be using are the **Extrude** and the **Extrude Inner** tool. The Extrude tool extends selected polygons outward or inward perpendicular to the surface. New polygons are created to bridge the extension to the surface. The Extrude Inner tool shrinks or expands the selected polygons within the same plane.

9. Select **Mesh > Create Tools > Extrude Inner**. The cursor changes to the Extrude Inner tool. In the viewport, click and drag to the right to add a small lip to the top of the cap (Figure 9.10).

Figure 9.10: *Use the Extrude Inner tool to create a small lip on the top cap.*

10. Go to **Select > Select Connected** again to add the new polygons you just created with the Extrude Inner tool to the selected polygons.

11. Use the viewport's navigation icons in the top right corner to view the side of the polygon model.

12. Select **Mesh > Create Tools > Extrude**. The cursor changes to the Extrude tool. In the viewport, click and drag to the right to create the thickness of the lid for the ice cream container (Figure 9.11).

Figure 9.11: *Use the Extrude tool to create the lid for the ice cream container.*

13. Click on the **Live Section (Arrow)** 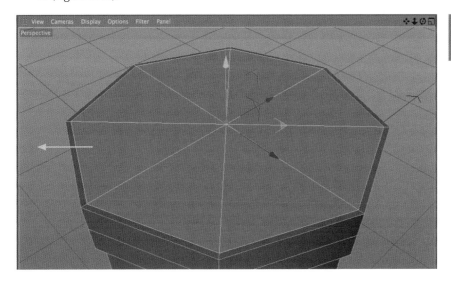 tool above the viewport. Click anywhere outside the model to deselect the polygons.

14. Let's add some more detail to the top cap of the lid. Go to **Select > Loop Selection**. Move the cursor over the top of the cap to highlight all of its faces. Click on a face to select only the top polygon faces.

15. Select **Mesh > Create Tools > Extrude Inner**. In the viewport, click and drag to the left to shrink the selected polygons in a little from the top edge of the lid (Figure 9.12).

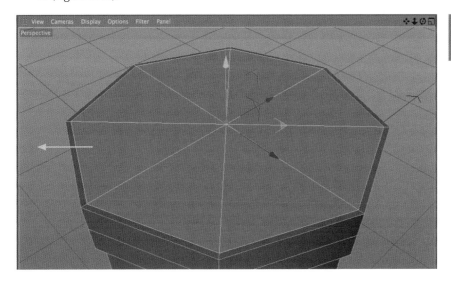

Figure 9.12: *Use the Extrude Inner tool to shrink the selected polygons inward.*

16. Select **Mesh > Create Tools > Extrude**. In the viewport, click and drag to the right to extend the selected polygons up (Figure 9.13).

Figure 9.13: *Use the Extrude tool to raise the selected polygons.*

17. Select **Mesh > Create Tools > Extrude Inner**. In the viewport, click and drag to the left to shrink the selected polygons in a little (Figure 9.14).

Figure 9.14: *Use the Extrude Inner tool to shrink the selected polygons inward.*

18. Select **Mesh > Create Tools > Extrude**. In the viewport, click and drag to the left to push the selected polygons inward (Figure 9.15).

19. Click on the **Live Section (Arrow)** tool above the viewport. Click anywhere outside the model to deselect the polygons. It is a good idea to always select the Live Selection tool when you are done modeling to avoid adding any additional extruded or inner extruded polygons.

Figure 9.15: *Use the Extrude tool to lower the selected polygons inward.*

20. Let's smooth out the mesh of the polygonal object. Go to the Objects Manager and select the **Cylinder** object.

21. Hold down the Option key and select the **Subdivision Surface** icon above the viewport (Figure 9.16). Holding down the Option key automatically makes the Cylinder a child of the Subdivision Surface object.

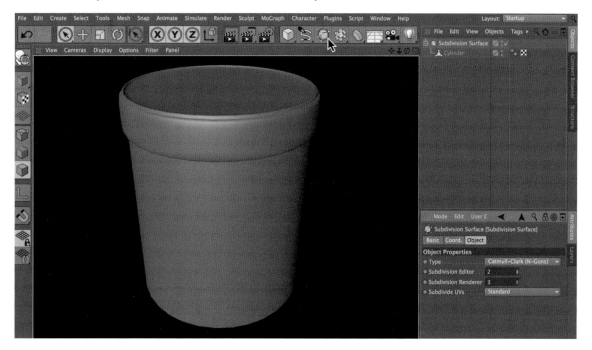

Figure 9.16: *The Subdivision Surface object adds a smooth function for the model.*

Modeling with Points, Edges, and Polygons

22. Let's taper the bottom of the container using a deformer. To make it easier to see the effects of the deformer, go to the viewport and select **Cameras > Front**

23. Click and hold the Deformer icon above the viewport to reveal the pop-up palette. While this palette is open, left-click on the **Taper** icon to add the deformer to the scene (Figure 9.17). Note that there are more deformers to choose from in professional version of CINEMA 4D.

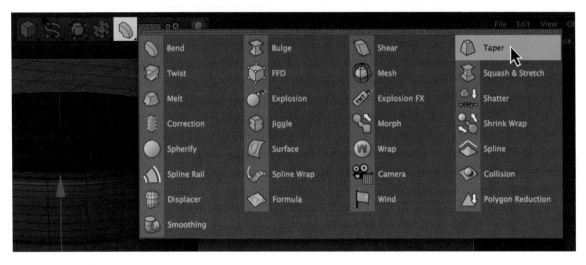

Figure 9.17: *Add a Taper deformer to the 3D scene.*

24. The Taper deformer must be a child of the Cylinder object in order for it to work. Go to the Objects Manager and click and drag the Taper deformer into the Cylinder object.

25. Click on the **Model** tool to the left of the viewport.

26. While the Taper object is highlighted in the Objects Manager, go to the Coordinates Manager and change the **Banking** rotation to **180 degrees** (Figure 9.18). This flips the taper object vertically in the viewport.

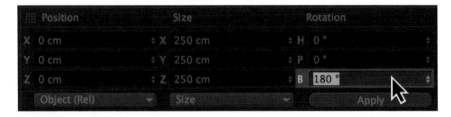

Figure 9.18: *Rotate the Taper deformer in the 3D scene.*

27. Go to the viewport. Click and drag the orange interactive handle for the deformer to taper in the bottom of the model (Figure 9.19).

28. Select **Cameras > Perspective**.

Chapter 9: Beyond CINEMA 4D Lite

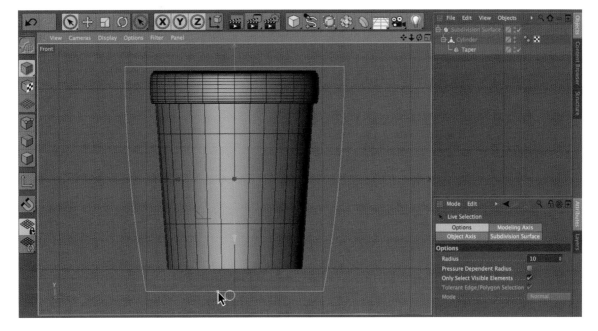

Figure 9.19: *Taper the bottom of the polygon object.*

29. Save your CINEMA 4D file as **IceCream.c4d** into the **Footage** folder within the downloaded **Chapter_09** folder on your desktop.

Exercise 2: Using Set Selection to Apply Materials

Now that the model of the ice cream container is done, the next step is to add the materials. For this exercise, you will use the **Set Selection** command. This allows you store polygon selections. You can then apply materials just to those selected faces. This works well for adding labels or decals to complex models.

1. Go to the Materials Manager. Select **Create > New Material**.

2. Double-click on the **Mat** icon to open the Material Editor dialog box.

3. While the **Color** channel is selected in the left column, change the **RGB Color** values to R = **150**, G = **50**, B = **40** in the right column. This will create a dark red color for your container. Rename the material to **Container** (Figure 9.20).

Figure 9.20: *Create the color material for the ice cream container.*

4. Go to the Materials Manager. Select **Create > New Material** to add a second new material to the manager's panel. For this material, you will import a bitmap image of the container's label.

5. Go to the Material Editor dialog box. While the **Color** channel is selected, make the following changes (Figure 9.21):

 ▸ Click on the **Texture** arrow and select **Load Image** from the pop-up menu.

 ▸ Locate the **IceCreamLabel.jpg** file in the **tex** folder in **Chapter_09**. Click **Open**.

 ▸ Double-click on the **Mat** name. Rename the texture to **Label**.

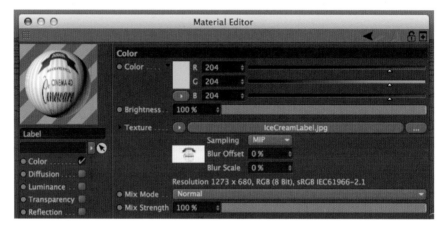

Figure 9.21: *Create the label texture using an imported bitmap image.*

6. Go to the Materials Manager. Select **Create > New Material** to add a third new material to the manager's panel.

7. Go to the Material Editor dialog box. While the **Color** channel is selected, make the following changes:

 ▸ Click on the **Texture** arrow and select **Load Image** from the pop-up menu.

 ▸ Locate the **IceCreamLabel_Top.png** file in the **tex** folder in **Chapter_09**. Click **Open**.

 ▸ Double-click on the **Mat** name. Rename the texture to **Top Label**.

8. Click on the checkbox next to the **Alpha** channel to activate it. Click on the **Texture** arrow and select **Bitmaps > IceCreamLabel_Top.png** from the pop-up menu. CINEMA 4D uses the alpha channel in the PNG file.

9. Click and drag the **Container** material from the Materials Manager and drop it onto the **Cylinder name** in the Objects Manager.

10. Make sure the **Cylinder** is selected in the Objects Manager. Click on the **Polygons** icon on the left side of the viewport.

11. Go to **Select > Ring Selection**. Move the cursor over the bottom part of the container to highlight all of its faces. Click to select them (Figure 9.22).

Figure 9.22: *Select all the polygons of the container.*

12. Go to **Select > Set Selection** to store the selected polygon faces in a Polygon Selection tag in the Objects Manager (Figure 9.23).

Figure 9.23: *Add a Polygon Selection tag to the Cylinder in the Objects Manager.*

13. Click and drag the **Label** material from the Materials Manager and drop it onto the selected polygon faces in the viewport. The material is only applied to those polygons. Go to the Attributes Manager and change the **Projection** property from **UVW Mapping** to **Cylindrical** (Figure 9.24).

Figure 9.24: *Apply the material to the selected polygon faces.*

14. Use the navigation icons in the top right corner of the viewport to frame the top cap of the lid. This will allow you to select the polygon faces.

15. Go to **Select > Loop Selection**. Move the cursor over the polygon faces on the lid. Click to select them. Shift-click to add additional loops (Figure 9.25).

Figure 9.25: *Select the polygons on the lid.*

16. Click and drag the **Top Label** material from the Materials Manager and drop It onto the selected polygon faces in the viewport. This will automatically create a new Polygon Selection tag in the Objects Manager.

17. Go to the Attributes Manager and change the **Projection** property from **UVW Mapping** to **Cubic** (Figure 9.26).

 ▸ Uncheck the checkbox for **Tile**. You only need one image of the label.

 ▸ Change the **Offset U** value to **5%**, the **Offset V** value to **5%**.

 ▸ Change the **Length U** value to **90%**, the **Length V** value to **90%**.

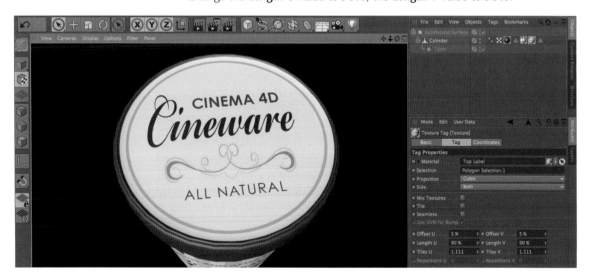

Figure 9.26: *Adjust the placement of the top label using the Attributes Manager.*

18. Save your CINEMA 4D file. Select **File > Save**.

19. Click on the **Live Section (Arrow)** tool above the viewport. Click anywhere outside the model to deselect any selected polygons.

20. Click on the **Model** tool to the left of the viewport.

21. Click and hold the Environment icon above the viewport to reveal the pop-up palette of objects. While this palette is open, left-click on the **Floor** icon.

22. Go to the Objects Manager and select the **Subdivision Surface** object. Go to the Coordinates Manager to set the **Y-Position** to **100 cm** to raise the ice cream container up to sit on the surface of the floor (Figure 9.27).

Figure 9.27: *Reposition the polygon model to sit on top of the Floor object.*

23. Let's add a spoon to the scene. This has already been created in a separate CINEMA 4D file. To import the spoon, go to the Objects Manager.

 ▸ Select **File > Merge Objects**.

 ▸ Locate and select the **Spoon.c4d** file inside the **Footage** folder.

 ▸ Click **Open**. The CINEMA 4D object and its material is added (Figure 9.28).

Figure 9.28: *Add the spoon model to the scene.*

The model of the spoon started as a primitive cube that was scaled vertically and additional segments were added using its parametric parameters. After the cube was made editable, the Extrude tool extended the polygon sides to create the basic shape. Through a combination of polygon modeling tools and manually repositioning the points in the mesh, the spoon model took its final shape (Figure 9.29).

Figure 9.29: *The model of the spoon was created from a primitive cube using the polygon modeling tools and manually manipulating its points on the mesh.*

To smooth out the spoon, the subdivided polygon was added as a child of a Subdivision Surface (HyperNURBS) generator. This generator examined each of the polygonal faces created by the Extrude tool, and then rounded the mid-points of each face in 3D space. It is through this rounding that you achieve a smooth looking model in CINEMA 4D (Figure 9.30).

Figure 9.30: *The Subdivision Surface generator applies a smoothing effect to the model.*

Chapter 9: Beyond CINEMA 4D Lite

Experiment with adding lights to your scene (Figure 9.31). Think about the three-point lighting system you built in Chapter 2. When you are done save your CINEMA 4D file and import it into After Effects to add additional effects.

Figure 9.31: *Experiment with lighting and composition in your 3D scene.*

Parametric objects and objects formed from applying generators to splines, such as lathe and extruded NURBS, have many applications in 3D modeling. CINEMA 4D Lite allows you to create a wide variety of models using these methods. However, complex objects requiring detailed modeling of surfaces need to be done with polygonal modeling. Only the professional versions of CINEMA 4D provide these tools to add to your 3D modeling skillset.

Exploring MoGraph Objects in CINEMA 4D

MoGraph in CINEMA 4D is something every motion graphics designer should become familiar with. It is an add-on module for creating motion graphics. The concept behind its workflow is quite simple. In fact, you already experienced this in Chapter 1.

Basically, MoGraph works by adding a model to a Mograph "Object." You then apply "Effectors" that affect properties of the "Object" to create visual effects. Effectors can be stacked to create complex hierarchies and animation. The following is an overview of some of the popular MoGraph Objects.

Let's start with the **Cloner** object which is a key element in many MoGraph projects. Its name defines what it does. Objects that are added as children of a Cloner object are duplicated in one of four modes: **Linear** arranges each clone in a straight line. **Radial** arranges the clones in a circular array. **Grid Array** stacks the clones in a grid along the X-Y-Z axis. The final mode is **Object** where the clones are attached to vertices or faces of another object (Figure 9.32)

Figure 9.32: *The Cloner object provides four different modes to arrange the duplicated objects in the scene.*

The **Fracture** object is included with CINEMA 4D Lite. Child objects are treated as clones, and any disconnected polygon, cap, or extruded letter within the object can also be treated as an individual clone and animated separately. In the first chapter, extruded text was placed into a Fracture object and each letter was separated as an individual clone (Figure 9.33).

Figure 9.33: *Fracture can explode and connect the individual clones.*

An effector manipulates the clones of the Fracture object, typically breaking them apart in a couple of different modes. One of the Fracture modes is called

Explode Segments and Connect where each individual clone is treated as a separate object (Figure 9.33). Another mode is simply called **Explode Segments**. If a child object is made up of segments, the extruded text spline, caps, and extrusion are treated as separate objects (Figure 9.34).

Figure 9.34: *Fracture can also explode splines, caps, and extrusions as separate objects.*

The **MoText** object automatically extrudes a text spline. Effectors can be applied to manipulate attributes like scale, rotate, and position. An effector, or group of effectors, can be used to modify the text on a per letter, word, line, or all text basis. You can create a MoText object and then attach the Random effector for each letter. If you change the random mode to "Noise" you have instant animated text (Figure 9.35).

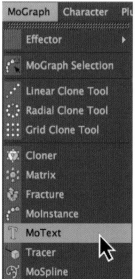

Figure 9.35: *MoText automatically extrudes the text spline for animation.*

The **MoSpline** object is a special spline generator. What makes it special is that the MoSpline is actually a cloning system in itself with which splines can be created, modified or multiplied mathematically or using an existing spline. This works well for generating abstract art or growing plants. Let's experiment with the basic functionality of the MoSpline to see how it works. The following exercise explores using the MoSpline in conjunction with a Sweep NURBS to create a growing vine.

Exercise 3: Creating and Animating a MoSpline

Locate and play the **Vinery.mov** file in the **Completed** folder inside **Chapter 09** (Figure 9.36). The animated growing vine was created using a combination of a MoSpline and a Sweep NURBS object.

Figure 9.36: *The growing vine was created using a MoSpline object.*

1. In CINEMA 4D Broadcast or Studio, open the **Vinery.c4d** file located inside the **Footage** folder in **Chapter_09**. The file contains extruded text and a spline path. For this exercise, the spline was generated from left to right. Make a note of this if you are using your own spline curves.

2. Select the **Circle** spline from the Spline palette above the viewport window (Figure 9.37). The spline appears in the 3D scene.

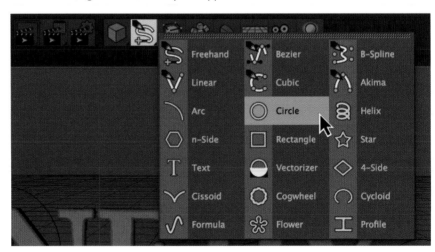

Figure 9.37: *Add a circle spline to the scene.*

3. Go to the Attributes Manager and change the circle's **Radius** to **10 cm**.

4. Select **MoGraph > MoSpline** to add a MoSpline object to the Objects Manager.

5. Go to the Attributes Manager. Click on the **Object** tab and, since we will be using an existing spline object as a base, set the **Mode** to **Spline** (Figure 9.38). Keep the **Grow Mode** set to **Complete Spline** since the final vine will use the entire spline not individual segments.

Figure 9.38: Change the MoSpline parameters in the Attributes Manager.

6. Click on the **Spline** tab in the Attributes Manager and drag the **Vine** spline object into the **Source Spline** field. The generated vine should have a **Width** of **6 cm** set this value in the corresponding parameter.

Figure 9.39: Set the spline source to the Vine spline object and increase the width.

7. Select the **Sweep NURBS** from the NURBS object palette above the viewport. In order for the generator to work you need to place both splines inside the **Sweep NURBS** object in the Objects Manager. The order is important:

 ► Click and drag the **MoSpline** object into the Sweep NURBS object.

 ► Click and drag the **Circle** spline into the Sweep NURBS object. In the viewport, you will see the vine appear wrapping around the text (Figure 9.40).

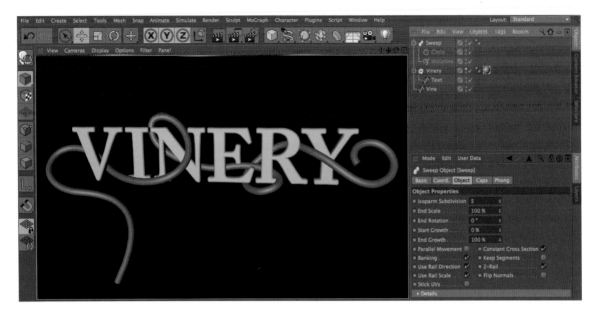

Figure 9.40: *Create a Sweep NURBS to generate the vine.*

8. The Sweep NURBS is a little too thick. Select it in the Objects Manager. Go to the Attributes Manager and decrease the **End Scale** value to **10%** (Figure 9.41).

Figure 9.41: *Decrease the scale of the Sweep NURBS in the Attributes Manager.*

9. Let's fine-tune the MoSpline object to extend beyond the end of the source spline. Select the **MoSpline** object in the Objects Manager. Go to the Attributes Manager and click on the **Object** tab. Set the **End** value to **120%** (Figure 9.42). In the viewport, the end of the MoSpline extends into a spiral of curves. This can be controlled in the Attributes Manager to refine its scale and smoothness.

Figure 9.42: *Extend the MoSpline's end point beyond its source spline's end point.*

Chapter 9: Beyond CINEMA 4D Lite

10. Open the **Extend End** parameters' menu by clicking on the arrow at the left of its name. Decrease the **Spiral** to **30%** and the **Spiral Scale** to **0%** (Figure 9.43).

Figure 9.43: *Adjust the spiral at the end of the MoSpline.*

11. The current state of the MoSpline represents the last frame of the animation we want to create. We want the vine to grow up and animate over the extruded letters ending with the spiral you created in the previous step. Go to the Animation Palette located under the viewport. Click and drag the Current Time Indicator (green square) to **frame 140** in the Timeline Ruler (Figure 9.44).

Figure 9.44: *Move the Current Time Indicator (green square) to frame 140.*

12. Go to the Attributes Manager. Hold down the Control key and click on the gray round circle in front of the **End** parameter. The circle will fill solid red indicating that a keyframe was recorded at frame 140.

13. Go to the Animation Palette and click and drag the Current Time Indicator (green square) back to **frame 0** in the Timeline Ruler.

14. Go to the Attributes Manager and change the **End** value to **0%**. Hold down the Control key and click on the orange round circle in front of the **End** parameter. The circle will fill solid red indicating that a keyframe was recorded at frame 0.

15. Click the **Play Forwards** button to see the animated vine grow (Figure 9.45).

Figure 9.45: *Preview the animation of the MoSpline in the viewport.*

Exercise 4: Adding Materials, Lights, and a Camera

Now that the growing vine animation is complete, the next step is to add the materials and lighting to the scene.

1. Go to the Materials Manager. Select **Create > New Material**.

2. Double-click on the **Mat** icon to open the Material Editor dialog box.

3. While the **Color** channel is selected in the left column, change the **RGB Color** values to R = **150**, G = **140**, B = **70** in the right column. This will create an olive green color for your vine. Rename the material to **Vine**.

4. While the **Color** channel is selected, make the following changes (Figure 9.46):

 ▸ Click on the **Texture** arrow and select **Noise** from the pop-up menu.

 ▸ Click on the **Noise** button to open its parameters.

 ▸ Decrease the **Global Scale** value to **5%** to give the material a little texture.

 ▸ Click on the **back arrow** ◀ at the top-right corner of the Material Editor to return to the **Color** parameters. Set the top Noise layer's mixing mode to **Multiply** (Figure 9.46).

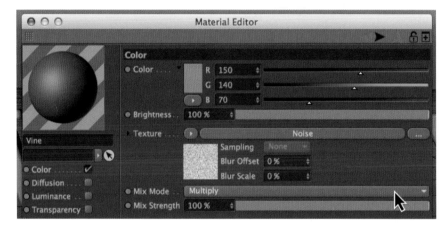

Figure 9.46: *Add a little Noise to the color to give the material some texture.*

5. Click and drag the **Vine** material from the Materials Manager and drop it onto the **Sweep name** in the Objects Manager. Next, let's add some lights.

6. Click on the **Light** icon to add a light source to your 3D scene. In the Objects Manager, rename the light to **Left Light**. This will be positioned on the left side of the text and vine.

7. Go to the Attributes Manager and click on the **Coord.** tab:

 ▸ Set the **X-Position** to **-50 cm**.

 ▸ Set the **Y-Position** to **200 cm**.

 ▸ Set the **Z-Position** to **-400 cm**.

8. Click on the **General** tab and decrease the **Intensity** value to **90%**.

9. Change the **RGB Color** values to R = 255, G = 205, B = 174.

10. Turn on the light's shadows by selecting **Shadows Maps (Soft)** from the **Shadow** drop-down menu.

11. Click on the **Light** icon again to add another light source to your scene. In the Objects Manager, rename the light to **Back Light**.

12. Go to the Attributes Manager and click on the **Coord.** tab:
 ▸ Set the **Y-Position** to **-200 cm**.
 ▸ Set the **Z-Position** to **200 cm**.

13. Click on the **General** tab and increase the **Intensity** value to **120%**.

14. Click on the **Light** icon again to a third light source to your scene. In the Objects Manager, rename the light to **Key Light**.

15. Go to the Attributes Manager and click on the **Coord.** tab:
 ▸ Set the **Y-Position** to **-50 cm**.
 ▸ Set the **Z-Position** to **-200 cm**.

16. Click on the **General** tab and decrease the **Intensity** value to **70%**.

17. Change the **RGB Color** values to R = 255, G = 188, B = 126.

18. Click on the **Light** icon again to a final light source to your scene. In the Objects Manager, rename the light to **Rim Light**.

19. Go to the Attributes Manager and click on the **Coord.** tab:
 ▸ Set the **X-Position** to **400 cm**.
 ▸ Set the **Y-Position** to **-50 cm**.
 ▸ Set the **Z-Position** to **-100 cm**.

20. Click on the **General** tab and decrease the **Intensity** value to **80%**.

21. Change the **RGB Color** values to R= 252, G = 185, B = 155.

22. In the Attributes Manager, click on the **Details** tab.
 ▸ Set the **Falloff** property to **Inverse Square (Physically Accurate)**.
 ▸ Set the **Radius/Decay** of the falloff to **400 cm**.

23. Click on the **Render View** icon to preview the lighting.

24. Click on the **Camera** icon to add a placed camera to your 3D scene.

25. Go to the Attributes Manager and click on the **Coord.** tab (Figure 6.58):
 ▸ Set the **X-Position** to **15 cm**.
 ▸ Set the **Y-Position** to **-80 cm**.
 ▸ Set the **Z-Position** to **-775 cm**.

- ▸ Set the **Rotation Heading (R.H)** to **0.5 degrees**.
- ▸ Set the **Rotation Pitch (R.P)** to **8 degrees**.
- ▸ Set the **Rotation Bank (R.B)** to **0 degrees**.

26. Go to the Animation Palette. Make sure the Current Time Indicator is on **frame 0** in the Timeline Ruler.

27. Click on the **Record Active Objects** icon to record keyframes for the camera's position and rotation on frame 0 in the Timeline Ruler.

28. Click and drag the Current Time Indicator (green square) to **frame 120** in the Timeline Ruler (Figure 9.47).

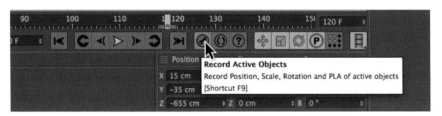

Figure 9.47: *Move the Current Time Indicator (green square) to frame 120.*

29. Make sure the **Camera** is selected in the Objects Manager. Go to the Attributes Manager and make the following changes to truck the camera in:

- ▸ Set the **Y-Position** to **-35 cm**.
- ▸ Set the **Z-Position** to **-655 cm**.
- ▸ Set the **Rotation Pitch (R.P)** to **6 degrees**.

30. Click on the **Record Active Objects** icon to record keyframes for the camera.

Figure 9.48: *Preview the final animation of the MoSpline and camera movement.*

31. Click the **Play Forwards** button to see the final animation (Figure 9.48).

32. Save your CINEMA 4D file. Select **File > Save**.

33. Launch After Effects and open the **MoSpline.aep** file inside the downloaded **Chapter_09** folder. It contains a composition named **Vinery** with two layers.

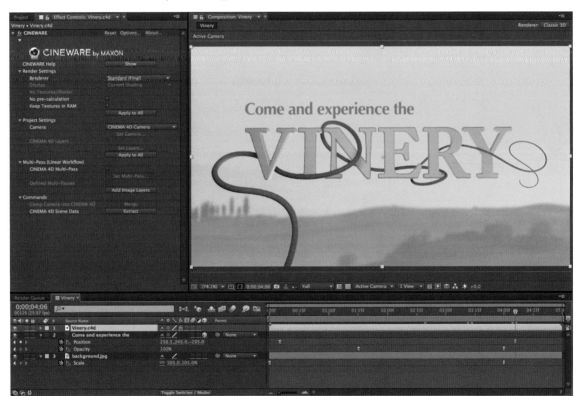

34. Double-click in the Project panel to open the Import File dialog box. Locate the **Vinery.c4d** file in the **Footage** folder inside **Chapter_09**. Click **Open** to import the footage into the Project panel.

35. Click and drag the **Vinery.c4d** file from the Projects panel to the Timeline. Position it at the top of the layers in the Timeline.

36. Make sure the CINEWARE **Renderer** is set to **Standard (Final)** in the Effect Controls panel.

37. Click on the **RAM Preview** button to see the imported MoSpline animation inside the After Effects composition (Figure 9.49).

Figure 9.49: *Preview the CINEMA 4D file in After Effects using the CINEWARE plug-in.*

This completes the exercise. Make any adjustments to the project that you want. When you are done, render out the composition as a QuickTime movie. The next part of this chapter explores how Effectors affect MoGraph Objects.

Animating with Sound Effectors

Effectors create the animated visual effects in CINEMA 4D. They take MoGraph objects, such as clones and MoText, and change their position, scale, rotation using effector specific properties like sound. This next exercise focuses on using the Sound effector to synchronize several objects' movement to the music.

Exercise 5: MoText and Cloner Objects

1. In CINEMA 4D Broadcast or Studio, open the **Dance.c4d** file located inside the **Footage** folder in **Chapter_09**. The file contains a MoText object, a primitive cube, several lights and a placed camera (Figure 9.50). As mentioned previously, a MoText object is essentially extruded text.

Figure 9.50: *The CINEMA 4D file contains a MoText object.*

2. Let's create a dance floor using the cube and a Cloner object. Select **MoGraph > Cloner** to add the object to the Objects Manager.

3. Click and drag the **Cube** object into the Cloner object. This will make the cube a child of the Cloner object and simultaneously create three copies, or clones, stacked vertically one on top of the other. This is the default Linear mode.

4. Select the **Cloner** object in the Objects Manager. Go to the Attributes Manager and change the **Mode** from **Linear** to **Grid Array**. The clones will now be arranged into a cube. Change the **Count** to **20**, **1**, and **20**. Setting the Y-Count to **1** flattens the grid. Increase the **Size** to **1100**, **200**, and **1100** (Figure 9.51).

Figure 9.51: *Change the Cloner object's parameters in the Attributes Manager.*

Cloners are one of the main ingredients in creating complex motion graphics in CINEMA 4D. Using MoGraph effectors to animate the clones saves a lot of time from manually setting keyframes in the Timeline. Now that the floor grid and MoText are in place, the next step is to start applying effectors to create the animation. For this exercise, you will add a Sound effector.

5. With the Cloner object selected, select **MoGraph > Effector > Sound**.

6. Go to the Attributes Manager. For the **Sound File**, load the **dance.mp3** file located in the **Footage** folder in **Chapter_09**. Change the **Apply Mode** to **Step** to animate each clone separately. Increase the **Compression** to **60%** (Figure 9.52).

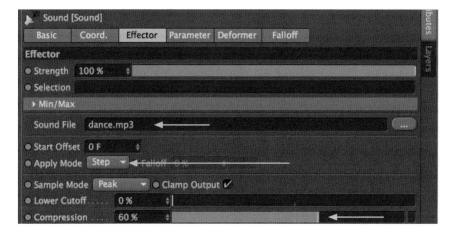

Figure 9.52: *Change the Sound effector's parameters in the Attributes Manager.*

7. Click the **Play Forwards** button to see the Sound effector in action.

The Sound effector animates the vertical position of the clones using the imported sound file. The effector analyzes the frequencies in the audio and applies the data to the grid array. The filter spline graph allows you to define which frequencies the effector uses, or to isolate particular frequency ranges.

8. Select the **Cloner** object in the Objects Manager. Go to the Attributes Manager and click on the **Effectors** tab. When you selected the Cloner object and added the Effector from the Effector menu, it automatically showed up in the Effector field. If you didn't select the Cloner you would need to add the effector manually.

9. Select **MoGraph > Effector > Delay**. This applies a delay to the movement that the Sound effector generates. It helps smooth out the motion (Figure 9.53).

10. Go to the Attributes Manager and increase the Delay's **Strength** to **60%**.

11. Select the **MoText** object in the Objects Manager. Go to the Attributes Manager and click on the **Letters** tab. Let's manually apply the same effectors to the text.

 ▸ Click and drag the **Sound** effector into the **Effects** field.

 ▸ Click and drag the **Delay** effector into the **Effects** field (Figure 9.54).

Figure 9.53: *Add a Delay effector to the Cloner object to smooth out the motion generated by the sound file.*

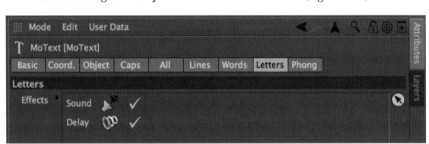

Figure 9.54: *Add the effectors to the MoText object manually.*

12. Click the **Play Forwards** button to see the effectors in action (Figure 9.55).

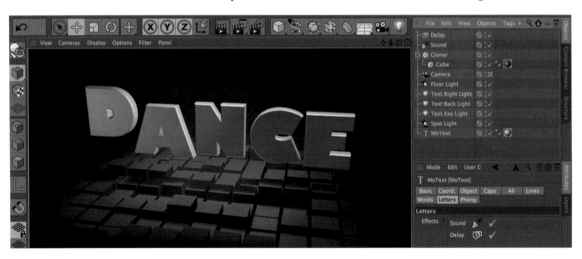

Figure 9.55: *Preview the synchronized animation in the viewport.*

By manipulating the Delay's strength, you are essentially morphing from one effect to the other. Each effector offers a Strength parameter to combine multiple effects together in various ways. The variation in what you can do is almost endless. There are so many settings for effectors that it's impossible to cover everything in detail. The best advice is to experiment with each setting.

13. Save your CINEMA 4D Lite file. Select **File > Save**. This completes this exercise. Experiment with the Sound effector parameters. When you are done save your CINEMA 4D file and import it into After Effects to add additional effects.

Adding Dynamics to a Scene

CINEMA 4D offers a dynamics engine that calculates the physical movement and collision of 3D objects. This produces very realistic movement of objects that would be next to impossible to create manually with keyframes. Locate and play the **Dynamics.mov** file in the **Completed** folder inside **Chapter_09** (Figure 9.56). The goal of this last exercise is to become familiar with dynamics using two Simulation tags, the **Rigid Body** and the **Collider Body**.

Figure 9.56: *Dynamics control the objects' collision detection with the falling spheres.*

Exercise 6: Adding Simulation Tags

1. In CINEMA 4D Broadcast or Studio, open the **Dynamics.c4d** file located inside the **Footage** folder in **Chapter_09**. The file contains a 3D scene with extruded text, two Sweep NURBS, a Plane object, lighting, and a placed camera.

2. Locate the cube icon above the viewport window. Click and hold the icon to reveal the pop-up palette of primitive shapes. While this palette is open, left-click on the **Sphere** icon to add the shape to the scene (9.57).

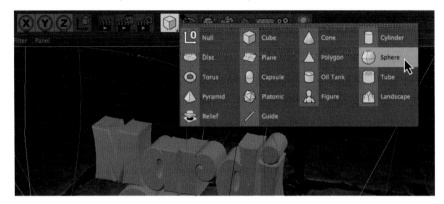

Figure 9.57: *Add a sphere to the scene.*

3. Go to the Attributes Manager and change the **Radius** property to **10 cm**.

4. Select **MoGraph > Cloner** to add the object to the Objects Manager.

5. Click and drag the **Sphere** object into the Cloner object.

6. Select the **Cloner** object in the Objects Manager. Go to the Attributes Manager and change the **Mode** to **Grid Array**. The clones will now be arranged into a cube. Change the **Count** to **8**, **8**, and **6**. Increase the **Size** to **600**, **300**, and **200**.

7. Go to the Coordinates Manager and change the **Y-Position** to **600 cm**. This will position the grid of clones above the extruded text (Figure 9.58).

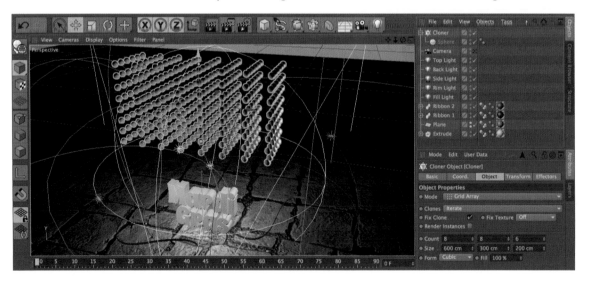

Figure 9.58: *Create clones of the sphere and position them above the extruded text.*

8. Make sure the **Cloner** object is still selected in the Objects Manager. Select **Tag > Simulation Tags > Rigid Body** (Figure 9.59). A new Dynamics Body Tag appears in the Objects Manager. What is a rigid body? A marble is a good example where its sides are inflexible.

9. Select the **Rigid Body Tag** in the Objects Manager. Go to the Attributes Manager and set the **Collision Inherit Tag** to **Apply Tag to Children**. Set the **Individual Elements** to **All**. This will treat each clone as a separate object for the dynamics engine (Figure 9.60).

Figure 9.59: *Add a Rigid Body Dynamics tag to the Cloner object in the scene.*

Figure 9.60: *Change the Dynamics Body Tag to treat each clone as a separate object.*

10. Click the **Play Forwards** button to see the dynamics engine in action. The rigid spheres fall and pass right through the text and plane. That's because these models are not part of the dynamics engine yet. The spheres fall due to the gravity in the scene. This can be adjusted in the Project Settings.

11. You now have one half of the dynamics engine completed. In order to see the rigid bodies collide with other objects, you need to add a collider object.

 ▸ Click on the **Plane** in the Objects Manager. Select **Tag > Simulation Tags > Collider Body** to add a Dynamics Body Tag.

 ▸ Shift-select the **Ribbon 1**, **Ribbon 2**, and the **Extrude** object in the Objects Manager. Select **Tag > Simulation Tags > Collider Body** to add Dynamics Body Tags to the three items.

12. With these three new Dynamics Body Tags selected, go to the Attributes Manager. Set the **Shape** to **Automatic (MoDynamics)**. This will allow the spheres to fall inside the negative space inside the text and Sweep NURBS. If you do not change this, the collision detection will occur based on the models' bounding boxes, not their actual 3D shapes (Figure 9.61).

Figure 9.61: *Change the collider object to detect its actual shape, not bounding box.*

Adding Dynamics to a Scene

13. Click the **Play Forwards** button to see the dynamics engine in action. The spheres now react to the collider bodies and move in a realistic manner (Figure 9.62). Imagine trying to animate this manually with keyframes.

Figure 9.62: *Preview the Rigid Body and Collider Body dynamics in the viewport.*

Exercise 7: Apply a Color Shader to Generate Random Colors

Let's add some color to the falling spheres. In addition to Cloners and Effectors, Mograph also offers a **Color Shader** that generates a random set of colors for the clones. It is fairly easy to set up. All you need is a new material.

1. Go to the Materials Manager. Select **Create > New Material**.

2. Double-click on the **Mat** icon to open the Material Editor dialog box.

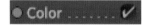

3. While the **Color** channel is selected in the left column, change the **RGB Color** values to R = **173**, G = **4**, B = **125** in the right column. This will create a dark pink color for your cone. Rename the material to **Color Shader**.

4. While the **Color** channel is selected, make the following changes (Figure 9.46):
 ▸ Click on the **Texture** arrow and select **Mograph > Color Shader**.
 ▸ Decrease the **Mix Strength** value to **30%**.

5. In the **Specular** channel make the following changes (Figure 9.63):
 ▸ Decrease the **Width** value to **30%** and increase the **Height** value to **50%**.
 ▸ Decrease the **Falloff** value to **-10%**.
 ▸ Increase the **Inner Width** value to **30%**.

Figure 9.63: *Adjust the specular highlight settings in the Material Editor.*

6. When you are done, close the Material Editor dialog box. Click and drag the **Color Shader** material from the Materials Manager and drop it onto the **Cloner name** in the Objects Manager.

7. In order to generate random colors, you need a Random effector. Make sure the Cloner object is selected in the Objects Manager. Select **Mograph > Effector > Random** to apply it automatically to the clones.

8. Go to the Attributes Manager. Click on the **Parameter** tab. Change the **Color Mode** to **On**. The spheres randomly change color in the viewport (Figure 9.64).

Figure 9.64: *Turn on the Color Mode for the Random effector.*

The **Mix Strength** setting for the Color Shader controls the number of random colors generated. You set it to 30% in the material, which narrows the choices to the warm pinks and reds. Setting the value to 100% would give you all the colors in the spectrum. Go back to the Material Editor and experiment.

9. To view what the camera object is looking at in the viewport, go to the Objects Manager. Click on the **target** to the right of the **Camera name**. The target will turn white. The viewport will animate to display what the camera is looking at. This is the final position for the camera (Figure 9.65).

10. Click the **Play Forwards** button to see the final 3D animation (Figure 9.65).

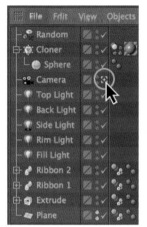

Figure 9.65: *Preview the final animation.*

11. Save your CINEMA 4D Lite file. Select **File > Save**. This completes this exercise. Experiment with the Rigid Body and Collider Body parameters to control the bounce and friction of the objects. When you are done save your CINEMA 4D file and import it into After Effects to add additional effects.

Summary

This completes this chapter and this book. Upgrading CINEMA 4D Lite will unlock even more features and functions to enhance your motion graphics projects. This chapter only scratched the surface of the tools and features available in the professional versions of CINEMA 4D. To continue to delve deeper into CINEMA 4D and CINEWARE, I suggest the following resources:

► www.cineversity.com
► www.greyscalegorilla.com

Your journey has come full-circle. You started your quest by learning about the workspace and workflow in CINEMA 4D and CINEWARE. Along the way you created 3D visual effects and animation using both CINEMA 4D Lite and After Effects. Hopefully you have been inspired to explore more uncharted possibilities using these two powerhouse applications. Thank you for taking the journey into the world of 3D motion graphics.

Index

DATE DUE

4/20/16 O/X	
SEP - 9 2016	
SEP - 9 2016	
CPQ	
Huk	

PRINTED IN U.S.A.